HOW TO IDENTIFY

NIGHT SKY

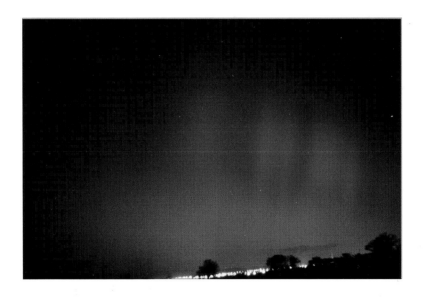

STORM DUNLOP • WIL TIRION

BARNES
&NOBLE
BOOKS

This edition published by Barnes & Noble, Inc.
by arrangement with (HarperCollins*Publishers,* London)

2003 Barnes & Noble

ISBN 0-7607-4198-0

M 10 9 8 7 6 5 4 3 2 1

ISBN 0 00 710361 1

Storm Dunlop, author of *Collins Wild Guide Night Sky*, has written numerous other books and articles on both astronomy and meteorology. Fellow of the Royal Astronomical Society and the Royal Meteorological Society, he also teaches adult education classes, and gives lectures and talks.

Wil Tirion is the world's foremost celestial cartographer. His works include *Uranometria 2000.0* and *Collins Pocket Guide Stars and Planets.*

All charts created by Wil Tirion.
The copyright in the photographs belongs to the following:
Albers, Steve 121b; Albrecht, Bill 115m; Bone, Neil 1, 22, 113; Buczynski, Denis 75, 104; Courtesy of the Observatories of the Carnegie Institution of Washington 79t, 79b, 80t ; Denyer, Graham 111m; Dunlop, Storm 15, 29, 46; Edberg, Steve 43, 47, 145t, 145m, 147, 149, 151, 153, 155, 157, 159, 161, 163, 165, 167, 169, 171, 173, 175, 177, 179, 181, 183, 187, 189, 191, 193, 195, 197, 199, 201, 203, 205, 209, 211, 213, 215, 219, 221, 223, 225, 227, 229, 231, 237, 239, 241, 243, 245, 247; Fuji, Akira 72–73t, 76m, 76–77b, 90bl, 90bm, 90br, 91b; Gavine, Dave 111b, 112; Gill, Peter 123; Grafton, Ed 27m, 126, 127, 136, 137, 143t; UC Regents/Lick Observatory 80b, 81, 82, 84, 86, 88; Massey, Steve 19, 27m, 139, 140, 143m, 143b; McNaught, Robert 121t; Mobberley, Martin 122; Nye, Paul 114; Pitt, Stephen 8, 9, 73, 117, 124, 141, 142; Royal Astronomical Society 20; Robin Scagell/Galaxy 207, 235; Sewell, Dave 115t; Tezel, Tunc 28, 91t, 92; Toone, John 129, 132

Cover photograph: The Pleiades. © Anglo Australian Observatory/Royal Observatory Edinburgh
Title page photograph: Red auroral rays seen over Chichester during the major display of 24–25 April 1991.

Typeset and designed by D & N Publishing, Baydon, Wiltshire.
Colour reproduction by Colourscan, Singapore
Printed and bound by Imago

CONTENTS

HOW TO USE THIS BOOK

This book is intended for those taking an interest in the sky, wanting to find their way around among the many constellations, and also carry out simple observing with the naked eye, binoculars or small telescopes.

The first section begins with some general advice on observing (pp.6–9). This is followed (pp.10–27) by information that will help readers to locate objects in the sky, and also to understand the charts, diagrams, and tables of positions that are provided both in this book and elsewhere. This portion includes descriptions on the names of stars and other celestial objects (pp.24–27), together with the reasons for their differences in brightness and colour. The section ends with some information about simple photography.

The next section will help beginners to find their way around the sky. This is not as complicated as it might at first appear. Everyone starts by learning to recognize the five main circumpolar constellations, which are visible whenever the sky is clear (pp.30–35). The next few pages describe the location and recognition of the constellations that are most clearly visible at different seasons, together with the most notable objects in that part of the sky. Although arranged to start with the winter, readers may choose any season to begin observing. The same applies to the following section (pp.46–71), which shows the appearance of the night sky with two charts for each month of the year, looking north and looking south.

Specific information about individual objects follows, beginning with the Moon (pp.72–89), and then the planets, including detailed charts showing planetary positions for a period of five years (pp.94–103). These are followed by charts showing the periods when some of the brighter minor planets (asteroids) are visible in small instruments.

The next section (pp.110–143) describes individual phenomena or objects in more detail, ranging from unusual high-altitude clouds that are visible in twilight or in the middle of the night, to distant galaxies.

The final section (pp.144–247) may be used at any time, but comes into its own when readers are moderately familiar with finding their way around the sky. There are charts and photographs of all the constellations visible to mid-latitude northern-hemisphere observers, together with a description of objects of interest. The positions of meteor radiants are shown, and charts and comparison stars are given for a number of interesting variable stars. Details of sources of further information may be found on p.248, and a glossary begins on p.251.

WHAT TO USE

If you have only just become interested in astronomy, resist the temptation to rush out and buy a telescope. The majority of cheap telescopes offered in many shops and magazines are generally not worth buying. You do not need any equipment at all to learn to find your way around the sky, identify the brightest objects, and begin observing.

Once you can find your way around, you can consider using some form of optical equipment. Old-fashioned opera glasses are actually quite useful, because they have a low magnification – so you do not become lost – but are not particularly common nowadays. It is probably best to invest in a good pair of binoculars. These are always designated by their magnification and aperture, such as '8 × 42' or '7 × 50', where the first figure indicates the magnification (8 and 7 times, respectively) and the second the aperture – the diameter of the main lens (the objective or object glass) through which light enters the instrument. As a general rule in astronomy, the larger the aperture the better, because more light is being gathered.

Binoculars have one disadvantage: if too large or heavy they are difficult to keep steady. You can buy or make suitable mountings for binoculars, but these tend to be cumbersome and make life difficult for beginners. Avoid very high magnifications, because these restrict the field of view and amplify every minor movement. (The modern image-stabilized binoculars are marvellous to use, but extremely expensive.) Generally, magnifications of 7×, 8×, and 10× are best, while one of 12× becomes difficult to hold steady. Some simple tricks that help with the problem of steadiness are sitting in a garden chair that has arms to support the elbows; resting the binoculars on top of a broom, a wall, or something similar; and tying a length of string or light chain to the binoculars, and standing on one end while gently pushing upwards to put the string or chain in tension. When trying to observe objects right overhead, it is best to lie flat on the ground on a suitable mattress.

You must also avoid too low a magnification. In the dark, the pupil of the eye expands to a maximum diameter of about 7 mm – slightly less for older people. The light leaving any optical instrument does so as a circular beam, the diameter of which equals the aperture of the

instrument divided by the magnification. Put in simple terms, the diameter of the exit pupil should not be larger than the maximum diameter of the pupil of the observer's eye. With 7 × 50 binoculars, the exit pupil is about 7 mm, which is about the maximum for useful work. (Technically this is simplification and other factors affect an instrument's performance, but it is a useful rule-of-thumb.)

Monoculars, many of which essentially consist of half of a pair of binoculars, are also useful. The types used by birdwatchers often come with a tripod, but observation of objects high in the sky may be difficult. The magnification on many monoculars, however, is often too high for most astronomical purposes.

If you become sufficiently interested in astronomy to want to observe fainter objects, there are many different types of telescope that you can buy (or even build). Details about choosing between the different types are given in some of the publications mentioned under 'Further Information'. Although some amateurs have highly sophisticated equipment, including computer-controlled telescopes and electronic (CCD) cameras, it is worth remembering that serious scientific work is carried out by many observers with nothing more than a pair of 7 × 50 binoculars.

Measure the circular exit pupil by holding the binoculars in front of an evenly illuminated surface (such as the blue sky). If the exit pupil has flattened sides, the prisms inside the binoculars are cutting off some of the light.

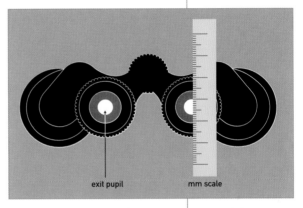

exit pupil mm scale

View a horizontal line on a distant object, and move the binoculars away from your eyes until you see twin images. They should be perfectly aligned (TOP). If one is slightly higher than the other (CENTRE), your eyes may be able to correct the difference, but if they are tilted (BOTTOM), eyestrain will result.

STARTING OUT

There are a few points to remember when you start observing. You need to find somewhere fairly close by where it is dark and you have a clear view of the sky. (When you become more experienced, you may be happy to travel considerable distances to suitable observing sites, but initially you need somewhere that is convenient.) Because of the problems of light pollution it may be difficult to avoid a general glow of light in the sky, but try to find somewhere that is at least out of any direct lighting. You may need to use more than one position to see the whole sky. Ideally, find somewhere that is also sheltered from the wind.

Choose the darkest position possible, because this will help your eyes to become dark adapted. Unlike the expansion in size of your pupils which happens almost instantaneously when you move into a dark area, dark adaptation depends upon the concentration of a particular pigment in the retinas of your eyes. This accumulates after a period in the dark and may take 15–20 minutes (or even longer if you are tired), and enables you to see faint objects. Although it varies between individuals, most people are actually able to see quite well – enough to move about with-

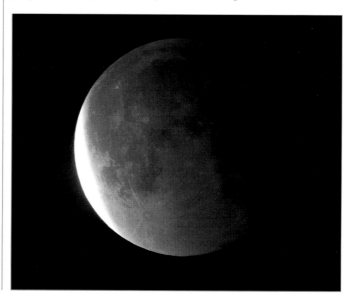

The Moon, moving from west to east (right to left) is just leaving total eclipse.

out falling over things – by starlight alone. It help greatly if garden paths, patios, or similar areas are light in colour, especially because dark-adapted vision is colourless, so everything just appears as a shade of grey.

Unfortunately bright light destroys dark adaption, so astronomers use dim red lights to illuminate their charts, books, and notebooks, because this colour has the smallest effect. If you do not have a dim red light, cover a torch (flashlight) with red plastic or cellophane. For some types of observation it is not essential to be able to see what one is writing – if it consists of figures, letters, words or times, perhaps, rather than drawings – so some astronomers develop the habit of writing in the dark, using a dark pencil and drawing a thick line under each observation. They then transcribe their notes later – exactly, with no changes whatsoever, but more neatly – into their observing notebooks.

It is also important to keep warm and dry. Depending on where you are, it may become cold at night even in summer, so warm clothing is always important. Roughly a quarter of body heat is lost through the head, so wear a proper hat. Make sure you have adequate footwear and, if it is likely to be very cold, wear two pairs of socks and have proper gloves or mitts. Try to avoid standing on wet grass and, if you do have to lie down to make observations high overhead, use a groundsheet and a thick piece of foam. An adjustable garden chair with arms is extremely helpful, but even here try to avoid sitting over wet grass. In some climates, it may be warmer at night, but you may then have to think about wearing clothing that protects you against insect bites, or using insect repellent.

Finally, it is useful to keep a note of your observations. Use a notebook with fixed leaves, rather than a loose-leaf type. Keeping records need not be a chore. At first you may have little to record, but even a simple note of your observing sessions can prove very useful. Make a habit of recording the date and time of any observation. This is particularly important when you see anything unusual – such as an aurora or extremely bright meteor – and we will discuss dates and times shortly.

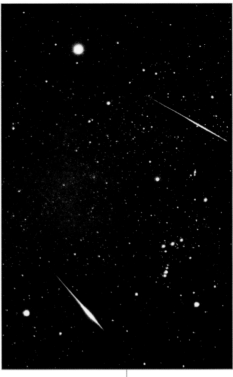

Two Leonid meteors frame Orion. Jupiter is the bright, over-exposed object in Gemini, and the tiny red dot in the centre is the Rosette Nebula in Monoceros.

EXPLORING THE SKY

It is not difficult to start finding your way around the sky, but there are a few details and some specific terms that need to be mentioned first. Initially, it helps to have some idea of the location of north from your observing position. (We shall see shortly how this may be determined accurately from the stars themselves.)

Everything in the sky appears to lie on a gigantic sphere (the celestial sphere), centred on the observer. From our position on Earth, we can, of course, see only half of this at any one time, because half is below our horizon. Although in practice the actual horizon is irregular, and quite large parts of the sky may be hidden by mountains, hills, trees, buildings or other objects, the astronomical horizon is assumed to be a perfectly even boundary, like a sea horizon. It forms the basis of one method of describing positions in the sky, using co-ordinates known as altitude and azimuth.

Altitude is the elevation of an object, in degrees, above the horizon, ranging from 0° (object on the horizon), to 90° (object directly overhead). Note that objects may have negative altitude, i.e., be below the horizon. The second co-ordinate, azimuth, is measured from 0–360 degrees, clockwise, from the north point of the horizon. Due north is thus 0° (and 360°), east 90°, south 180°, and west 270°. (Note that some

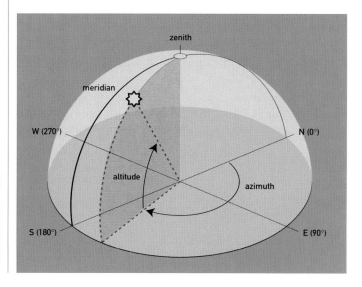

Important terms for positions in the sky, relative to the observer at the centre.

older books use a different definition of azimuth, but the one just described is the form generally used today.)

The point directly above the observer's head is known as the zenith (altitude 90°) and is frequently used in astronomy. The corresponding point directly below the observer's feet is known as the nadir.

An important line in the sky is the meridian, which runs around the sky from the north point, through the zenith, the south point, the nadir, and back to the north point. From the surface of the Earth, only half of the meridian is visible at any one time, of course. Astronomers use the term 'transit' for when an object crosses the meridian in the south, when it is also said to 'culminate' (reach its highest altitude).

Because of the Earth's rotation from west to east, the celestial sphere seems to rotate round the Earth once a day from east to west. Everyone is used to seeing the Sun (and Moon) rise in the east and set in the west, but it still comes as a surprise to some people that the stars and planets do the exactly same.

The celestial sphere appears to rotate around an invisible axis, running from the north celestial pole, through the centre of the Earth, to the south celestial pole. The location of the celestial poles relative to an observer depends upon the latter's position on Earth, more specifically, on their latitude. At the North Pole, the North Celestial Pole is directly overhead (at the zenith); at the Equator, both celestial poles lie (theoretically) on the horizon; and at the South Pole, it is the South Celestial Pole that is at the zenith, with the North Celestial Pole at the nadir. The altitude of the celestial pole is exactly the same as the observer's latitude. At 40°N, for example, the North Celestial Pole has a altitude of 40°, and an azimuth of 0°. Similar considerations apply in the southern hemisphere.

> The altitude of Polaris above the northern horizon is equal to the observer's latitude.

This has an important effect. An area of sky around the celestial pole, with a radius equal to the observer's latitude, is always above the horizon. Stars in this region are circumpolar: they are visible whenever it is dark. Identifying the constellations in this area is therefore easy, and an ideal way of starting to learn your way around the sky.

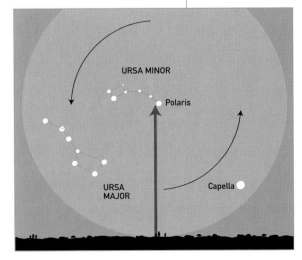

THE CELESTIAL SPHERE

Although it would be possible to locate anything in the sky by referring to its altitude and azimuth, this is not particularly practical for most observers. Both co-ordinates alter throughout the night as an object moves across the sky and, in any case, they are different for every observer. Computer-controlled telescopes (including the largest telescopes on Earth) do use altitude and azimuth, but the positions of objects on the celestial sphere, on charts and atlases, and in catalogues are always specified by a different pair of co-ordinates.

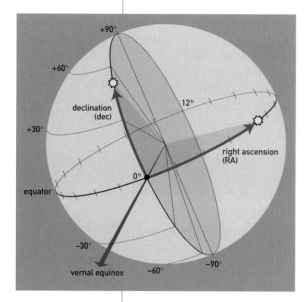

How the celestial co-ordinates Right Ascension and Declination are determined.

These are right ascension and declination, which correspond to longitude and latitude, respectively, used to specify positions on Earth. Let us start with declination. We have already seen that the Earth's axis points to the North and South Celestial Poles, which directly correspond to the Earth's North and South Poles. Similarly, the celestial equator lies in the same plane as the Earth's equator, and divides the sky into northern and southern hemispheres. Declination is measured north and south of the celestial equator (which has a declination of 0°), positive towards the north, and negative towards the south. So the South Celestial Pole has a declination of -90°, for example.

Right ascension is slightly different from longitude in that it is reckoned in hours, minutes and seconds of time (rather than in degrees). One hour equals 15°, so right ascension runs from 0^h to 24^h (0–360°). But just as declination has a zero point (the celestial equator), one is required by right ascension. Longitude on Earth is measured from Longitude 0°, which is actually defined as the optical axis of the Airey Transit Telescope at the Old Royal Greenwich Observatory. The zero point for right ascension is the point at which the Sun, travelling along its apparent path in

space (the ecliptic), crosses the celestial equator from south to north. This point is known as the vernal (spring) equinox, otherwise known as the First Point of Aries.

From this point (0^h), right ascension is measured eastwards along the celestial equator (anticlockwise looking down on the North Pole). As the Earth rotates, the right ascension on the meridian (or in any other fixed direction) continuously increases. As we shall see shortly, however, after 24 hours as shown by our terrestrial clocks, the right ascension on the meridian will not be precisely the same as the previous day, but will have increased by approximately $3^m 56^s$. The line of right ascension passing through an object is known as the hour circle.

For various dynamical reasons, the Earth's axis is not fixed in space, but undergoes a series of motions. The most important of these is known as precession, which causes the axis to describe a cone in space over a period of about 25,800 years. This causes the celestial poles, the celestial equator and thus the position of the vernal equinox, to change over time. It is obviously impractical for quoted positions on the sky to be constantly changing, so catalogues and charts give positions at a specific point in time, known as an epoch, usually revised at 50-year intervals. At present the epoch used is 2000.0, so the position of Betelgeuse (α Orionis) the bright red star in Orion, given in full, would be: RA = $05^h 55^m 14^s$, Dec = $+07° 24' 26"$ (2000.0). All the charts in this book and most others published in recent years are for epoch 2000.0. You may encounter some older charts for epoch 1950.0 or even earlier dates. For naked-eye, binocular, and small-telescope observation the differences between two epochs are largely irrelevant, but they do become important when aligning and using moderate-sized telescopes and computer-controlled equipment. Similarly, seconds of time and seconds of arc are omitted from the positions given here, because such precision is unnecessary for simple observations.

Because of precession, the vernal equinox has migrated from Aries into Pisces, and is moving southwest towards Aquarius.

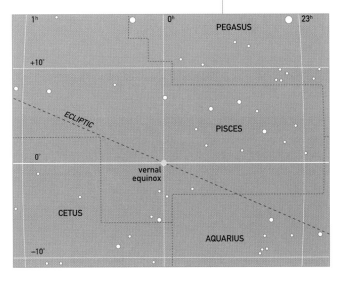

POSITIONS IN THE SKY

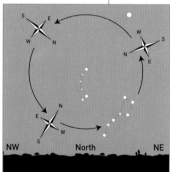

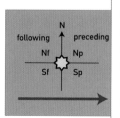

Describing the directions of celestial objects may cause confusion unless one is careful. We must be certain whether we are talking about the position of an object relative to the horizon and the standard compass points, or whether we are referring to its position on the celestial sphere. Generally if a celestial object as said to lie north-west (for example) of a particular star it is taken to mean that the directions are those that apply on the celestial sphere.

Because we are looking at the 'inside' of the celestial sphere, care is needed. Looking south in the northern hemisphere, west is always to the right (and east to the left), as might be expected. Looking towards the northern sky, however, we have to be a bit more cautious. The direction of 'west' changes depending on where the objects lie relative to the North Celestial Pole. Going west you circle the Pole in an anticlockwise direction – to the right below it, and to the left above it.

Partly to avoid this confusion, astronomers also use the unambiguous terms 'preceding' and 'following' when describing the relative positions of objects. These are related to an object's right ascension. It two stars have the same declination, the star that rises (and sets) first, precedes the other. In general, except perhaps near 0^h (24^h) RA, it has a lower value of right ascension. Looking south in the northern hemisphere, it lies to the right. The opposite criteria obviously apply to 'following'. The two terms are nearly always combined with the directions north and south, to divide the sky around the reference object into four quadrants: north preceding, north following, south following, and south preceding, usually abbreviated 'Np', 'Nf', 'Sf', and 'Sp', respectively.

Occasionally you may come across the 'position angle', which is an accurate method of describing an object with reference to another. It is particularly use in connection with double and multiple stars and, as such, is described on p.127.

STAR-HOPPING

The easiest method of finding things on the sky is to use the time-honoured method known as 'star-hopping'. This simply consists of using stars, or patterns of stars, that you know, to help you find less familiar ones. It is the method everyone uses to learn the constellations, and may be applied just as successfully to fainter objects, whether using the naked eye, binoculars, or a telescope.

As this photograph of Perseus shows, the eye tends to travel outwards from the brighter stars by recognizing lines and specific patterns of stars.

Generally, one works from bright, known stars or patterns to the fainter ones. When faced with finding an unknown object from a star chart, start by locating some stars that you know or can find easily on the sky. Use these to extend a line across the sky; to form the base of a triangle; the start of a curve of stars; perhaps even an 'arrow' pointing in the right direction; or some similar sort of pattern to take you to another star, pair or group of stars, closer to your destination. You can use this next reference point to repeat the process. It all sounds more complicated than it is in practice, because pattern recognition is so innate in everyone that it soon becomes second nature to apply it to stars and star charts.

DATE AND TIME

One important aspect of astronomy is the question of time. Because observers are scattered across the globe, they lie in different time zones, and an event (such as the eclipse of one of Jupiter's satellites, for example), may happen in daylight for one observer, and in darkness for another. Then there are the problems caused by the use of summer time (daylight-saving time) in certain countries, especially when (as in the United States) not all parts of a country adopt it.

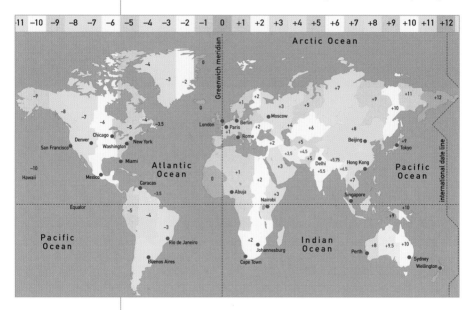

Chart of time zones

The solution is for all astronomical events and observational reports to be given in Universal Time, which is the same for everyone, everywhere. Universal Time (UT) is the time of the Greenwich meridian, originally known as Greenwich Mean Time (GMT). It runs from 00:00 to 24:00 hours, starting at midnight. It is used for all the astronomical phenomena that are listed in the standard yearbooks and handbooks (such as those listed under 'Further Reading'). In tables of planetary positions, for example, the Right Ascension and Declination of planets are normally given for 00:00 UT (i.e., midnight on the Greenwich meridian).

LOCAL TIME

Because the periods of day and night that you experience depend upon your position on the Earth, you do need to take local time into account in determining whether an event will be visible (unless you live close to the Greenwich meridian).

The map shows the different time zones around the world, and the amount by which each is in ahead or behind Universal Time. Note that the boundaries of the time zones are generally chosen to coincide with political boundaries, and are highly irregular. For exact calculations, allow a difference of one hour for every 15° east or west of the Greenwich meridian, 4 minutes for every degree, etc.

SUMMER TIME / DAYLIGHT-SAVING TIME

It is, unfortunately, also necessary to take summer time (daylight-saving time) into account when planning observing sessions. Because most people observe in the evening, the monthly charts in this book are drawn for 22:00 local time (10 p.m.), which is 23:00 local summer time (11 p.m.). This is a compromise, because at high latitudes in summer twilight persists throughout the night and even at 23:00 summer time it may not be really dark.

In Europe, summer time is in force between the last Sunday in March to the last Sunday in October. The change (forwards in spring, backwards in autumn) takes place at 01:00 GMT (UT) on the dates given. In the United States and Canada, daylight-saving time starts on the first Sunday in April, and ends (as for Europe) on the last Sunday in October.

> **NOTE**
> At the time of writing, Hawaii, Saskatchewan, and parts of Arizona and Indiana do not employ daylight-saving time.

YEAR	SUMMER TIME BEGINS	SUMMER TIME ENDS
2002	Mar. 31	Oct. 27
2003	Mar. 30	Oct. 26
2004	Mar. 28	Oct. 31
2005	Mar. 27	Oct. 30
2006	Mar. 26	Oct. 29

Europe

YEAR	SUMMER TIME BEGINS	SUMMER TIME ENDS
2002	Apr. 07	Oct. 27
2003	Apr. 06	Oct. 26
2004	Apr. 04	Oct. 31
2005	Apr. 03	Oct. 30
2006	Apr. 02	Oct. 29

United States & Canada

THE DATE

The other important point to bear in mind is that of the date. For astronomers world-wide, this changes at midnight (24:00 hours) UT. This may cause confusion, because observers in a different time zone, east of the Greenwich meridian, will have already changed their civil date, and for observers to the west, their civil date has yet to alter. The simplest solution is to have a clock that permanently shows Universal Time, preferably a digital one that also shows the date. All serious observers in the Greenwich time zone also do the same, because it avoids any potential confusion over the use of summer time.

How should you record the date and time? The best way is to use the standard scientific method, in which the elements are given in descending order of size: Year, Month, Day, Hour, Minute, and Second (and in very precise cases, decimal fractions of a second). Again, to prevent confusion, it is best to record the month as an abbreviation rather than a number. So we might have a date and time given as (say) 2001 Oct. 05, 01:35:07 UT. This is unambiguous, and in many countries (such as Great Britain) is a legally recognized way of specifying the date and time.

If you happen to observe an important event – perhaps a brilliant day-time fireball, for example – when a watch or clock showing Universal Time is not immediately to hand, then write down the observation using the current local time (even summer or daylight-saving time), making sure that you record that fact as well. A correction to UT may be made later. Don't try to work out the correction there and then, because this takes your attention away from the event in question and is liable to error. It is all too easy to add an hour in 'correcting' summer time, for example, instead of subtracting one.

Another method to reckoning the date (the Julian Date) will be described later, when discussing variable stars.

A solar day is slightly longer than a sideral day, because the Earth must rotate through an additional angle before the Sun again crosses the meridian.

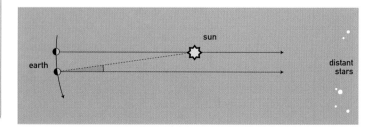

SIDEREAL TIME

We have already noted how the stars visible on any night slowly change throughout the year, new stars rising over the eastern horizon at dusk, as stars that have been visible for some months disappear beneath the western horizon. This change occurs because although our civil time is based on the Earth's rotation, relative to the Sun, where one day equals 24 hours, relative to the stars, the Earth rotates once in 23 hours, 56 minutes, and 4 seconds. (The difference arises because of the Earth's motion around the Sun, which means it has to rotate a little further to bring the Sun back into the same position in the sky.)

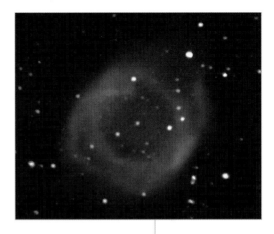

Knowing the sidereal time (the RA on the meridian) can be of considerable help in locating faint objects, such as the Helix Nebula (NGC 7293) in Aquarius.

Sidereal time is time as determined by the stars. It is equal to the right ascension of objects that are currently on the meridian. If you know the sidereal time, you can immediately tell which objects are visible in the sky. Sidereal time obviously differs for every location around the planet.

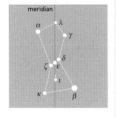

If ε Ori is now on the meridian, exactly 24 hours earlier, δ had just passed the meridian and, tomorrow night, 24 hours later, ζ will be just approaching it.

Handbooks often tabulate the sidereal time at the Greenwich Meridian for 00:00 UT, and you can obtain your local sidereal time by making the appropriate corrections for the time that has elapsed since 00:00 UT and for your longitude. Many amateur astronomers, however, adjust a clock to run slightly fast, and thus keep sidereal time. Once set, this gives an immediate indication of objects that are on their local meridian.

You may occasionally come across the term 'hour angle' used to describe the position of an object in the sky. Hour angle is the angle, measured westwards along the equator (i.e., anticlockwise looking down on the North Pole), between the meridian and the hour circle passing through the object in question. Hour angle therefore increases with the passage of time.

SEE ALSO

Julian Date (p.135)

Right ascension & declination (p.12)

CONSTELLATIONS

The celestial sphere is divided into 88 individual constellations. Many of these hark back to antiquity, and various ancient civilizations divided the sky in different ways and had a whole range of myths that were associated with the various groups of stars. The constellation names that we use today largely derive from Greek and Roman sources. Very few bear any resemblance to the objects that they purport to represent.

This pictorial depiction of Perseus, carrying the head of Medusa, comes from the second edition of Johannes Bayer's URANOMETRIA, originally published in 1603.

Northern constellations are often ancient, but many of those for the southern hemisphere were introduced about the middle of the 18th century by the French astronomer de Lacaille. For hundreds of years the boundaries between constellations were extremely fluid, and largely depended on the whim of the person drawing up the descriptions or charts. The boundaries were more or less arbitrary lines around the figures. Stars might be allocated to one constellation by one cartographer, and to the neighbouring constellation by another person. Various map-makers introduced smaller constellations of their own, some of which have survived, but most of which have disappeared.

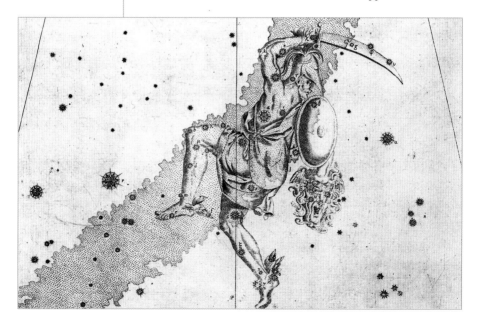

The end to this confusion came in 1920 when the International Astronomical Union (IAU) adopted a standard set of constellation names; and again in 1930, when specific constellation boundaries were laid down. The latter were defined as straight lines in right ascension and declination for epoch 1855. This date was selected because that epoch had already been used for defining many southern constellations. If you glance at a modern chart, you will see that, because of precession, the constellation boundaries have drifted away from the modern co-ordinate grid.

Although popular names for the constellations are sometimes encountered, astronomers always use the Latin forms, so these are employed throughout this book, as are the appropriate genitive forms and standardized three-letter abbreviations, all of which were formally adopted by the IAU.

SEE ALSO

ecliptic (p.13)

epoch (p.13)

equinox (p.13)

ASTERISMS

An asterism is a conspicuous pair or group of stars that is given a specific name, but which does not necessarily form a whole constellation. One example is The Plough – known as the Big Dipper in North America, as well as by many other names – the seven brightest stars in Ursa Major, a large constellation that includes dozens of other stars.

SOME COMMON ASTERISMS

BELT OF ORION – δ, ε, and ζ Orionis

BIG DIPPER – α, β, γ, δ, ε, ζ, and η Ursae Majoris

BULL OF PONIATOWSKI – 66, 67, 68, and 70 Ophiuchi

CIRCLET – γ, ϑ, ι, λ, and κ Piscium

FREDERICK'S GLORY – ι, κ, λ, and ψ Andromedae

GUARDS (OR GUARDIANS) – β and γ Ursae Minoris

HEAD OF CETUS – α, γ, ξ², μ, and λ Ceti

HEAD OF DRACO – β, γ, χ, and φ Draconis

HEAD OF HYDRA – δ, ε, ζ, η, ρ, and σ Hydrae

KEYSTONE – ε, ζ, η, and π Herculis

KIDS – ε, ζ, and η Aurigae

LITTLE DIPPER – β, γ, η, ζ, ε, δ, and α Ursae Minoris

LOZENGE = Head of Draco

MILK DIPPER – ζ, γ, σ, φ, and λ Sagittarii

PLOUGH – α, β, γ, δ, ε, ζ, and η Ursae Majoris

POINTERS – α and β Ursae Majoris

SICKLE – α, η, γ, ζ, μ, and ε Leonis

SQUARE OF PEGASUS – α, β, and γ Pegasi with α Andromedae

SWORD OF ORION – ϑ and ι Orionis

TEAPOT – γ, ε, δ, λ, φ, σ, τ, and ζ Sagittarii

WAIN (OR CHARLES' WAIN) – α, β, γ, δ, ε, ζ, and η Ursae Majoris

WATER JAR – γ, η, κ, and ζ Aquarii

Y OF AQUARIUS = Water Jar

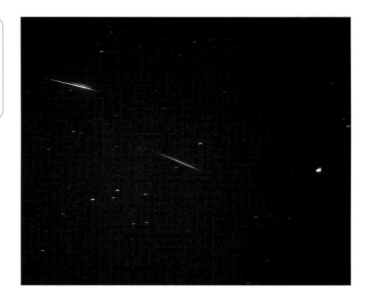

Two Leonid meteors photographed near the distinctive asterism that forms the 'Head of Hydra'.

THE ZODIAC

The Zodiac was originally a specific set of twelve constellations with a particular significance for ancient civilizations. They were the constellations in which the Sun, Moon, and major planets were found. As such, they were centred on the ecliptic, the Sun's apparent path across the sky, and each constellation was regarded as extending for 30° along the ecliptic. Because the majority of the constellations were associated with animals, the whole band was named the Zodiac.

It was once believed that stars and planets exerted a direct influence upon human affairs, so the twelve constellations assumed an astrological significance and were seen as specific 'signs'. Rational people no longer believe in such superstitions, and precession has shifted the position of the constellations eastwards by some 30-odd degrees, so they no longer agree with their signs. Changes in constellation boundaries mean that some constellations occupy more or less than 30° of the ecliptic, and also that the Sun, Moon and planets may appear in various additional constellations, most notably Cetus, Orion, Sextans, and Ophiuchus. The Zodiac is now defined as a band, stretching 8° on either side of the ecliptic, and regarded as including parts of all these different constellations. Charts of the zodiac are useful for showing planetary positions, as seen later in this book.

ZODIACAL CONSTELLATIONS

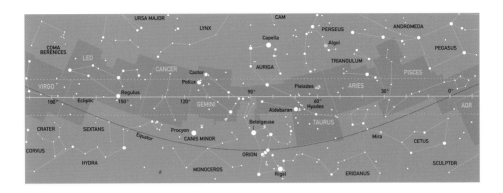

Pisces to Leo: the zodiac is the strip between the two broken yellow lines, where the Sun, Moon and planets are found.

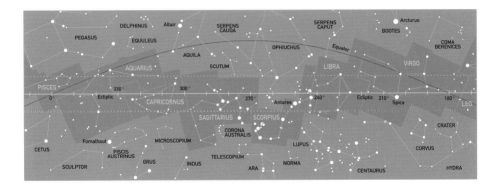

Virgo to Aquarius: the zodiac is the strip between the two broken yellow lines, where the Sun, Moon and planets are found.

THE NAMES OF STARS AND OTHER OBJECTS

Originally, only some of the brightest stars were given individual names. Some are of Greek or Roman origin (such as Sirius and Polaris), but many were devised by medieval Arab astronomers (Betelgeuse, Deneb, Zubenelgenubi, etc.). For hundreds of years fainter stars tended to be identified as 'the first in Orion's club' or 'the right foot of Hercules', and other similar, ambiguous descriptions. The first step in introducing a sensible method of identifying stars was taken by the German cartographer, Johannes Bayer, who published the first true stellar atlas, the Uranometria, in 1603.

Bayer designated each of the brightest stars in every individual constellation by a Greek letter, arranged approximately in decreasing order of brightness, so that the brightest was labelled α (alpha), the second brightest β (beta), and so on. When Bayer exhausted the Greek alphabet, he employed lower-case Roman letters (a, b, c ...), and in just a few instances, when he had also exhausted those, he used upper-case Roman letters (A, B, C ... Q). Although we now know that there are exceptions to the correct order, in general all these names have been retained to the present day. Astronomers tend to use the Bayer letters in preference to the proper names. The Greek names are followed by the genitive of the Latin constellation name, so the star Alpheratz, for example, is α Andromedae or, abbreviated, α And. Occasionally, the Greek letters have been supplemented by adding a superscript number, usually where stars are close together. The extreme example of this is in Orion, where, on the western side, there is a chain of stars designated π^1 to π^6.

With advances in astronomy – and particularly with the advent of the telescope – it became important to give designations to many fainter stars. The British astronomer, John Flamsteed was the first to carry this out systematically, and his catalogue of 1725 gave numbers to all the stars in a constellation in increasing right ascension – i.e., from west to east – including stars that Bayer had labelled. These Flamsteed numbers continue to be used, but to prevent confusion, the older, Bayer letters are generally given where applicable. For example, α And is also Flamsteed 21 Andromedae, usually written 'Fl 21' or '21 And'. If a number appears on a chart, in the absence of any information to the contrary, it may be assumed to be a Flamsteed number.

With the advent of photography, tens and hundreds of thousands of stars had to be catalogued, and so all later catalogues use a numerical format. Such numbers are rarely required when dealing with the majority of objects visible with the naked eye or small instruments.

Variable stars have a complex system of names, but the brightest in any constellation will generally have a single, upper-case, Roman letter designation in the range R to Z – the letters Bayer did not use. Other variables will have a double letter designation (e.g., CH Cygni), or be known by the letter 'V' followed by a number (e.g., V465 Cassiopeiae). The Bayer, Greek-letter designations are retained for those stars that have subsequently proved to be variable, for consistency with older records.

THE GREEK ALPHABET			
α	alpha	ν	nu
β	beta	ξ	xi
γ	gamma	ο	omicron
δ	delta	π	pi
ε	epsilon	ρ	rho
ζ	zeta	σ	sigma
η	eta	τ	tau
ϑ	theta	υ	upsilon
ι	iota	φ	phi
κ	kappa	χ	chi
λ	lambda	ψ	psi
μ	mu	ω	omega

MESSIER, NGC & IC NUMBERS

Non-stellar objects frequently have names consisting of the letter 'M' followed by a number in the range 1–110. This stands for the designation in the catalogue of non-stellar objects prepared by Charles Messier in the late 18th century to help in the search for comets. Messier catalogued 103 objects, M104 to M110 being added by later observers.

Similar numbered catalogues prepared in the 19th century were the New General Catalogue (NGC) and the Index Catalogue (IC), and these abbreviations are frequently encountered. These catalogues included objects in the Messier list, so alternative designations are sometimes encountered. The great Andromeda Galaxy, M31, for example, is also NGC 224.

MAGNITUDES

The brightness of a star, planet, or satellite is known as its magnitude. Originally, when this system was first devised, the brightest stars were judged to be of first magnitude, slightly fainter ones as second magnitude, and so on, down to sixth magnitude, which were the faintest visible to the naked eye.

This very crude system survived until the nineteenth century, when it was set on a firm scientific basis. A first magnitude star was defined as being 100 times as bright as a sixth magnitude star, leading to a precise mathematical relationship between magnitudes. A first-magnitude star is 2.512 times as bright as a second-magnitude star. This apparently rather odd relationship – a logarithmic ratio – actually closely matches the way in which the eye perceives brightness.

There was no problem in extending the scale to the innumerable fainter stars that could be seen with telescopes, but it was found that a few stars (and certain planets at particular times) were brighter than the star that was selected as the zero point of the scale. So the scale was extended to negative magnitudes. The brightest star in the sky, Sirius, in Orion, is of magnitude -1.4, Venus and Jupiter occasionally reach magnitude -4, while the Full Moon is about magnitude -13.

The sizes of stars on charts are carefully related to their actual magnitudes.

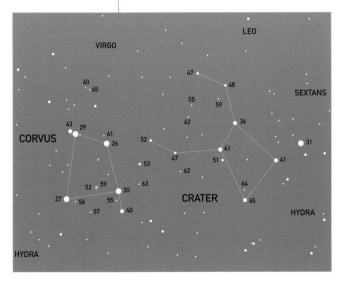

The faintest star that is visible with the naked eye, or with a particular instrument is known as the limiting magnitude. Under perfect conditions, with an absolutely black, pollution-free sky, the limiting magnitude for the naked eye is about magnitude 6.5. The colour of a particular star can affect the way in which it is detected by the eye, and this will be discussed later.

Stars of different magnitudes are shown on most star charts as dots of differing sizes: the larger the dot, the brighter the star. If care is taken in choosing the correct dot sizes, most people find it relatively easy to relate stars on a chart to stars of different brightness in the night sky. Depending on the scale of the charts and their intended purpose, their limiting magnitudes will vary. The individual constellation charts given later in this book reach magnitude 6.5 and thus show all the stars visible to the naked eye. Individual finder charts for certain specific objects have fainter limiting magnitudes.

SEE ALSO
colours of stars
(p.126)

LUMINOSITIES

The magnitudes that we have discussed are the apparent magnitudes (m), that is, the magnitudes as they appear in the sky, taking no account of the stars' very differing distances.

If we know the distance to a star, we can calculate the magnitude that it would have at some specific distance and this is chosen to be 10 parsecs (32.616 light-years). Magnitudes calculated for this standard distance are known as absolute magnitudes (M) and are a measure of the actual luminosity of stars. These luminosities are found to cover an extremely wide range, from thousands of times the luminosity of the Sun, to thousandths of its luminosity.

Although apparent magnitudes are often quoted for non-stellar objects, such as planets, comets, nebulae, and galaxies, they need to be treated with some caution, because they do not apply to point sources. The magnitude is taken over the whole extent of the object, so it is far more difficult to see a 7th-magnitude comet or nebula than a 7th-magnitude star.

The magnitudes quoted for extragalactic objects such as M88 (in Coma Berenices) are often deceptive, because they include the light from the outer regions, which are difficult to detect.

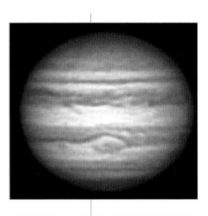

ABOVE: Jupiter (shown here) and Venus are the brightest planets in the sky, often reaching magnitude -4.

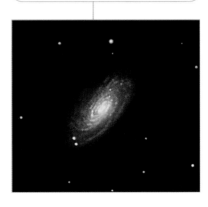

PHOTOGRAPHING THE NIGHT SKY

It is not difficult to take photographs of the night sky, and most of those shown in this book have been obtained with relatively simple equipment. Because photographs of constellations usually bear a close resemblance to the sky, many people find them easier to understand than maps and charts, especially when they are first beginning to recognize the constellations.

You can use almost any camera, provided only that it has a 'B' setting, allowing the shutter to be open for an extended period of time. Older cameras are sometimes better for this work than the very latest models. Some modern single-lens reflex cameras use battery power to raise the mirror during exposure. If the battery fails, the mirror may drop, breaking off the exposure. You will, of course, require a stable tripod, and a long cable release, preferably one of the locking type, so that you do not have to keep pressure on the release button.

With 35-mm film, a standard 50-mm lens will give a usefully sized field that is sufficient to include the main body of Orion, for example. (It covers about $35° \times 47°$ on the sky.) Such a lens is often also very suitable to photographs of planetary conjunctions taken at twilight, when you will probably want to include some foreground objects to provide a more attractive picture. Remember, however, that images of the Moon and planets are extremely small with ordinary camera lenses. (With a 50-mm lens, the Moon occupies approximately one hundredth of the width of a 35-mm frame.) For large images, you need to use a telescope, driven to follow the object in the sky.

Alignment may be a problem. If you are using a single-lens reflex camera with a fairly fast lens (say f/2.8) you will be able to see the brightest stars through the viewfinder. It may be more difficult with straight-through viewfinders like those on compact cameras. It should be possible to make a wire frame to

A powerful telephoto lens or a telescope is required to obtain large images as in this photograph of the crescent Moon and Venus.

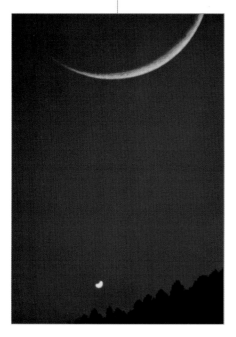

indicate the field of view (adjusting it by daylight) and fix this to the camera or tripod.

If you use normal commercial processing, transparency films tend to give better results. Standard printing methods are not ideal for images of the night sky, although if you ask (and pay for) more specialized printing very good results may be obtained. With transparency films, it is important to specify that the film should be returned to you uncut, because automated machinery will sometimes cut through the centre of each frame. Some films tend to produce greenish, rather than truly black backgrounds, but the Ektachrome range has been found to be one of the best for avoiding this problem. Standard ideas of film speeds do not fully apply to astronomical subjects, but films in the range ISO 100-400 will generally give good results. If you want to take long-exposure star trails, choose a slower-speed film and this will help to ensure that the background remains dark.

Because you are using a fixed tripod and camera position, and the Earth is rotating, everything will record as a trail, but with very short exposures the trailing may be too small to see. Experiment with exposures of 10, 15, 20, and 30 seconds, and choose whichever you think best. Remember that the apparent rotation of the sky is fastest near the equator, so you may be able to use longer exposures near the poles. Long star trails are really only limited by your patience, and by the amount of light pollution that you experience, which will cause the sky background to be bright, and may eventually spoil the picture. Long star trails often look dramatic, but they may make it difficult to recognize the constellations that have been photographed.

A trailed photograph of Orion taken with a standard 50-mm lens, a fixed 35-mm camera, and an exposure of 5 minutes.

The circumpolar stars are the key to starting to identify the constellations. Not only are they visible at any time of the year, but nearly everyone living in the northern hemisphere is familiar with the seven stars of the Plough – known as the Big Dipper in North America – an asterism that forms part of the large constellation of Ursa Major. This is where we start. There are five main constellations to identify.

Because of the movement of the stars caused by the passage of the seasons, Ursa Major lies in different parts of the evening sky at different periods of the year. The diagram shows its position for the four main seasons to give you a guide as to where to look. The seven stars remain visible throughout the year anywhere north of latitude 40°N. At that latitude, however, they may be very low on the northern horizon, especially in autumn. Much of the remainder of the constellation is then hidden below the horizon for part of the night.

Ursa Major is a large constellation, but initially few people are familiar with the extended groups of stars that form part of it and lie well to the south and east. In the centre of the curve of stars that form the 'tail' of the Bear (or the 'handle' of the Dipper) lies the small constellation of Canes Venatici, which consists of two moderately bright stars and a scattering of fainter ones.

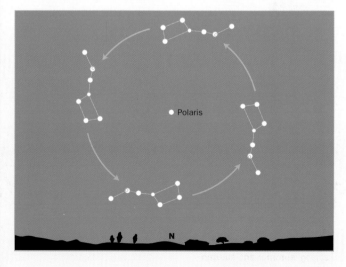

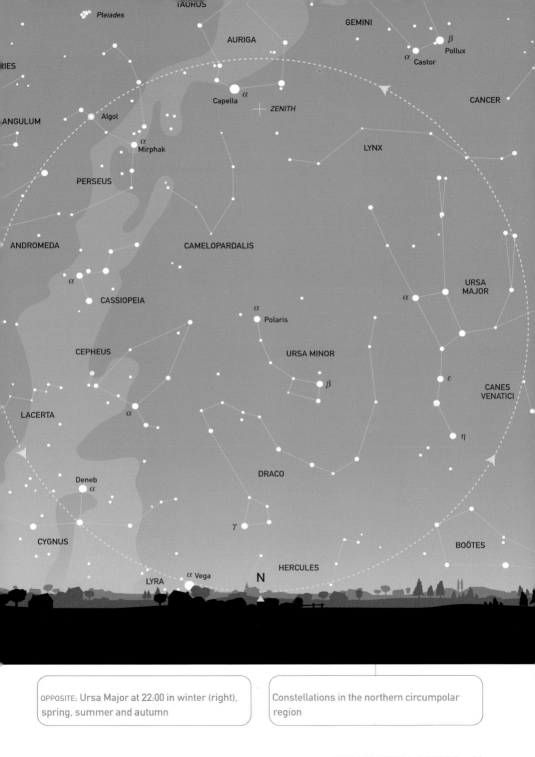

Pleiades

TAURUS

GEMINI

AURIGA

β
Pollux

α
Castor

α
Capella

ZENITH

CANCER

RIES

Algol

α
Mirphak

LYNX

ANGULUM

PERSEUS

ANDROMEDA

CAMELOPARDALIS

α

CASSIOPEIA

α
Polaris

URSA
MAJOR

α

URSA MINOR

β

CEPHEUS

ε

CANES
VENATICI

LACERTA

α

η

Deneb
α

DRACO

γ

CYGNUS

BOÖTES

HERCULES

N

α Vega

LYRA

OPPOSITE: Ursa Major at 22:00 in winter (right), spring, summer and autumn

Constellations in the northern circumpolar region

POLARIS AND URSA MINOR

Once you have identified the seven bright stars, locate the two stars, α and β UMa farthest away from the 'tail'. These two, named Dubhe and Merak, respectively, are known as the 'Pointers'. A line from Merak to Dubhe, extended to about five times their separation, leads to a fairly isolated bright star. This is the Pole Star, Polaris, or α Ursae Minoris. All the stars in the northern sky appear to rotate around it. In fact, it lies slightly less than one degree away from the true pole, and a trailed photograph of the northern sky shows that it traces a tiny circle (about 1.5 degrees across) around the pole.

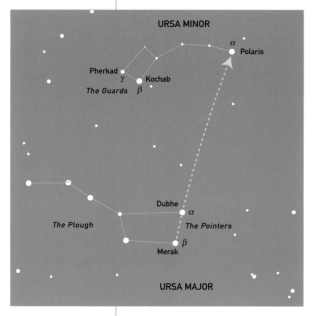

Finding UMa and Polaris

Apart from this small variation, the elevation of Polaris above the northern horizon is always equal to the observer's latitude. This was an extremely useful property, used as a guide to navigation by generations of sailors from the time of the Greeks to comparatively modern times.

In contrast to Ursa Major, Ursa Minor is a small constellation, consisting of little more than the relatively faint, stars that form the 'Little Dipper' (as it is known in North America). Strangely, the asterism has no common name in Britain, other than the Little Bear, despite being superficially similar to the seven stars of the Plough. Five stars – including a moderately close pair – form the body of the constellation, with another three forming the 'tail' at the tip of which lies Polaris – the end of the 'handle' of the Little Dipper. The two stars farthest from the pole, β and γ UMi (Kochab and Phercad, respectively) are known in English-speaking countries as 'The Guards'.

CASSIOPEIA

On the opposite of the North Pole from Ursa Major lies Cassiopeia. It has a highly distinctive shape, appearing as five stars that form a letter 'W' or 'M' depending on its orientation. Provided the sky is reasonably clear of clouds, you will nearly always be able to see either Ursa Major or Cassiopeia, and thus be able to orientate yourself on the sky.

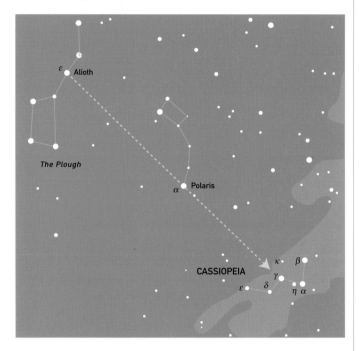

Finding Cassiopeia from the Plough and Polaris

To find Cassiopeia from Ursa Major, start with **ε** UMa (Alioth), the first star in the tail of the Bear. A line from this star extended through Polaris points directly towards **γ** Cas (Cih), the central star of the five. Cassiopeia lies right in the centre of the band of the Milky Way, so on a clear night a large number of fainter stars surround the five main stars, and this may sometimes make identification slightly more difficult for beginners. Even when the Milky Way is not readily visible because of moonlight or light pollution, some people are still occasionally confused by the presence of the moderately bright stars, **η** and **κ** Cas. With just a little practice, however, Cassiopeia becomes easy to recognize.

CEPHEUS

Although the constellation of Cepheus is circumpolar, it is not nearly as well known as Ursa Major, Ursa Minor or Cassiopeia. This is partly because it does not form a highly distinct pattern on the sky, and also because some of its stars are faint. Its shape is often likened to (and does actually resemble) the gable end of a house, with the 'ground' lying in the Milky Way not far from Cassiopeia, and the tip of the gable pointing towards the pole.

Locating the constellation of Cepheus

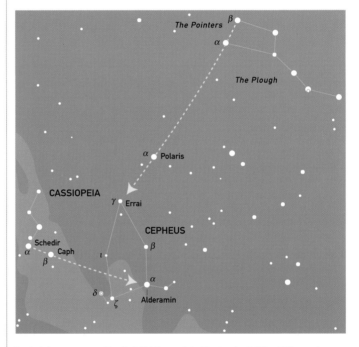

Its brightest star, α Cephei (Alderamin), lies in the Milky-Way region, at the 'bottom right-hand corner' of the figure. A line from α to β Cassiopeiae (Shedir to Caph), extended about three times the separation, passes just north of Alderamin. The star at the tip of the 'gable', γ Cephei (Errai) lies close to the line from α UMa (Polaris) to β as (Caph). The line from the Pointers to Polaris, if extended, also passes just 'below' the tip of the 'gable'.

The last of the circumpolar constellations that is fairly easy to identify is Draco, although it is so long that it takes a bit of practice to recognize it easily. It consists of a quadrilateral of stars, known, logically enough, as the Head of Draco (and also the 'Lozenge'), and a long chain of stars forming the neck and body of the dragon.

Finding the Head of Draco is not particularly easy using just circumpolar stars. Locate the two stars (γ and δ UMa) at the opposite end of the bowl of the Plough from the Pointers. Extend a line from γ UMa (Phad) through δ UMa (Megrez) by about eight times their separation. This takes you right across the sky below the Guards in Ursa Minor, and close to ξ Dra (Grumium) at one corner of the quadrilateral. The brightest star, γ Dra (Etamin) lies farther to the south. From the

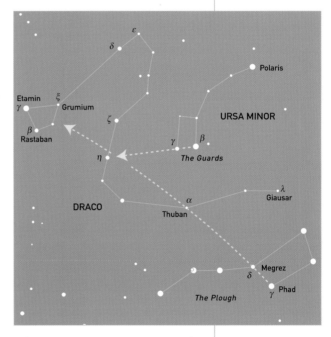

head of Draco, the constellation first runs north-east to δ and ε Dra, then doubles back southwards, before winding its way round between Ursa Minor and Ursa Major, through α Dra (Thuban), before ending at λ Dra (Giansar) almost on the line between the Pointers and Polaris.

Finding the head of Draco

The circumpolar chart shows that there is a large area of sky between Ursa Major and Cassiopeia that has relatively few bright stars. There is one constellation here, Camelopardalis, which is always circumpolar, but which is so faint that it is easier to learn to find it after you have gained some experience, and are familiar with some of the constellations that lie farther south. Large parts of the constellations of Auriga, Cygnus, Lynx, and Perseus are also often circumpolar, depending on your exact latitude. These will be described shortly.

SEASONAL CONSTELLATIONS

Although it is generally best to start with the circumpolar constellations when learning the night sky, the visibility of areas farther south depends greatly on the season. Luckily, there are conspicuous, easily recognized constellations visible at every season: Orion, Taurus, Gemini, and Auriga in winter; Leo, Hydra, and Boötes in spring; Cygnus, Lyra, and Aquila in summer; Pegasus and Andromeda in autumn. The limitations posed by summer twilight may cause problems in learning that area of the sky, but the brilliant stars of the Summer Triangle (Deneb, Vega, and Altair) are readily seen and act as guides even in twilight.

WINTER CONSTELLATIONS

For northern-hemisphere observers, the winter sky is always dominated by the magnificent constellation of Orion. It is readily recognizable, with orange-red Betelgeuse (α Orionis) in the North-east, brilliant, blue-white Rigel (β Orionis) in the south-west, and the three stars forming the 'Belt' in the centre of the constellation.

The stars of the Belt point down towards Sirius (α Canis Majoris), the brightest star in the sky. The southern part of Canis Major, with δ (Wezen) and ϵ (Adhara), is low from most northern latitudes and requires clear skies to be readily seen. West of Canis Major, and beneath Orion, is the small, but distinctive constellation of Lepus. South of that, low on the horizon, Columba may be seen when skies are clear. Farther west, the long, straggling constellation of Eridanus begins close to Rigel and sweeps in a wide arc to the west before plunging below the southern horizon.

Following the Belt stars in the opposite direction, they point north-west, approximately in the direction of orange Aldebaran (α Tauri) and the nearby 'V'-shaped cluster of the Hyades. Still farther north-west lies the conspicuous cluster of blue-white stars known as the Pleiades. The rest of the constellation of Taurus is relatively inconspicuous, and the second-brightest star β (Alnath) was once regarded as part of Auriga. The brightest star in Auriga itself, yellowish-white Capella (α Aurigae), is high overhead, near

the zenith. The constellation forms a rough pentagon with β Tauri, with a distinctive triangle of stars (known as 'the Kids') west of Capella.

Northwest of Auriga, above the Pleiades, lies Perseus, with no distinct shape, but which essentially consists of three lines of stars, meeting at α Persei (Mirfak). One line runs down towards the south, the second, containing the famous variable Algol towards the south-west, and the third extends away from Taurus and Orion towards Cassiopeia. Southeast of Auriga lies Gemini, with the bright stars Castor and Pollux. Castor (α Gemini), the northernmost, is the fainter of the two, and may also be found by extending a line from Rigel, at the foot of Orion, through Betelgeuse. Pollux (β Gemini), lies to the south-east. The rest of the constellation largely consists of two lines of stars that run back from Castor and Pollux towards Orion.

Forming an approximate equilateral triangle with Betelgeuse and Sirius is Procyon (α Canis Minoris), the single bright star (magnitude 0.4) in an otherwise inconspicuous constellation. More or less centred in the same equilateral triangle is the sprawling, but very faint, constellation of Monoceros.

The Milky Way runs right across this region of the sky, from Cassiopeia, through Perseus, Auriga, Gemini, Orion, and Monoceros. Although less conspicuous than the dense star clouds that stretch from Cygnus to Sagittarius, it is nevertheless readily seen in dark, clear skies. The swarms of faint stars sometimes make it difficult to pick out the pattern of Monoceros, and beginners occasionally encounter problems in identifying the fainter stars in Perseus for the same reason.

The northernmost star of Orion's Belt, Mintaka (δ Orionis) is just slightly to the south of the celestial equator. Trailed photographs of Orion rising in the east show Mintaka's trail as an almost perfectly straight line, while the trails of stars farther north and south show increasing curvature.

The Sun reaches its northernmost declination (at the northern summer solstice) just inside the eastern border of Taurus, precession having carried it out of Gemini. If the line of latitude at which the Sun is overhead at the summer solstice were named nowadays, instead of being known as the Tropic of Cancer, it would be the Tropic of Taurus.

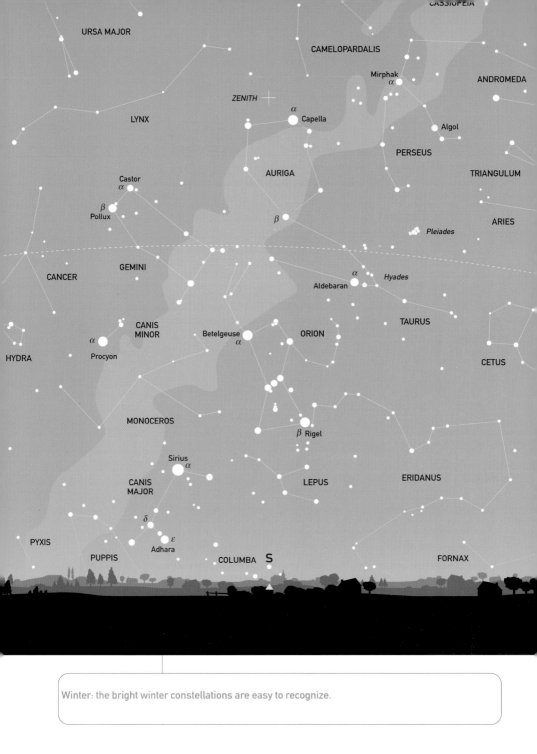

CASSIOPEIA

URSA MAJOR

CAMELOPARDALIS

Mirphak
α

ANDROMEDA

Algol

PERSEUS

ZENITH

LYNX

α
Capella

AURIGA

TRIANGULUM

Castor
α

β
Pollux

β

Pleiades

ARIES

GEMINI

CANCER

α
Aldebaran

Hyades

TAURUS

HYDRA

CANIS
MINOR

α
Procyon

Betelgeuse
α

ORION

CETUS

MONOCEROS

β Rigel

Sirius
α

CANIS
MAJOR

LEPUS

ERIDANUS

δ

ε
Adhara

PYXIS

PUPPIS

COLUMBA S

FORNAX

Winter: the bright winter constellations are easy to recognize.

SPRING CONSTELLATIONS

The most distinctive constellation in the spring sky is Leo, whose brightest star, Regulus (α Leonis) lies extremely close to the ecliptic. When Leo is low in the sky, it may be located by extending the line of the Pointers (α and β Ursae Majoris) in the opposite direction to normal, away from Polaris. Regulus may also be found by extending a line through δ and γ Ursae Majoris (Megrez and Phad) towards the south-west. Above Regulus is the characteristic asterism known as the Sickle, looking like a 'backwards question-mark' or a shepherd's crook in the sky. Two lines of stars run eastwards from Regulus and the centre of the Sickle to form the body of Leo, converging at Denebola (β Leonis) in the east. Regulus, being so close to the ecliptic, is occasionally occulted by the Moon.

Between Ursa Major and Leo is the tiny, faint constellation of Leo Minor, only three stars of which are readily visible to the naked eye. Also in this area, beginning above the Sickle, is the straggling line of faint stars that forms Lynx, another unremarkable constellation. Cancer, the faintest of the zodiacal constellations, lies west of Leo. It consists of three lines of stars that meet at the central star, δ Cancri, on the ecliptic.

Following the curve of the 'tail' of Ursa Major is the standard way of locating yellowish-orange Arcturus, α Boötes, which is the brightest star in the northern hemisphere of the sky. (Sirius is in the southern hemisphere.) The constellation of Boötes forms a sort of 'kite' or 'P' shape north of Arcturus. Continuing the same arc from Ursa Major takes one down to another bright blue-white star, Spica, α Virginis, which is slightly south of the ecliptic. The shape of Virgo, which is the second largest constellation, is difficult to define, but consists of a roughly rectangular arrangement of stars, with lines running from each corner towards west and east. Because Virgo is another zodiacal constellation, Spica (like Regulus) may sometimes be occulted by the Moon.

In the area between Ursa Major, Boötes, Virgo, and Leo lie two faint constellations: Canes Venatici, within the arc of the 'tail' of Ursa Major and, farther south, Coma Berenices, the brightest three stars of which form a right-angle in the sky.

Spring is the best time in the year for seeing the largest constellation of all, Hydra, which starts at the distinctive asterism (the 'Head of Hydra') south of Cancer in the west, and straggles eastwards below both

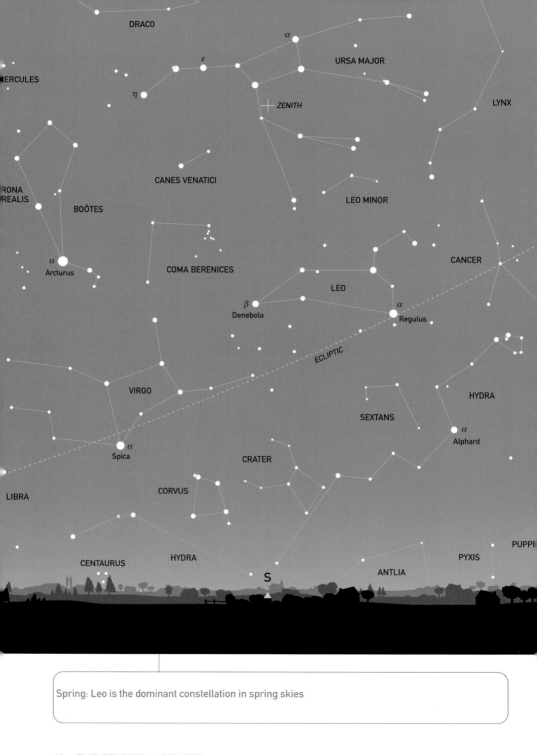

DRACO

HERCULES

URSA MAJOR

α

ε

η

ZENITH

LYNX

CANES VENATICI

LEO MINOR

CORONA BOREALIS

BOÖTES

CANCER

COMA BERENICES

α
Arcturus

LEO

β
Denebola

α
Regulus

ECLIPTIC

VIRGO

HYDRA

SEXTANS

α
Alphard

α
Spica

CRATER

LIBRA

CORVUS

CENTAURUS

HYDRA

ANTLIA

PYXIS

PUPPIS

S

Spring: Leo is the dominant constellation in spring skies

Leo and Virgo. Although its brightest star, Alphard (α Hydrae), is often readily visible well below Regulus, the second brightest, β Hydrae, is frequently lost in the horizon haze at most mid-northern latitudes.

The small, unremarkable constellation of Sextans lies above Hydra, and immediately south of Regulus. Farther east is the slightly more conspicuous constellation of Crater. Its stars, although faint, do actually form a shape reminiscent of the ancient drinking vessel. Still farther east, below the western end of Virgo, is the marginally brighter constellation of Corvus. Its third-magnitude stars form a rough quadrilateral that is relatively distinct.

SUMMER CONSTELLATIONS

The light summer nights and the persistence of twilight mean that some of the constellations in this part of the sky are poorly known. For the time when the centre of this chart is due south (22:00 LMT) many of the fainter stars are difficult to detect. Two hours later, at local midnight, when it is darkest, the view is dominated by the famous Summer Triangle: the three bright stars Deneb, Vega, and Altair (α Cygni, α Lyrae, and α Aquilae, respectively). On a clear night, summer and early autumn are the best times of year to appreciate the full glory of the Milky Way that runs right across this region.

Lyra is a small constellation, which, to the naked eye, basically consists of blue-white Vega and a quadrilateral of fainter stars to its east. Cygnus forms a giant cross in the sky, and is easily envisaged as a swan, with Deneb at the tail – which is what the name means in Arabic – flying 'down' the Milky Way. It head is marked by Albireo, β Cygni, in the south. Beginning in Cygnus and running down the centre of the Milky Way towards the south is dark area apparently devoid of many stars. This is the Great Rift, and is actually caused by interstellar dust blocking the light from vast clouds of more distant stars.

Aquila, farther south, has a somewhat similar shape, with a rhombus of stars forming the 'wings' of the eagle and a 'head' and 'neck' also pointing down the Milky Way. Again, Altair (α Aquilae) marks the tail. Between the two celestial birds lies the inconspicuous constellation of Vulpecula, consisting of three faint stars, and the slightly more distinctive shape of Sagitta, pointing across the Milky Way. To the west are the five stars that form the tiny, but highly distinctive, constellation of Delphinus.

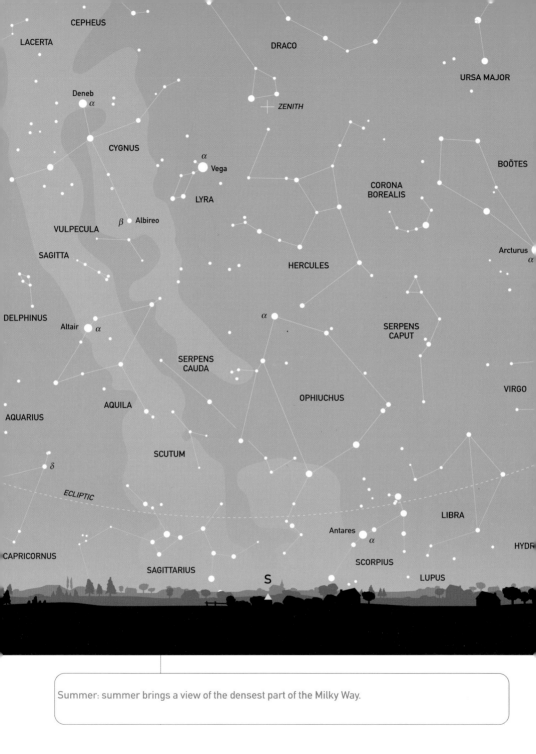

CEPHEUS

LACERTA

DRACO

URSA MAJOR

Deneb
α

ZENITH

CYGNUS

BOÖTES

α

Vega

CORONA
BOREALIS

LYRA

VULPECULA

β Albireo

Arcturus

SAGITTA

HERCULES

α

DELPHINUS

α

Altair α

SERPENS
CAPUT

SERPENS
CAUDA

VIRGO

AQUILA

OPHIUCHUS

AQUARIUS

δ

SCUTUM

ECLIPTIC

LIBRA

Antares

α

CAPRICORNUS

HYDR

SCORPIUS

SAGITTARIUS

LUPUS

S

Summer: summer brings a view of the densest part of the Milky Way.

The broad, constellation of Ophiuchus – sometimes described as looking like a tent with Rasalhague (α Ophiuchi) at the apex – lies to the west of the main band of the Milky Way. It represents the Serpent Bearer, and is located between the two halves of Serpens, the only divided constellation. The brighter, more distinct portion, Serpens Caput (the Head) lies in the west, while Serpens Cauda (the Tail) is a chain of faint stars lying along the centre of the Milky Way.

Below Serpens Caput, close to the horizon, and often difficult to recognize, is Libra, basically a triangle of stars lying across the ecliptic. It once formed part of the next zodiacal constellation to the east, Scorpius. Although many of the stars that form the body of the scorpion and its sting are often invisible below the horizon from mid-northern latitudes, bright red Antares (α Scorpii) and the arc of stars between it and Libra are usually visible. Still farther to the east is Sagittarius, where the ecliptic reaches its lowest declination and where the winter solstice is located. The southernmost stars of Sagittarius are often obscured, but the distinctive asterism of the 'Teapot', consisting of moderately bright stars is relatively easy to see.

Two more constellations lies between Boötes and Lyra. Immediately east of Boötes is the distinctive arc of stars that forms the small constellation of Corona Borealis. Farther towards Lyra lies Hercules. Here the central four stars (forming the asterism known as the 'Keystone') are readily recognized. From each corner, chains of stars form the 'arms' and 'legs' of Hercules (who is actually upside-down in the sky). One 'leg' ends close to the zenith, beyond which is the distinctive lozenge that is the head of Draco.

The constellation of Virgo with Spica to right of centre

AUTUMN CONSTELLATIONS

As summer begins to turn to autumn, and the Summer Triangle begins to dip towards the western horizon, the view to the south is dominated by the Great Square of Pegasus. Chains of stars run westwards from Markab and Scheat (α and β Pegasi) towards Delphinus and the Milky Way in Sagitta and Cygnus. One line ends at Enif (ϵ Pegasi), and between this star and Delphinus is the extremely faint, small constellation of Equuleus.

There are very few stars in this area of the sky, and even under extremely good conditions few people are able to see more than about 12 or 13 stars within the Great Square with the naked eye.

Alpheratz (α Andromedae) is the star marking the north-eastern corner of the Great Square, and Andromeda itself consists of two lines of stars running up towards Perseus, in the Milky Way, which arches over this region of the sky, passing through Cygnus and Cassiopeia. Below Perseus are the three stars that make up the constellation of Triangulum, and below that, the small zodiacal constellation of Aries.

Another zodiacal constellation, that of Pisces, lies to the south and east of the Great Square of Pegasus. Although consisting of faint stars, the Circlet, which represents the western fish, is fairly distinct below the Great Square. A line of stars connects it to Alresha (α Piscium) in the far west, from which another chain of stars extends north-west towards the centre of Andromeda. In the opposite direction, that line of stars points towards the famous variable star, Mira, in the constellation of Cetus. However, Mira sometimes drops below naked-eye visibility, when the constellation appears as two separate portions: a loop of stars to the North-east, and an irregular pattern of six moderately bright stars, including Deneb Kaitos (β Ceti), the brightest in the constellation, low in the south-west.

There are two more zodiacal constellations in this area of the sky. The first, Aquarius, is a rather straggling constellation in which the eye has difficulty in picking out any particular patterns. There are two moderately bright stars, Sadalmelik and Sadalsud (α and β Aquarii) and, to the west of Sadalmelik, four stars arranged in the distinctive 'Water Jar', also known as the 'Y of Aquarius'. To the west is the roughly triangular constellation of Capricornus, whose brightest stars, Deneb Algedi and Dabih (δ and β Capricorni) are at the eastern and western apex, respectively.

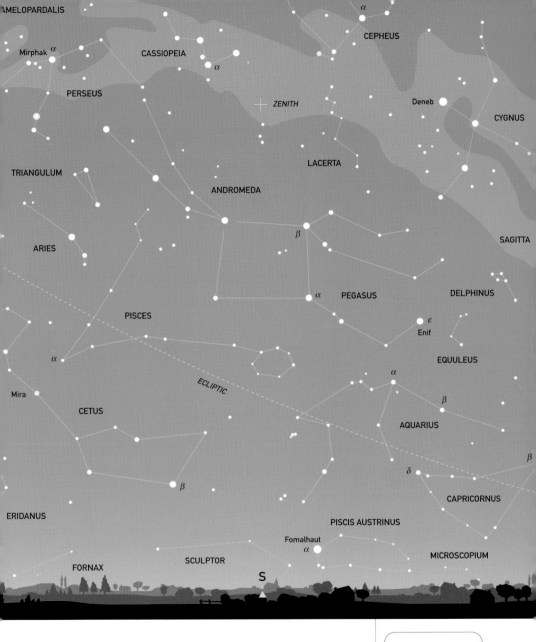

A line from Scheat (β Pegasi) through Markab (α Pegasi) points down to a solitary bright star, just above the southern horizon. This is Fomalhaut (α Piscis Austrini) in the otherwise faint constellation of Piscis Austrinus. High above, between Scheat and the bottom of Cepheus, lies a small zig-zag of faint stars that forms the constellation of Lacerta.

Autumn: Pegasus and Andromeda are guides to the autumn skies.

MONTHLY CHARTS

The following series of charts shows the sky, each month, looking north and looking south. They are drawn for latitude 50°N and so may be used over most of Europe, Canada, and the northern United States. Observers farther north – in Scandinavia, for example – will see less of the southern constellations, and conversely, observers farther south – such as in the southern United States and around the Mediterranean – will see more of the southern sky, but lose some stars on the northern horizon. Some of the more southerly constellations have been included among those shown in detail later.

The charts have also been prepared so that the pair for each month has a generous overlap, to ensure that the whole of the hemisphere of sky is clearly visible, including the area around the zenith. As for the circumpolar and seasonal charts, the general course of the Milky Way is shown to act as a guide.

Some explanation is needed of the dates and times for which the charts have been drawn. Each pair shows the appearance of the sky for the middle of the month, at 22:00 local time. Note that this applies regardless of your longitude. In other words, it will be 22:00 hours local time whether you are observing from Western Europe, Japan, or North America. The time (22:00) has been chosen as the most suitable

The brilliant Summer Triangle, consisting of Vega in Lyra (TOP), Deneb in Cygnus (CENTRE), and Altair in Aquila is a conspicuous guide to the summer skies.

for a series of charts to be used both in winter, when the sky is dark for a long period, and during the summer, when twilight reduces the hours of darkness. When summer time is in operation, the charts show the appearance at 23:00 summer time in the middle of the month. The dates between which summer time operates are given in the tables on p.17, together with details of those areas where summer time is not employed.

The charts also indicate the parts of the sky that are visible one hour later at the beginning of the month, and one hour earlier at the end. The first pair of charts, for example, show the sky at 23:00 on January 01, 22:00 on January 15, and 21:00 on February 01. The relevant dates and times are shown on each pair of charts for easy reference. There is a difference of two hours per month, so if you want to see the appearance of the sky two hours earlier than the time indicated, use the chart for the previous month, and for two hours later, the chart for the next month.

OPPOSITE: Orion is the dominant constellation in winter. This 25-second exposure may be compared with the trailed image on p.29.

Technically, the sky's appearance is correct only on the central meridian of each time zone, but in practice the charts may be used some distance east or west of this meridian. Some complications occur in North America, where, as the map on p.16 shows, the Local Mean Time (LMT) in the Eastern Time Zone has the correct difference from Universal Time, but large areas of the Central Mountain and Pacific Time Zones are using a clock time that is an hour (or more) earlier than correct for their geographical location. In such areas, the charts show the aspect of the sky later than the LMT given. In western Alaska, the difference is actually two hours, so here the chart for a month earlier is a better representation of the appearance of the sky.

SEE ALSO

Time zones (p.16)

Summer time (p.17)

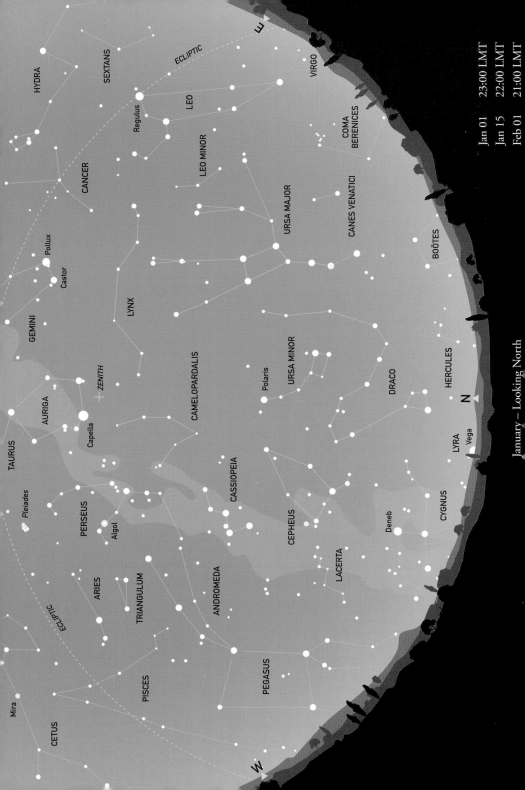

January – Looking North

Jan 01 23:00 LMT
Jan 15 22:00 LMT
Feb 01 21:00 LMT

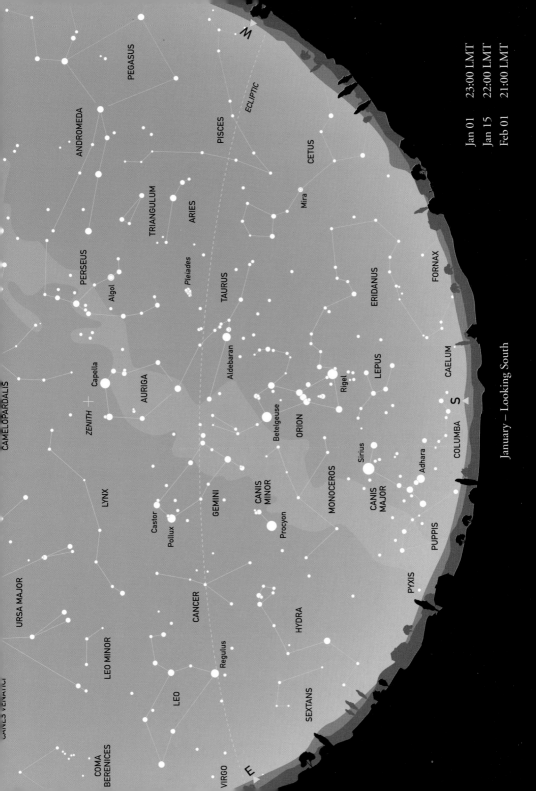

January – Looking South

Jan 01 23:00 LMT
Jan 15 22:00 LMT
Feb 01 21:00 LMT

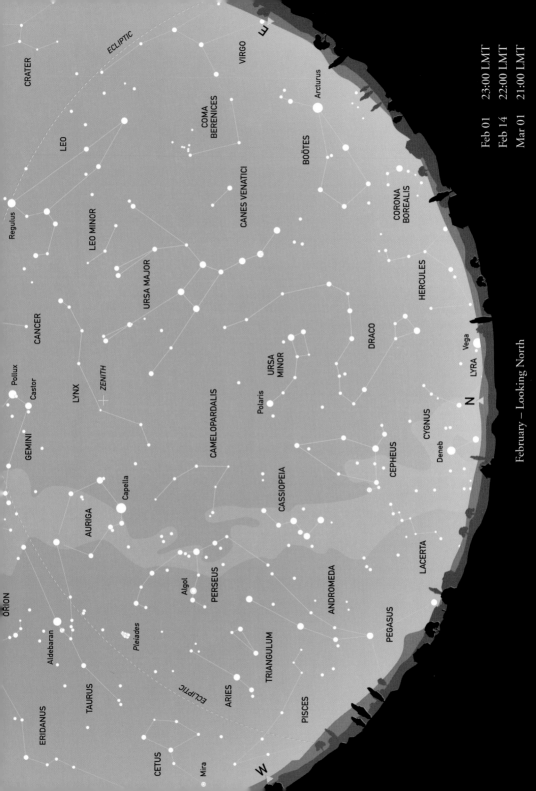

February – Looking North

Feb 01 23:00 LMT
Feb 14 22:00 LMT
Mar 01 21:00 LMT

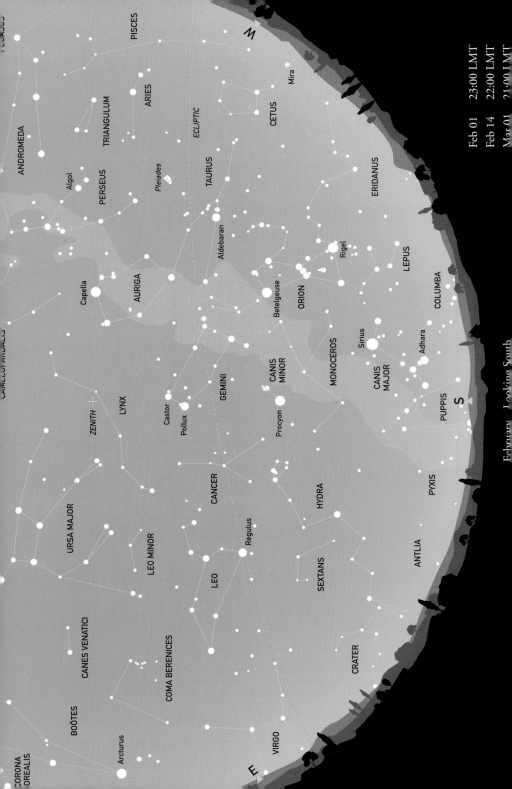

February, Looking South

Feb 01 23:00 LMT
Feb 14 22:00 LMT
Mar 01 21:00 LMT

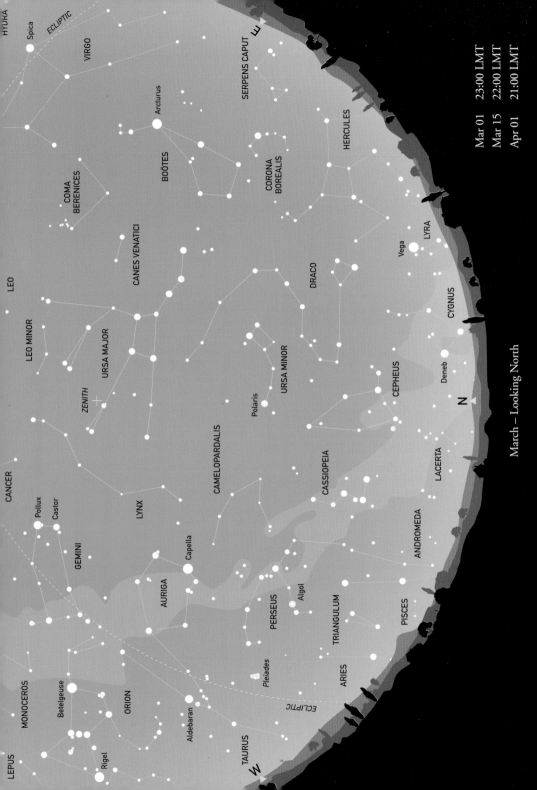

March – Looking North

Mar 01 23:00 LMT
Mar 15 22:00 LMT
Apr 01 21:00 LMT

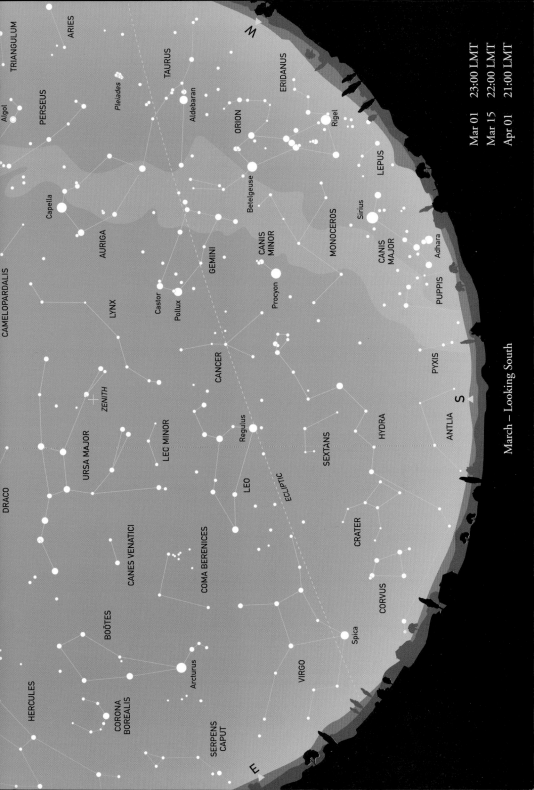

March – Looking South

Mar 01 23:00 LMT
Mar 15 22:00 LMT
Apr 01 21:00 LMT

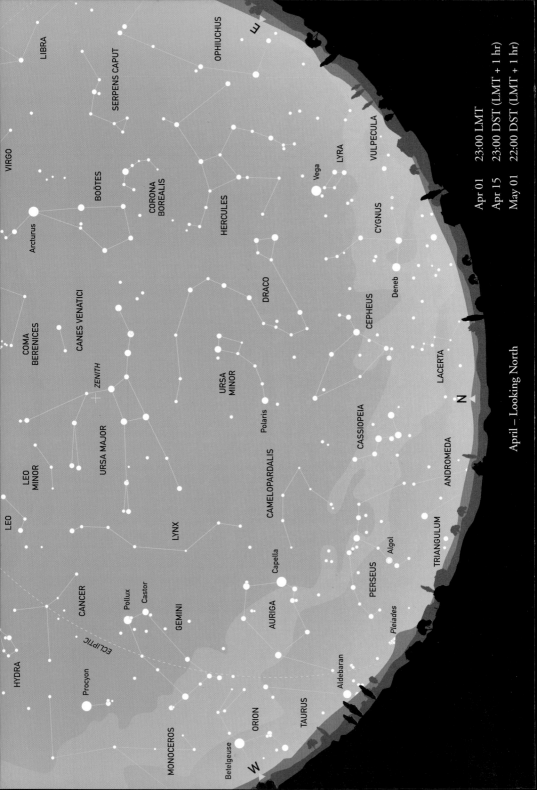

April – Looking North

Apr 01	23:00 LMT
Apr 15	23:00 DST (LMT + 1 hr)
May 01	22:00 DST (LMT + 1 hr)

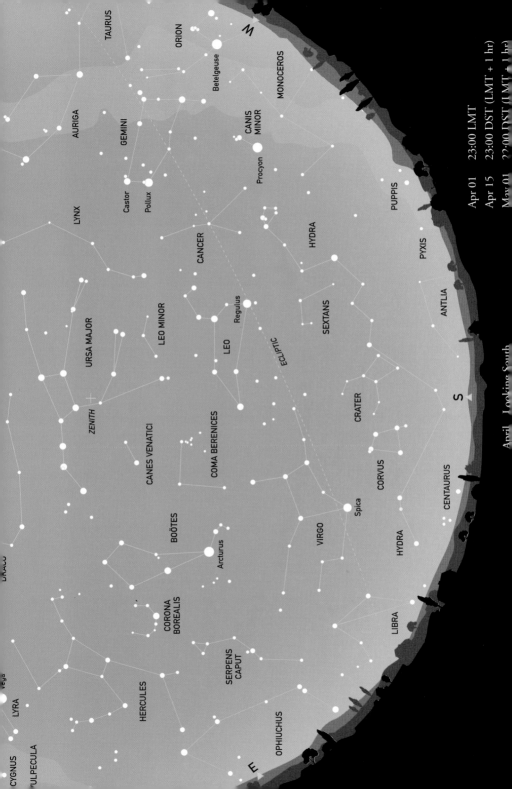

April, Looking South

Apr 01 23:00 LMT
Apr 15 23:00 DST (LMT + 1 hr)
May 01 22:00 DST (LMT + 1 hr)

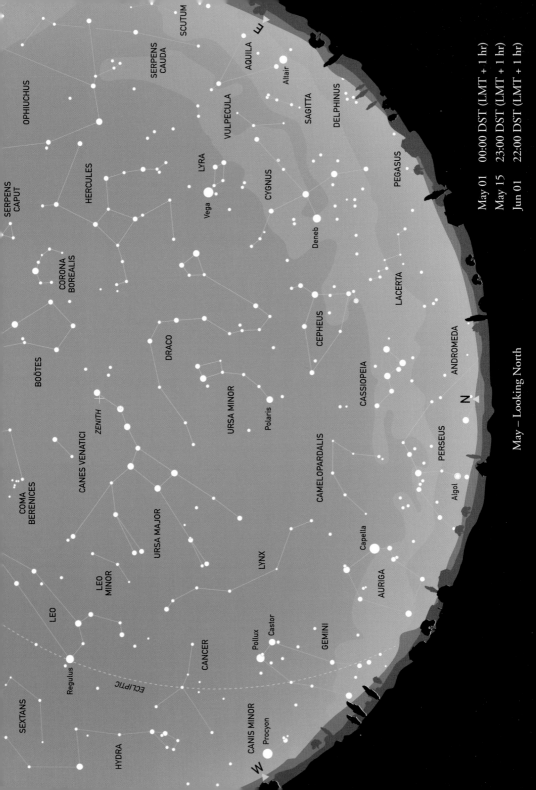

May – Looking North

May 01 00:00 DST (LMT + 1 hr)
May 15 23:00 DST (LMT + 1 hr)
Jun 01 22:00 DST (LMT + 1 hr)

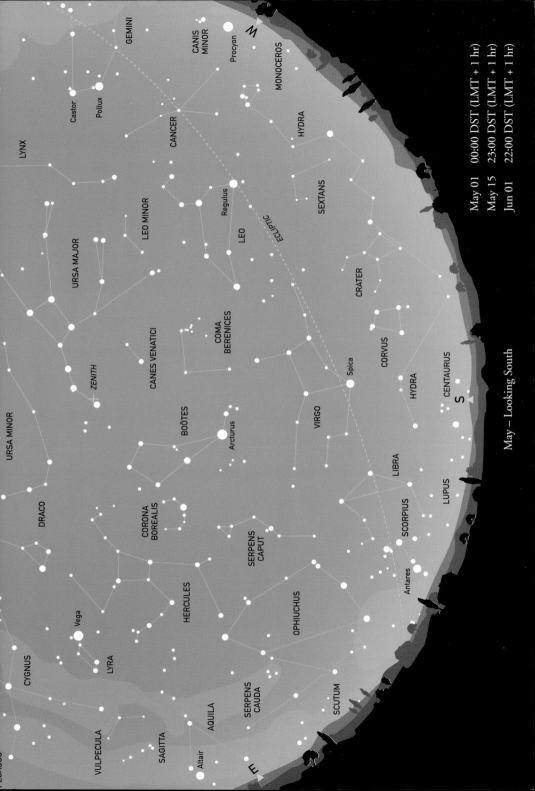

May – Looking South

May 01 00:00 DST (LMT + 1 hr)
May 15 23:00 DST (LMT + 1 hr)
Jun 01 22:00 DST (LMT + 1 hr)

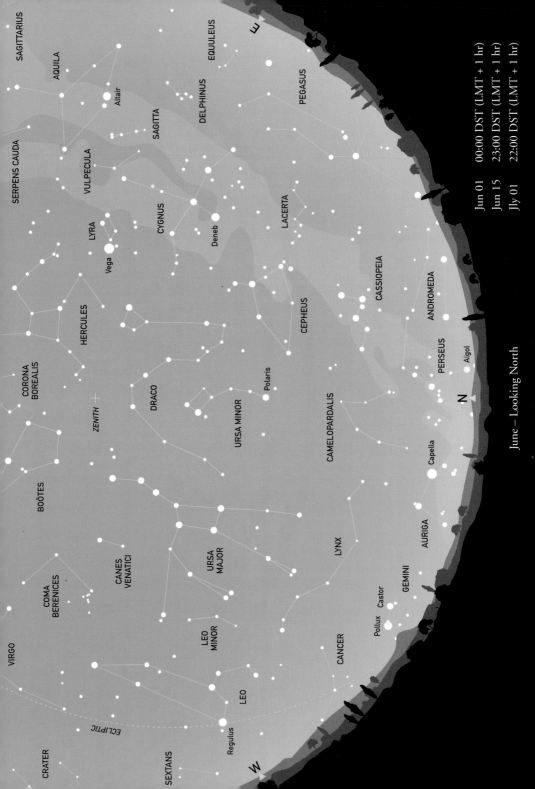

June – Looking North

Jun 01 00:00 DST (LMT + 1 hr)
Jun 15 23:00 DST (LMT + 1 hr)
Jly 01 22:00 DST (LMT + 1 hr)

SAGITTARIUS
AQUILA
Altair
SERPENS CAUDA
VULPECULA
LYRA
Vega
CYGNUS
Deneb
HERCULES
CORONA BOREALIS
ZENITH
DRACO
BOÖTES
CANES VENATICI
URSA MAJOR
COMA BERENICES
LEO MINOR
VIRGO
CRATER
SEXTANS
Regulus
ECLIPTIC
LEO
CANCER
Pollux
Castor
GEMINI
LYNX
AURIGA
Capella
CAMELOPARDALIS
URSA MINOR
Polaris
CEPHEUS
LACERTA
CASSIOPEIA
ANDROMEDA
PERSEUS
Algol
N
PEGASUS
EQUULEUS
DELPHINUS
SAGITTA
E
W

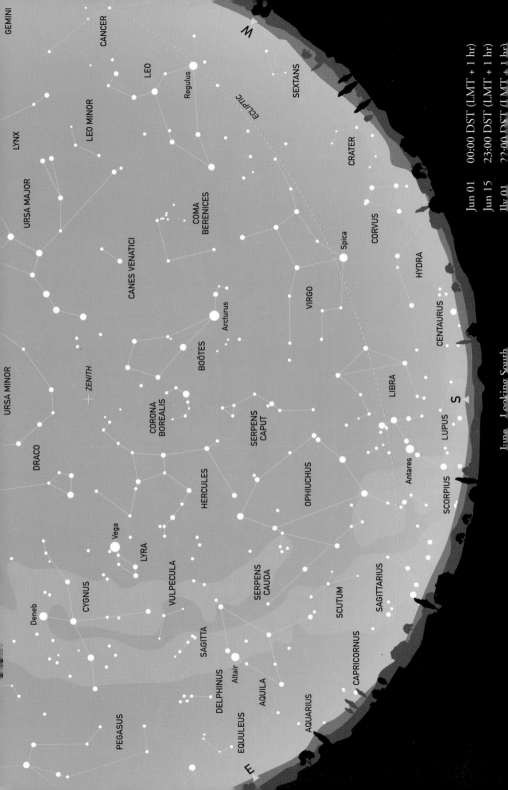

June. Looking South

Jun 01	00:00 DST (LMT + 1 hr)
Jun 15	23:00 DST (LMT + 1 hr)
Jly 01	22:00 DST (LMT + 1 hr)

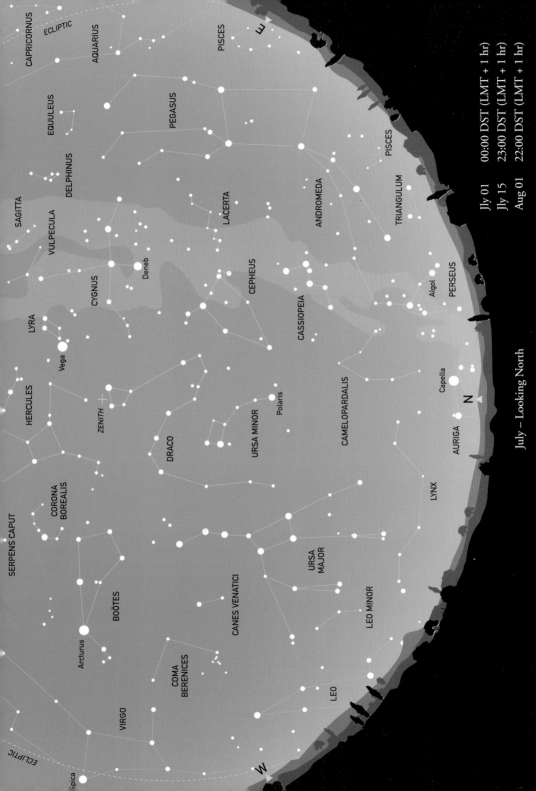

July – Looking North

Jly 01 00:00 DST (LMT + 1 hr)
Jly 15 23:00 DST (LMT + 1 hr)
Aug 01 22:00 DST (LMT + 1 hr)

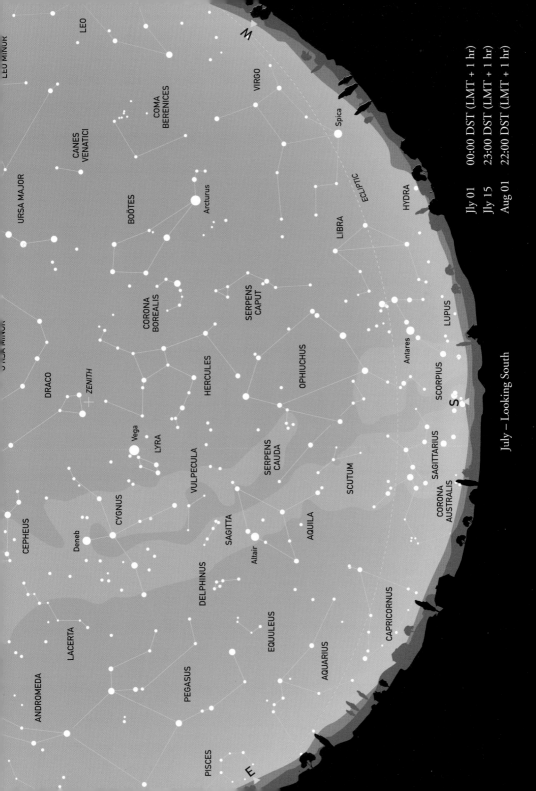

July – Looking South

Jly 01 00:00 DST (LMT + 1 hr)
Jly 15 23:00 DST (LMT + 1 hr)
Aug 01 22:00 DST (LMT + 1 hr)

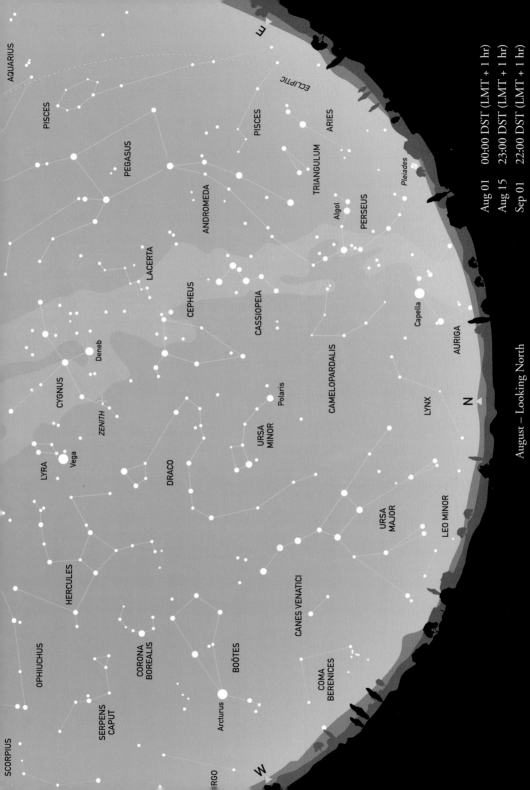

August – Looking North

Aug 01 00:00 DST (LMT + 1 hr)
Aug 15 23:00 DST (LMT + 1 hr)
Sep 01 22:00 DST (LMT + 1 hr)

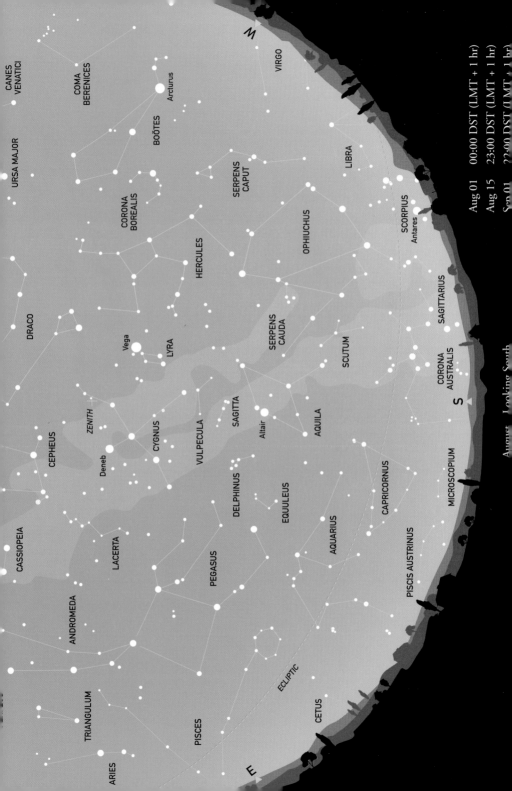

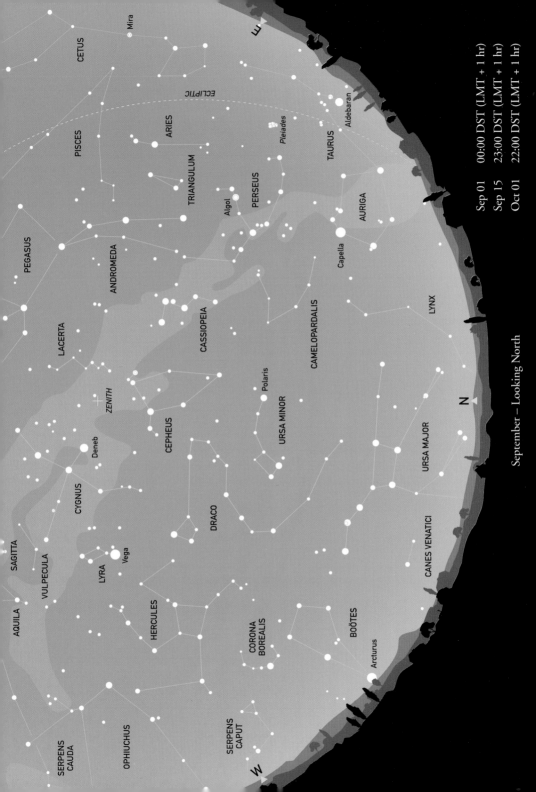

September – Looking North

Sep 01 00:00 DST (LMT + 1 hr)
Sep 15 23:00 DST (LMT + 1 hr)
Oct 01 22:00 DST (LMT + 1 hr)

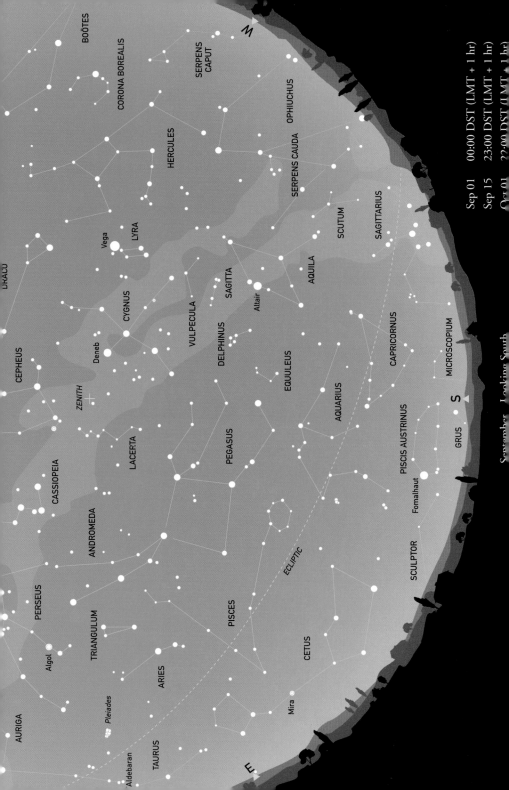

September — Looking South

Sep 01 00:00 DST (LMT + 1 hr)
Sep 15 23:00 DST (LMT + 1 hr)
Oct 01 22:00 DST (LMT + 1 hr)

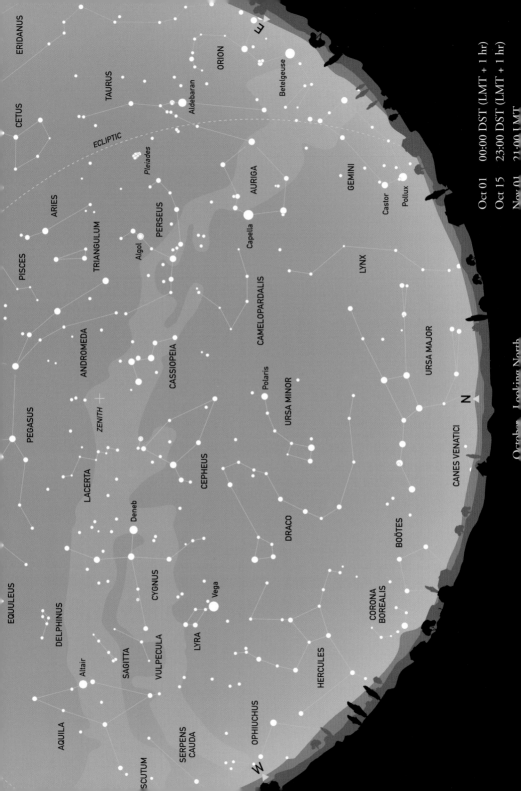

ERIDANUS

CETUS

TAURUS

ORION

Aldebaran

Betelgeuse

E

ARIES

Pleiades

PISCES

TRIANGULUM

PERSEUS

AURIGA

GEMINI

Castor

Pollux

ECLIPTIC

Algol

Capella

ANDROMEDA

CAMELOPARDALIS

LYNX

PEGASUS

CASSIOPEIA

URSA MAJOR

ZENITH

Polaris

LACERTA

URSA MINOR

CEPHEUS

CANES VENATICI

N

EQUULEUS

Deneb

DRACO

BOÖTES

DELPHINUS

CYGNUS

AQUILA

Altair

SAGITTA

VULPECULA

LYRA

Vega

HERCULES

CORONA
BOREALIS

SERPENS
CAUDA

OPHIUCHUS

SCUTUM

W

October, Looking North

Oct 01 00:00 DST (LMT + 1 hr)

Oct 15 23:00 DST (LMT + 1 hr)

Nov 01 21:00 LMT

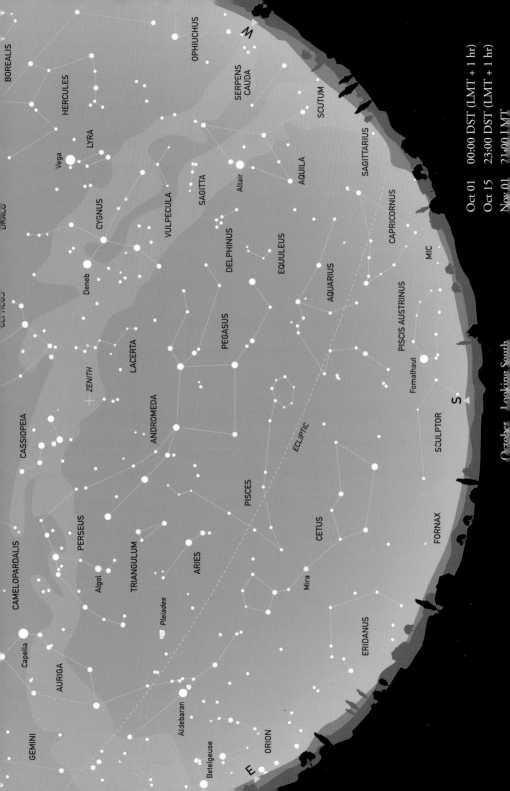

BOREALIS

OPHIUCHUS

HERCULES

SERPENS
CAUDA

LYRA

Vega

SCUTUM

CYGNUS

Altair

SAGITTARIUS

AQUILA

Deneb

VULPECULA

SAGITTA

CAPRICORNUS

DELPHINUS

EQUULEUS

LACERTA

MIC

ZENITH

PEGASUS

AQUARIUS

CASSIOPEIA

ANDROMEDA

PISCIS AUSTRINUS

Fomalhaut

ECLIPTIC

S

PISCES

SCULPTOR

PERSEUS

TRIANGULUM

CETUS

CAMELOPARDALIS

ARIES

FORNAX

Algol

Mira

Pleiades

Capella

AURIGA

ERIDANUS

GEMINI

Aldebaran

ORION

E

Betelgeuse

Oct 01 00:00 DST (LMT + 1 hr)
Oct 15 23:00 DST (LMT + 1 hr)
Nov 01 21:00 LMT

October — Looking South

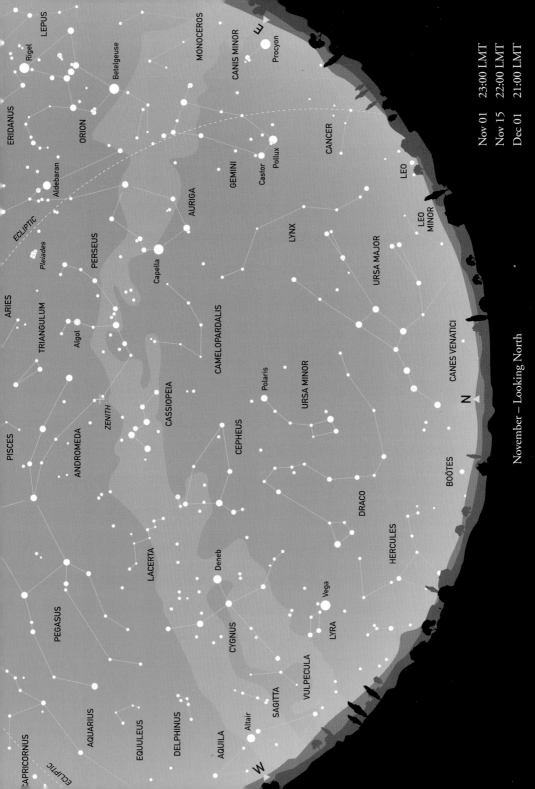

November – Looking North

Nov 01 23:00 LMT
Nov 15 22:00 LMT
Dec 01 21:00 LMT

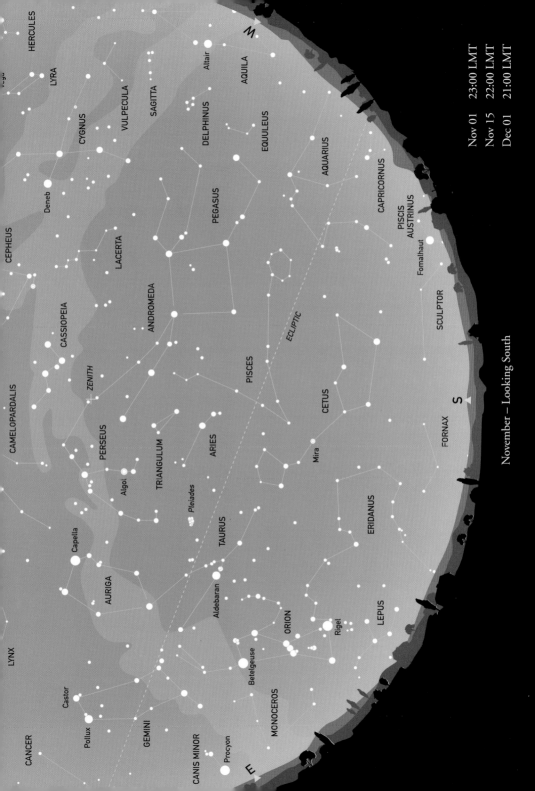

November – Looking South

Nov 01 23:00 LMT
Nov 15 22:00 LMT
Dec 01 21:00 LMT

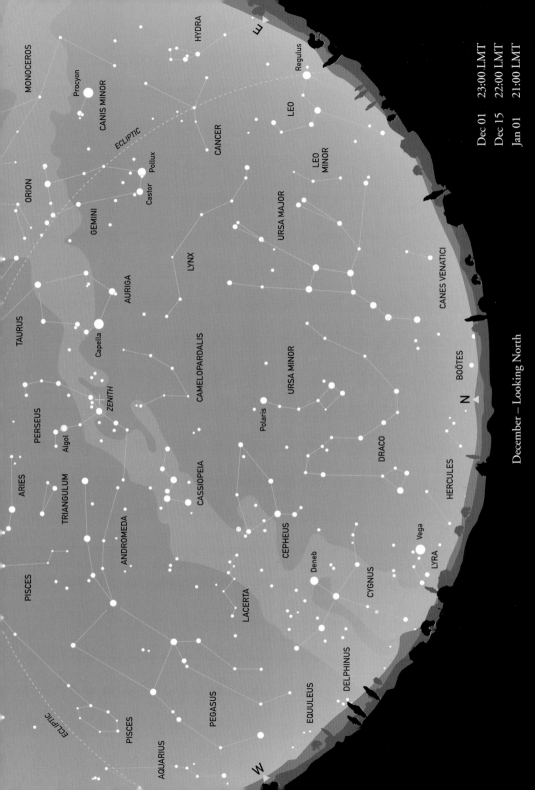

December – Looking North

Dec 01 23:00 LMT
Dec 15 22:00 LMT
Jan 01 21:00 LMT

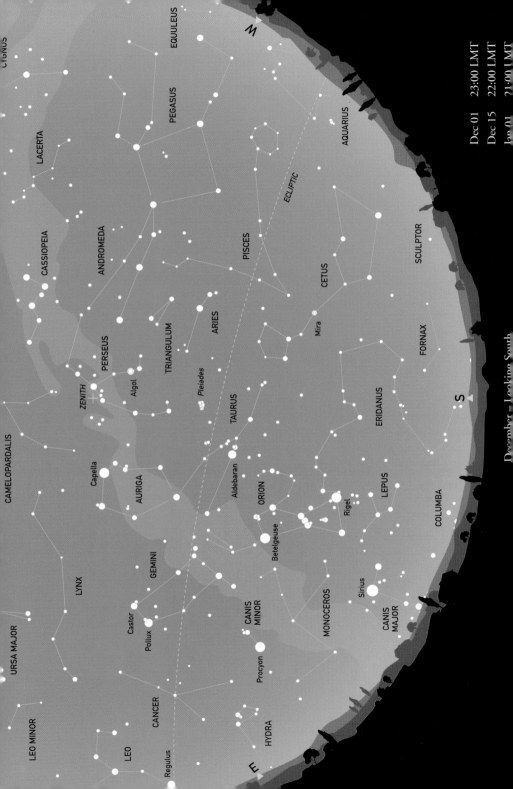

December – Looking South

Dec 01 23:00 LMT
Dec 15 22:00 LMT
Jan 01 21:00 LMT

THE MOON

The changes in the appearance of the Moon during the month are very familiar: increasing (waxing) from a narrow crescent just after New Moon (far right, above) to Full Moon and then decreasing (waning) back to a crescent as New Moon approaches (far left).

During the periods between First Quarter and Full Moon, and between Full Moon and Last Quarter, when more than half of the disk is illuminated, the phase is described as gibbous. To the casual eye, the changes in phase (the proportion of the illuminated disk that is visible from Earth), seem the same month after month but there are subtle variations, caused by the Moon's motion, which is actually extremely complex.

The Moon moves eastwards relative to the stars by approximately its own diameter in an hour. It takes 27.32 days to cover 360° and return to the same position relative to the stars. However – as with the sidereal and solar days on Earth – because of the Earth's motion in its own orbit around the Sun (carrying the Moon with it), the latter must move farther to return to the same phase. The month, as measured from New Moon to New Moon, is therefore about 29.5 days. The age is the number of days since New Moon.

PHASE	AGE (APPROXIMATE)	BEST VISIBILITY
New	0 days	–
Waxing crescent		Late April
First Quarter	7.5 days	Late March
Gibbous		
Full	14.75	Late December
Gibbous		
Last Quarter	22 days	Late September
Waning crescent		Late July

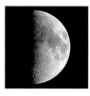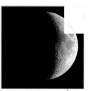

The Moon's orbit is inclined to the ecliptic, and is not fixed in space, so the Moon's position oscillates on either side of the ecliptic. In general, however, there are particular times of year when certain lunar phases are visible higher in the sky and for longer periods. Full Moon, for example, is obviously best seen when the ecliptic opposite the Sun is highest, and this is in December (around the winter solstice) for northern observers. For southern observers, the dates are shifted by six months.

Shortly after New Moon, when there is a thin crescent, the 'dark' portion of the Moon's disk is faintly illuminated. This effect, known as Earthshine, is caused by sunlight reflected onto the Moon by the Earth, and also occurs in the last few days before New Moon. The brightness of Earthshine varies, because it depends on the amount of cloud over the part of the Earth reflecting the sunlight. Photographs rarely record the effect properly, because of the great difference in brightness between the two regions of the Moon.

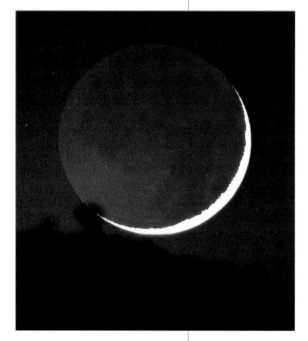

Earthshine provides sufficient illumination on the 'dark' portion of this setting crescent Moon for the major features to be seen.

The line dividing the illuminated and the unilluminated portions of the Moon is called the terminator. This boundary meets the limb of the Moon at two points known as the cusps, which are particularly well-defined during the crescent phases. A line joining the two cusps lies at right-angles to the direction of the Sun. Bearing in mind that any line joining the centres of the Sun and Moon is actually a curved arc, because it lies on the celestial sphere, the position of the cusps does give you a rough idea of where the Sun lies below the horizon.

LUNAR ECLIPSES

Lunar eclipses occur when the Moon enters the shadow cone cast by the Earth. This shadow takes the form of an outer cone, known as the penumbra, in which some (but not all) of the light from the Sun is blocked. The penumbra surrounds an inner, darker cone (the umbra) where no direct light can penetrate.

Because the Moon must, obviously, be opposite the Sun in the sky, lunar eclipses take place at Full Moon. However, the Moon's orbit is inclined to the plane of the ecliptic, and its orientation is not fixed in space, so eclipses do not occur at every Full Moon. For the same reasons, the Moon may follow different paths through the shadow cones, producing three types of eclipse: penumbral, when none of the Moon enters the umbra; partial, when a portion of the Moon enters the dark umbra; and total, when the whole Moon passes (however briefly) within the umbral cone.

Two or three eclipses occur every year, but many are penumbral, and in some years there are no partial or total eclipses – as in 2002, for example. Penumbral eclipses are of little interest, because the drop in illumination is too slight to be readily detectable. Partial eclipses are more striking, because the umbra slowly obscures part of the Moon. It was the curved edge of this shadow that gave early proof that the Earth was round. Most notable of all are total eclipses, when the whole Moon is obscured. The amount of the Moon that enters the umbra is given by the eclipse's magnitude, usually expressed as a percentage. Any figure less than 100 per cent is a partial eclipse, and more than 100 per cent implies that it is total. The greater the percentage, the longer the total eclipse lasts, up to a maximum of about 1 hour 42 minutes.

The Moon does not disappear completely at a total eclipse, however, because some sunlight is refracted into the umbra as it passes through the Earth's atmosphere (around the limb, as seen from the Moon). This light is orange or red, because (as at sunrise and sunset) the blue, green, and yellow wavelengths are absorbed by the atmosphere. The Moon is bathed in red light, although a bluish fringe – which is partly a contrast effect – is sometimes observed at the edge of the Earth's shadow as the Moon enters or leaves the umbra. When the Earth's atmosphere is clear, the Moon is a fairly bright, coppery colour, but if the atmosphere is full of clouds or other obscuration, such as volcanic dust, the Moon may be much darker, and deep red in

colour. There have been reports that the Moon has actually disappeared at mid-eclipse, but these seem to be exaggerations. Generally, the maria remain visible, as do some of the brighter craters, such as Copernicus, Kepler, and Aristarchus.

These variations in brightness and colour mean that every eclipse is different, and worth observing. Experienced observers, for example, estimate the brightness and colour on what is known as Danjon's eclipse scale, from the French observer who devised it. There are five steps:

	0	Very dark, Moon nearly invisible at mid-totality
	1	Dark grey or brownish in colour, few details visible
	2	Dark-red or rust-red with darker central area, outer regions quite bright
	3	Brick-red, often with a yellowish border
	4	Coppery or orange in colour, very bright, sometimes with bluish border

A very simple observation, but one that has actual scientific value, is to note the time at which it first becomes obvious that an eclipse is taking place. This information may be used to judge the accuracy of very early (pre-telescopic) historical accounts of eclipses. Such details may, in turn, be used to determine how the Earth's rate of rotation has changed over the course of time.

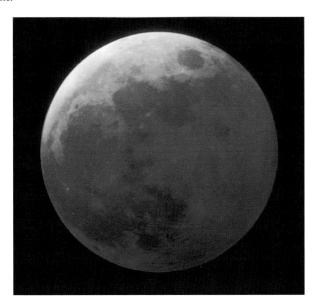

PHOTOGRAPHING LUNAR ECLIPSES

BELOW: At this dark eclipse, the Moon passed close to the edge of the umbral cone. Increased exposure at mid-eclipse shows that a small portion remained illuminated.

Lunar eclipses are so widely reported in the press and on radio and television that many people attempt to photograph them.

Unfortunately, ordinary cameras are just not suitable, and lead to disappointment. The diameter of the image of the Moon, taken with a 35-mm camera and standard 50-mm lens, is less than half a millimetre. With a moderate telephoto lens, it is best to fix the camera and take a series of exposures, allowing the motion of the sky to space the images across the film frame. All the photographs shown here were taken through a telescope.

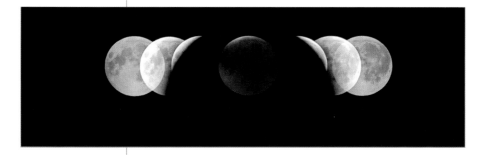

BELOW: In this sequence the exposure was adjusted to record an image at the middle of the eclipse.

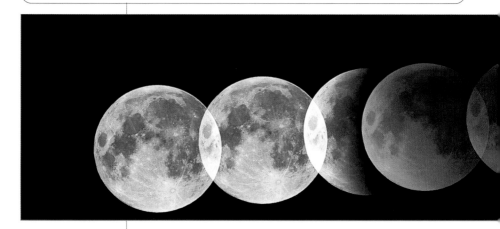

PARTIAL AND TOTAL LUNAR ECLIPSES

DATE	MAGNITUDE (%)	START OF PARTIAL PHASE	START OF TOTALITY	MID-ECLIPSE	END OF TOTALITY	END OF PARTIAL PHASE	NOTES AND ZONES OF VISIBILITY
2003							
May 16	113	02:06	03:17	03:43	04:09	05:20	Start visible in Europe, total in South America
Nov.09	102	23:35	01:09	01:20	01:31	03:05	Visible in Europe
2004							
May 04	130	18:49	19:53	20:30	21:07	22:11	Total in central Europe, end visible in W. Europe
Oct.28	131	01:15	02:24	03:04	03:44	04:53	Visible in Europe and America
2005							
Oct.17	7	11:34	–	12:02	–	12:30	Visible in the Pacific
2006							
Sep.07	19	18:10	–	18:54	–	19:38	Central Europe, end visible in W. Europe
2007							
Mar.03	24	21:33	22:47	23:23	23:59	01:13	Visible in Europe
Aug.28	148	08:51	09:51	10:36	11:21	12:21	Visible in the Pacific

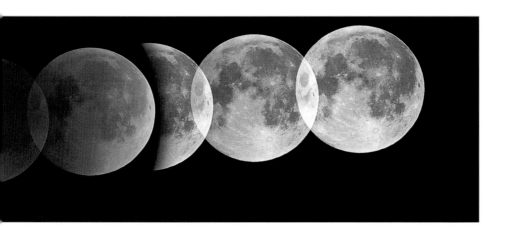

THE SURFACE OF THE MOON

The division of the Moon's surface into light and dark areas represents a basic difference in their nature. When the Moon was first formed, it was subject to intense meteoritic bombardment. This was so extreme that the whole surface was molten to a considerable depth. Even when a crust eventually formed, the impacts continued, creating innumerable craters of all sizes. Large portions of the densely cratered surface remain today, forming the light areas, usually known as the lunar highlands, although occasionally called by the formal term 'terrae', meaning 'lands'. Highland areas do not have specific names, which are instead given to individual craters.

Old books refer to positions on the Moon as it appears on the sky (TOP). Modern maps reverse east and west (BOTTOM) to be consistent with directions on Earth and other planets.

As may be seen from the photographs, the highland regions are extremely complex. Although many craters are distinct, many have been partially destroyed by subsequent impacts of all sizes. It has not been possible to reproduce this vast amount of detail in the maps included here, so it should be borne in mind that the seemingly blank, pale, highland areas are by no means featureless.

The bombardment gradually decreased and towards the end of the intense phase, a series of lava flows welled up from the interior. These flooded low-lying areas of the surface, sometimes just to the extent of filling the floor of an individual crater, but also spreading over vast areas of the surface, particularly in the very large impact basins. The largest dark regions are known as the maria (the plural of the Latin word 'mare' for 'sea') and are given specific names, such as Mare Nubium, or Mare Tranquilitatis.

Certain maria, such as Mare Imbrium (in particular) and Mare Serenitatis preserve a generally circular shape, bearing witness to where giant impact basins have been filled with lava. Other areas, such as Oceanus Procellarum, Mare Frigoris, and Sinus Medii, are more irregular in outline, a sign that they were originally interconnected low-lying areas, rather than single basins. The circular maria are often ringed by mountains, representing the raised rims or (in the very largest cases) mountain rings, which were created by the original impacts.

Impacts continued – at a much reduced rate – after lava upwelling ceased, so the maria are not completely devoid of craters. Some of the latest impacts are particularly conspicuous, because they ejected bright, finely powdered material over vast distances, creating ray craters. Coper-

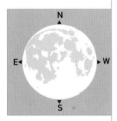

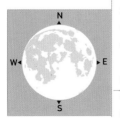

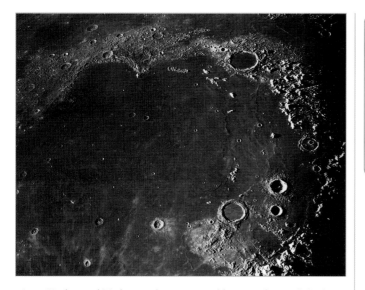

Mare Imbrium is a giant impact basin, bordered by many interesting features, including lava-flooded Sinus Iridum, Plato and Archimedes, as well as the Alpine Valley.

nicus, Kepler, and Tycho are the most notable examples, and the latter (in the southern highlands) has a vast system of rays, including one that runs across Mare Serenitatis in the north-eastern quadrant of the Moon.

Although the smallest craters may have a simple bowl-like shape, larger ones become increasing complex. The largest often have terraced walls, and many exhibit central peaks, formed by the rebound of material after the initial impact. Some, such as Gassendi, have complex systems of frac-

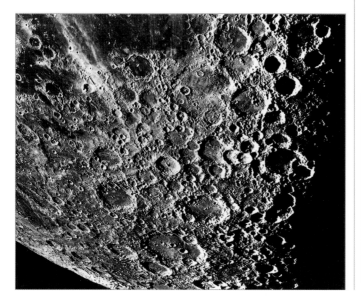

The crater Clavius, towards the bottom of this image, has a distinctive curving chain of smaller craters on its floor. Tycho (ABOVE AND TO THE LEFT) has a central peak, a dark halo, and rays that spread right across the disk of the Moon.

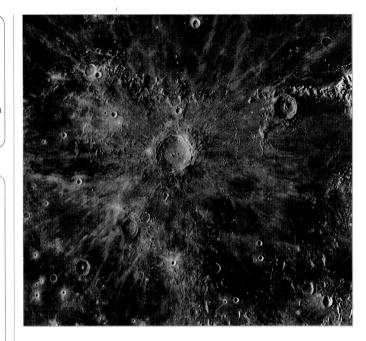

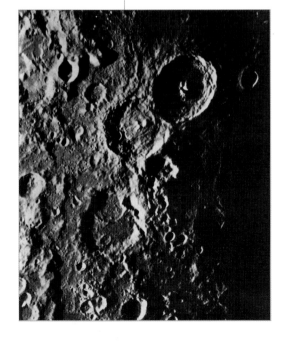

RIGHT: Copernicus, a relatively recent impact crater, has a complex interior with terraced walls and is the centre of a brilliant ray system.

A noted triplet of craters: Theophilus, with its central peak (TOP) is the youngest, having broken into the wall of Cyrillus (CENTRE). A large secondary crater occupies much of the floor of Catharina (BOTTOM).

tures on their floors, while others have been flooded by lava, with Plato and Grimaldi as just two notable examples. Again, it is not possible to show details of the central peaks on maps at this scale, so some of the most notable examples are indicated by a triangular symbol.

Although the Moon always turns the same face towards the Earth, the visible area varies slightly. Because the ecliptic and the Moon's orbit do not lie in the same plane, the Moon is sometimes above, and sometimes below the ecliptic, and we are able to see slightly more of the southern or northern limb regions. Similarly, although the Moon's rotation and orbital periods are exactly the same, the rotation rate is constant, but the orbital motion is not, because the Moon is moving in a ellipse. As a result, we sometimes see beyond the nominal limb on both the

eastern and western side. Smaller effects depend on the observer's position on Earth, and on whether the Moon is observed at rising or setting.

Overall, these effects, known as libration, mean that about 59.5 per cent of the Moon's surface is visible at some time. Experienced lunar observers use details of libration, which are given in astronomical handbooks, to search for features that are normally invisible. It may require considerable patience to await the correct combination of libration and a specific time in the lunation when the terminator is in the correct position to reveal the feature's details.

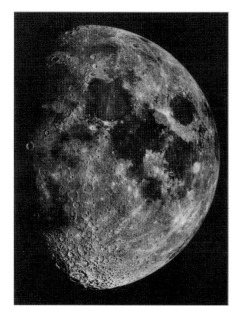 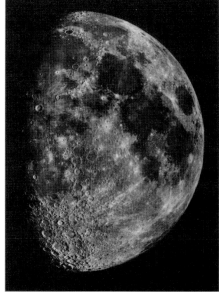

The visibility of lunar features is strongly dependent on their position relative to the terminator. The majority of craters show most detail when close to the terminator, when the grazing sunlight casts long shadows and accentuates the relief. In general, then, features are best seen twice during a lunation, but those close to the limb are greatly affected by the degree of libration, and may be detectable only once or twice a year. Around Full Moon, with nearly vertical illumination over most of the disk, most craters become indistinct. This is, however, the best time to see the bright ray systems, as well as the overall outlines of some of the maria. Because the Full Moon is so bright, filters that cut down the amount of light (particularly neutral density ones that do not introduce any colour) can help to reveal details of the surface.

Apart from Mare Crisium, note the changes caused by libration in the visibility of Mare Humboltianum, Mare Marginis, and Mare Smythii, all near the lunar limb.

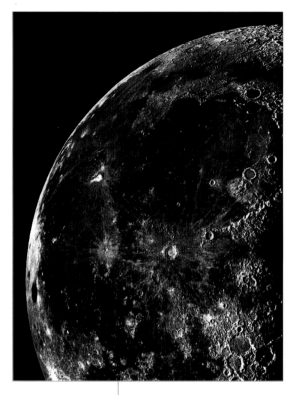

This region of the Moon is dominated by mare areas, particularly Oceanus Procellarum, Mare Imbrium, and Sinus Aestuum. Mare Imbrium is the best-defined of the major impact basins that were later filled with lava flows. It is almost completely ringed by mountains, except on the south-west, towards Oceanus Procellarum. Although the area has few prominent craters, these mountains exhibit striking changes in appearance as the direction of illumination alters throughout the month, as do the isolated peaks such as Pico within the mare area itself. Plato, in the narrow strip of highland terrain between Mare Imbrium and Mare Frigoris to the north, is a fine example of a crater with a dark lava-flooded floor, and Sinus Iridum of one where the wall towards the centre of the mare has been destroyed or submerged beneath the lava.

Two large, recent craters, Copernicus and Kepler, are prominent in Oceanus Procellarum and their surrounding rays are particularly bright around Full Moon under vertical illumination by the Sun, as is Aristarchus, which is one of the brightest areas of the whole Moon. Copernicus has a prominent central peak, and other craters worth noting are Archimedes and Eratosthenes, as well as several (including J. Herschel and Babbage) near the northern limb, and Struve, Russell, and Eddington in the west. A famous 'ghost' crater is Stadius on the north-western edge of Sinus Aestuum, completely overrun by lava which, when it cooled and shrank, left a raised partial ring, visible under grazing illumination.

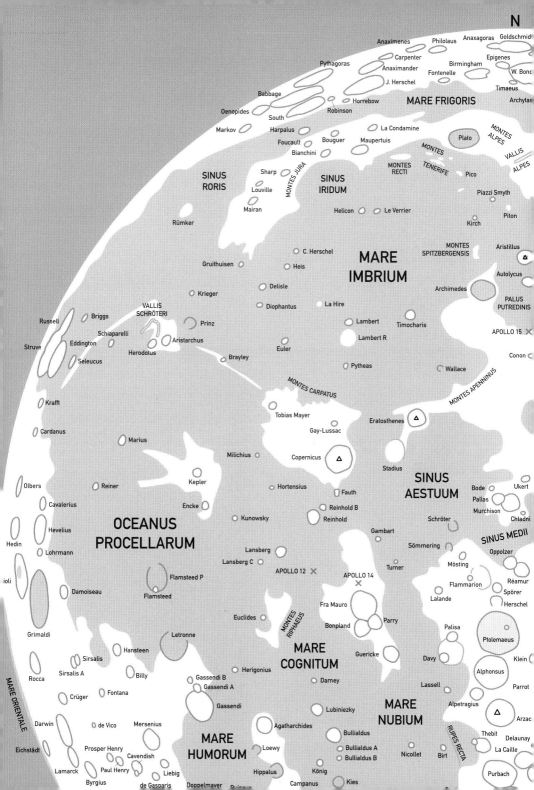

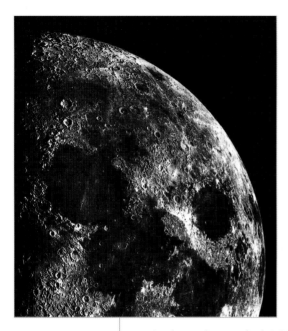

Mare Crisium is clearly visible shortly after New Moon, although noticeably foreshortened when there is unfavourable libration. The small, bright crater Proclus is easy to locate. Mare Serenitatis is approximately circular, with an extension to the northeast, known as Lacus Somniorum. Mare Tranquilitatis is more irregular and stretches across the equator to link with Mare Nectaris.

Mare Frigoris runs right across the northern latitudes. The area that includes Lacus Mortis is approximately the same size as Mare Crisium. On the northeastern limb is Mare Humboltianum, slightly easier to see than Mare Marginis and Mare Smythii, small maria close to the equator. Easier to find are Mare Undarum and Mare Spumans, the latter straddling the equator.

Large craters visible shortly after New Moon include Endymion, Mesala, and Meton (near the north pole). With good libration, the large crater Gauss is distinctive. Later, Geminus, Burkhardt, Berzelius, Franklin, and Atlas become visible, followed by Hercules, Newcomb, and Macrobius, and, still later, by Taruntius, Chacornac, Posidonius, Aristoteles, Eudoxus, and Le Monnier (a flooded 'bay' of Mare Serenitatis).

Julius Caesar on the edge of Mare Tranquilitatis is visible towards First Quarter as is Mare Vaporum, with its extension, Sinus Medii, at the centre of the Moon's visible disk. Seen now and around Last Quarter are Montes Haemus, bordering Mare Serenitatis, Montes Alpes, and Montes Caucasus, both bordering Mare Imbrium. Around First Quarter, we see Cassini, Aristillus and Autolycus, farther south, Palus Putredinis. Near the centre of the disk, Boscovich, Tempel, Agrippa, and Murchison appear around Mare Vaporum and Sinus Medii.

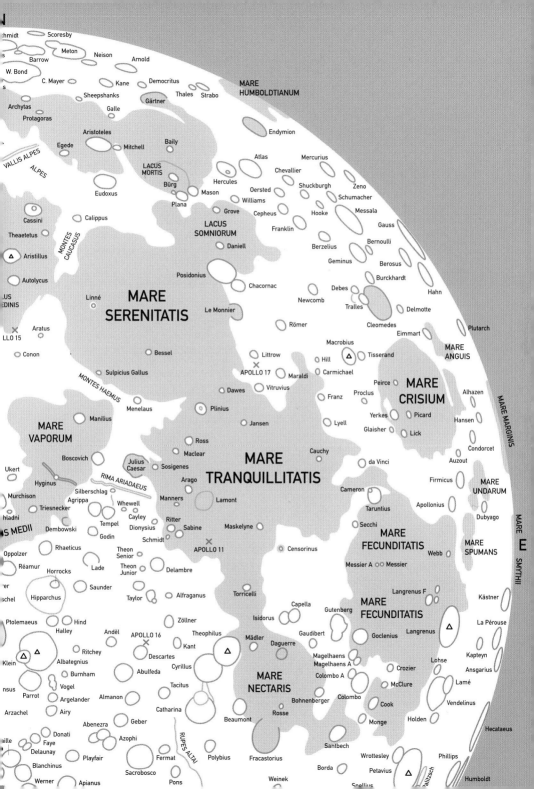

SOUTH-WEST QUADRANT

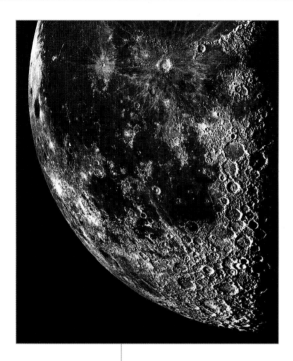

This quadrant contains the southern section of Oceanus Procellarum, the smaller mare areas of Mare Cognitum, Mare Humorum and Mare Nubium, and to the east and south, heavily cratered highlands. Near the central meridian are large craters such as Ptolomaus, Alphonsus, Arzachel, Purbach, Regiomontanus, Walter, and Maginus. Slightly farther west are Deslandres, Tycho, Clavius, and Longomontanus. Tycho has a central peak, a dark outer halo, and an extremely extensive ray system, the latter features best seen around Full Moon. The crater chain on the floor of Clavius is highly distinctive.

Just below the equator is Fra Mauro, with a complex inner rift system. At the eastern edge of Mare Nubium lies Rupes Recta (the Straight Wall), a fault, casting a distinctive shadow when illuminated at the right angle. West of Mare Humorum lies Gassendi, a large crater with a central peak and internal rifting.

The southern highlands are covered in craters; many large ones close to the limb becoming visible with favourable libration. There are Moretus, Klaproth, Blancanus, and Schiller with, farther west, Phocylides, Nasmyth, and Inghirami. Wargentin is remarkable because it has been filled with lava, forming a plateau, while larger Schikard has both light and dark areas on its floor.

In the west is Grimaldi, a large, dark, lava-flooded crater, near a group of craters straddling the equator: Riccioli, Hevelius, Cavalerius, and Hedin. Farther south there are large craters such as Darwin, Lamarck, and Byrgius. On the very limb, glimpses may sometimes be had of the mountain rings around Mare Orientale — the 'Eastern Sea'.

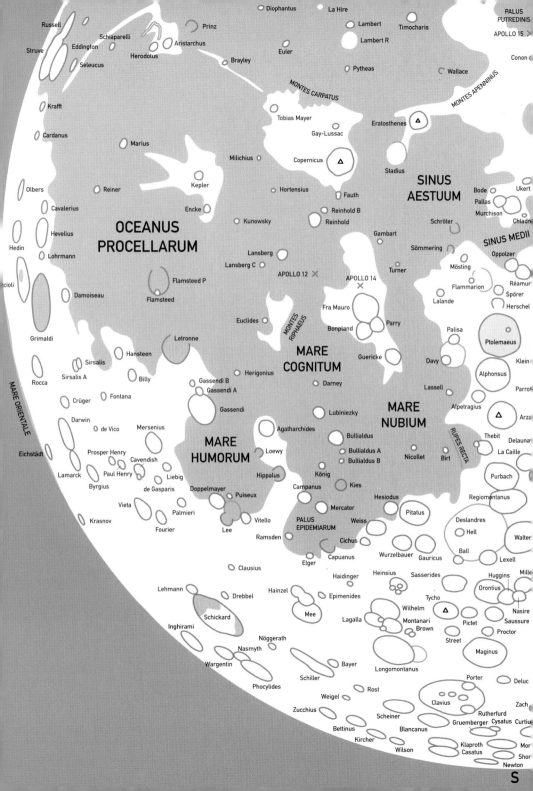

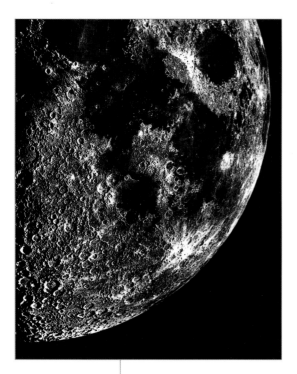

This quadrant contains the largest portion of the lunar highlands, with a vast number of individual craters — far too many to describe in detail. The mare areas are relatively small, largely consisting of Mare Fecunditatis and Mare Nectaris. Early in the lunation, a series of large craters east and south of Mare Fecunditatis is visible: Langrenus, Vendelinus, Petavius, and Furnerius, two of which have prominent central peaks. Slightly later, the craters west of Fecunditatis appear, including Gutenberg and Colombo with, farther south, Vallis Rheita (Rheita Valley), the large feature Janssen, and the adjacent craters Fabricius and Metius.

Under favourable conditions of libration, the edge of Mare Australe may be seen on the limb. It is slightly more conspicuous than Mare Smythii and Mare Marginis near the equator, and rather larger than Mare Humboltianum in the north-east.

The terminator then reaches Fracastorius, a large breached crater on the southern edge of Mare Nectaris and, in the far south, several large craters such as Pitiscus, Hommel, and Manzinus. Soon after this the very distinctive group of the three craters Theophilus, Cyrillus, and Catharina appears, together with the Rupes Altai (Altai Scarp).

This heavily cratered region repays extensive study. Some of the interesting craters in the northern area are Descartes, Abulfeda, Hipparchus, and Klein. Farther south there is Sacrobosco and, to the west the chain of craters: La Caille, Blanchinus, Werner, and Aliacensis. Still farther south, we have the group around Rabbi Levi (Zagut, Lindenau, and Riccius), Maurolycus and Barocius, Stöfler and Faraday.

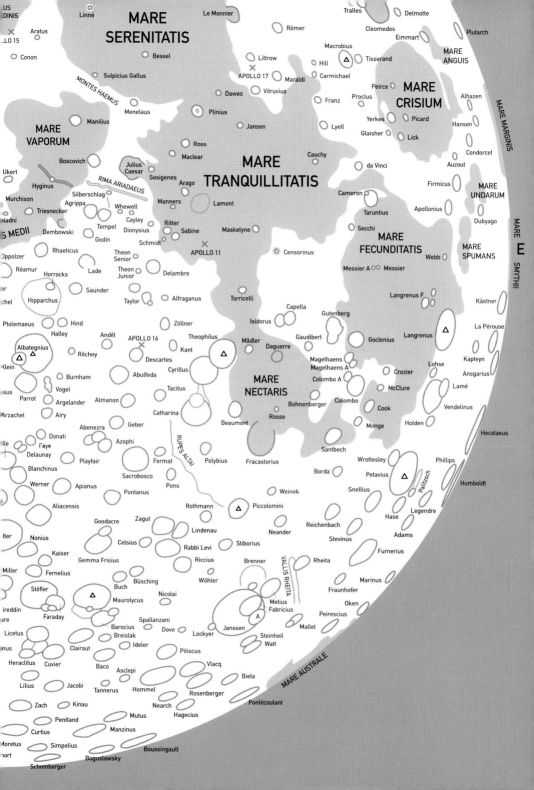

THE PLANETS

The planets often cause confusion among beginners because they may be bright and — at least when initially learning the sky — they may distort the patterns of stars making recognition of the constellations more difficult. The charts given shortly should help considerably in this respect.

Observing detail on the planets requires moderate-sized telescopes. It is generally held that refractors with objectives of at least 75—100 mm in diameter, or reflectors with apertures of about 150 mm are needed to see the Great Red Spot of Jupiter (for example). Jupiter's belts are detectable with smaller instruments (such as a 60-mm refractor), and the crescent phases of Venus are visible in good binoculars. Mars presents such a tiny disk that it really requires a much larger instrument for any details (such as the polar caps) to be detectable.

Jupiter's four major satellites present an ever-changing appearance. Known as the Galilean satellites after their discoverer, these are (in increasing distance from the planet) Io, Europa, Ganymede, and Callisto. They are easily visible in binoculars, having mean magnitudes when the planet is at opposition of between 4.6 and 5.6. Because they have different orbital periods, their positions relative to the planet and one another are constantly changing. Sometimes all four are on one side of the planet, and at others one or more may be invisible, either

BELOW LEFT: Although Venus often appears as a crescent, no details are ever visible on its cloud-covered surface. BELOW CENTRE: Faint markings and the polar caps of Mars may be detected in small telescopes. BELOW RIGHT: Saturn, with its striking system of rings, is the most beautiful planet in the Solar System.

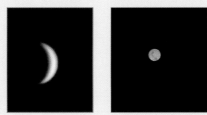
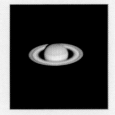

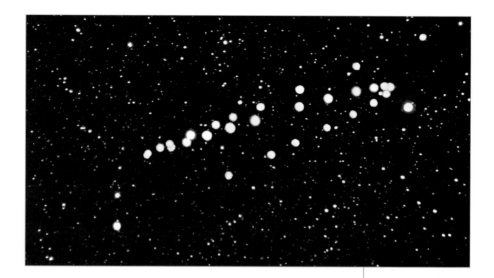

because they are passing behind the planet, or because they are crossing in front of it — in transit — and are lost against the planet's disk. (In large telescopes, their shadows on the cloud layer are often much easier to detect than the satellites themselves.) The satellites also pass through Jupiter's shadow cone — they are eclipsed — so may be seen to disappear or reappear some distance from the planet's limb.

Because the satellites' positions change from night to night, it is impractical to provide details in this book. However, many yearly handbooks do give this information, and there are also computer programs which will show their positions for any date and time.

A similar situation exists for Saturn, although here only Titan in visible in binoculars or small telescopes under good conditions. Its mean magnitude when the planet is at opposition is just 8.3.

The path of Mars in 1999, starting in January (RIGHT, TOP), retrograding between April and June, and ending in early August. The bright star is Spica in Virgo.

BELOW: Jupiter, with the Great Red Spot, and its four Galilean satellites, including orange-coloured Io.

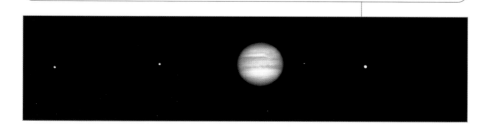

PLANETARY POSITIONS

This section shows the positions of the planets for the next few years. The two inferior planets (Mercury and Venus) are normally most readily visible around greatest elongation. At eastern elongation, the planet will be visible in the evening sky, and at western elongation it will appear before the Sun at dawn. Although all elongations are listed, sometimes the planets are low on the horizon and are not easy to detect. This is particularly the case with Mercury, which is often difficult to find in the twilit sky. The most favourable elongations occur when Mercury and Venus are above (i.e., north) of the ecliptic (for northern-hemisphere observers). These elongations are shown in the diagrams, together with certain notable appulses, when planets appear close to one another in the sky. Such appulses are often known as 'planetary conjunctions'.

Multiple exposures capture Venus looping in the evening sky, starting in September 2000 (BOTTOM) as it moves towards eastern elongation in December. The sequence ends in March 2001 as Venus again approaches the Sun.

It should be noted that the positions of the planets are shown relative to that of the Sun, which is assumed to be a fixed distance below the horizon. The compass directions shown should be taken as a general indication only, because the points at which the Sun actually rises and sets change from day to day throughout the year.

The dates of inferior conjunctions are also given. On rare occasions Mercury or Venus may then appear to transit the disk of the Sun. Such events are infrequent (the next occasions are 2003 May 3 and 2006 November 8 for Mercury; 2004 June 8 and 2012 June 6 for Venus). Need-

less to say, special methods should be used to observe these events. Never view the Sun directly through any optical instrument (at any time), because of the risk of severe damage to your eyesight. The only simple, safe method is to project the image onto a piece of white card, held behind the eyepiece.

The relative motions of the Earth and Venus mean that in most years the planet remains visible for an extended period of time. In some years this is particularly pronounced when the planet remains high in the sky for several months. The magnitude of Venus varies considerably, and it is brightest after eastern elongation and then again before western elongation (i.e., on either side of inferior conjunction). The brightest of all the planets, it may be seen in daylight, if one knows where to look. Even moderate optical equipment will show Venus with crescent or gibbous phases, as Galileo realised when he observed it with his first telescope in 1610. (It was this, of course, that convinced him that Venus orbited the Sun, and not the Earth.) The planet may be followed as it grows in diameter, becoming a thinner and thinner crescent as it approaches inferior conjunction. Following conjunction, it reappears as a thin crescent to the west of the Sun (i.e., as a morning object).

The superior planets (Mars, Jupiter, Saturn, Uranus, and Neptune) are most easily observed around the time of opposition, so these dates are given in the tables. Because of the length of its orbital period, relative to that of the Earth, Mars does not come to opposition every year, although there is usually a period when it is quite bright and conspicuous. Similarly (as with Saturn in 2004), a year may pass without an opposition of one of the other planets.

For each of the superior planets a chart shows their positions throughout the year. All, of course, exhibit retrograde motion at some time during the year, and oppositions occur in the middle of the retrograde portions of their paths. Note that these charts are centred on the zodiac, so the ecliptic appears as a straight line.

Because Uranus and Neptune are quite faint, even around opposition, they are often difficult to distinguish from stars, especially as low magnifications do not show them as disks, rather than points of light. Uranus is said to be just detectable with the naked eye under clear, dark skies and when around maximum brightness, but Neptune may be as low as magnitude 8 around opposition. Their charts therefore show all stars down to magnitude 8.5. As with minor planets, the only certain method of identification (particularly with Neptune) is to make a drawing and compare this with the sky on a subsequent night.

2002

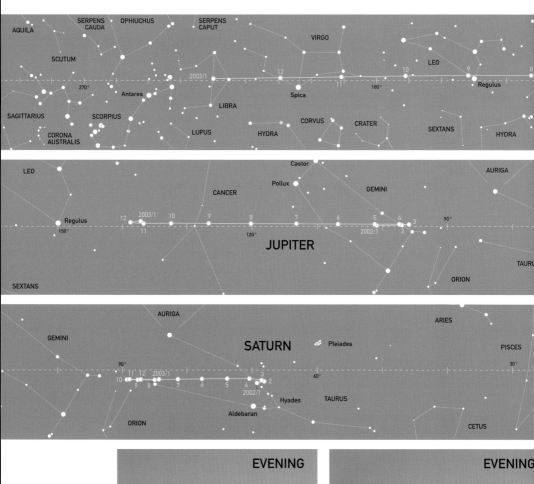

AQUILA · SERPENS CAUDA · OPHIUCHUS · SERPENS CAPUT · VIRGO · SCUTUM · LEO · 270° · 2003/1 · 12 · 10 · 9 · 8 · Antares · 11 · 180° · Regulus · Spica · SAGITTARIUS · SCORPIUS · LIBRA · CORVUS · CRATER · SEXTANS · HYDRA · CORONA AUSTRALIS · LUPUS · HYDRA

LEO · Castor · AURIGA · Pollux · CANCER · GEMINI · 12 · 2003/1 · 10 · 9 · 8 · 7 · 6 · 5 · 4 · 3 · 90° · Regulus · 150° · 11 · 120° · 2002/1 · 2 · JUPITER · TAURUS · ORION · SEXTANS

GEMINI · AURIGA · SATURN · ARIES · Pleiades · PISCES · 90° · 11 12 · 2003/1 · 3 · 30° · 10 · 9 8 · 7 · 6 · 5 · 4 · 2 · 60° · 2002/1 · Hyades · TAURUS · ORION · Aldebaran · CETUS

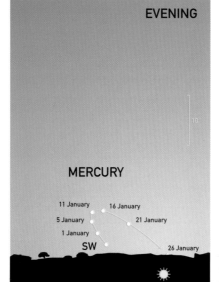

EVENING

10

MERCURY

11 January · 16 January
5 January · 21 January
1 January
26 January

SW

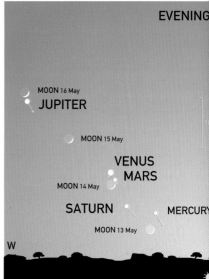

EVENING

MOON 16 May
JUPITER

MOON 15 May

VENUS
MARS
MOON 14 May

SATURN · MERCURY

MOON 13 May

W

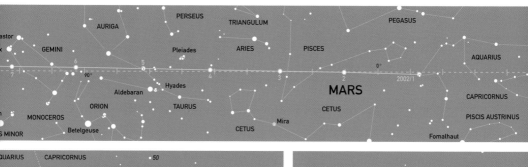

PERSEUS
TRIANGULUM
PEGASUS
AURIGA
GEMINI
astor
Pleiades
ARIES
PISCES
AQUARIUS
90°
0°
2002/1
MARS
Aldebaran
Hyades
CAPRICORNUS
ORION
TAURUS
CETUS
MONOCEROS
Mira
PISCIS AUSTRINUS
Betelgeuse
CETUS
S MINOR
Fomalhaut

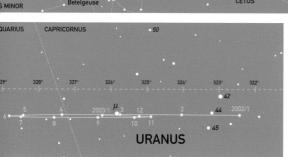

QUARIUS CAPRICORNUS 50
329° 328° 327° 326° 325° 324° 323° 322°
42
2003/1 μ 3 12 2 44 2002/1
6 5 45
7 8 9 10 11
URANUS

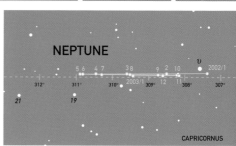

NEPTUNE
υ
5 6 4 7 3 8 9 2 10 2002/1
312° 311° 310° 2003/1 309° 12 11 308° 307°
21 19
CAPRICORNUS

rcury 2002	Oct 13	18°W
EATEST ELONGATION	Dec 26	20°W
11	19°E	
21	27°W	INFERIOR CONJUNCTION
y 04	21°E	Jan 27
21	23°W	May 27
01	27°E	Sep 27

Venus 2002

GREATEST ELONGATION
Aug 22 46°E

INFERIOR CONJUNCTION
Oct 31

Oppositions 2002

PLANET	DATE	MAG.
Mars	–	–
Jupiter	Jan 01	-2.3
Saturn	Dec 17	-0.3
Uranus	Aug 20	6.1
Neptune	Aug 02	7.7

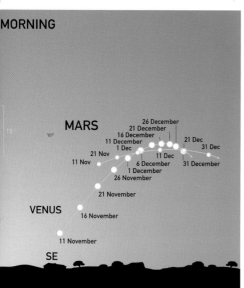

MORNING

MARS
26 December
21 December
16 December
11 December 21 Dec
1 Dec 31 Dec
21 Nov 11 Dec
11 Nov 6 December 31 December
1 December
26 November
21 November
VENUS
16 November
11 November
SE

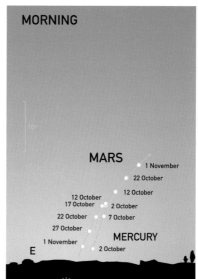

MORNING

MARS
1 November
22 October
12 October
12 October
17 October 2 October
22 October 7 October
27 October
1 November MERCURY
E 2 October

2003

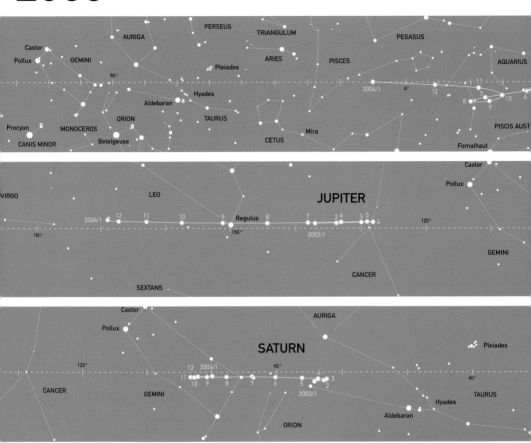

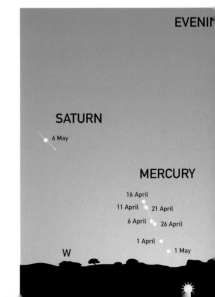

EVENIN

SATURN

6 May

MERCURY

16 April
11 April 21 April
6 April 26 April
1 April
1 May

W

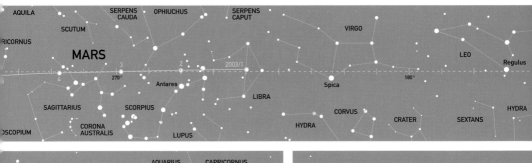

Star chart for MARS showing constellations: AQUILA, SERPENS CAUDA, OPHIUCHUS, SERPENS CAPUT, SCUTUM, VIRGO, RICORNUS, LEO, Regulus, 270°, 2003/1, 180°, Antares, Spica, LIBRA, SAGITTARIUS, SCORPIUS, CORVUS, HYDRA, CRATER, SEXTANS, OSCOPIUM, CORONA AUSTRALIS, LUPUS, HYDRA

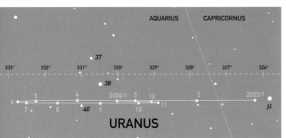

Star chart for URANUS showing constellations: AQUARIUS, CAPRICORNUS, 333°, 332°, 331°, 37, 330°, 329°, 328°, 327°, 326°, 38, 5, 4, 2004/1, 3, 12, 2, 2003/1, 6, 7, 8, 40, 9, 10, 11, μ

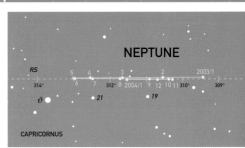

Star chart for NEPTUNE showing: RS, 5, 4, 3, 2, 2003/1, 314°, 6, 7, 312°, 2004/1, 9, 12, 10, 1, 310°, 309°, ϑ, 21, 19, CAPRICORNUS

Mercury 2003

GREATEST ELONGATION		INFERIOR CONJUNCTION
04	25°W	Jan 11
16	20°E	May 07 (transit)
03	24°W	Sep 11
14	27°E	Dec 27
26	18°W	
09	21°E	

Venus 2003

GREATEST ELONGATION	
Jan 11	47°W

INFERIOR CONJUNCTION

–

Oppositions 2003

PLANET	DATE	MAG.
Mars	Aug 28	-2.7
Jupiter	Feb 02	-2.1
Saturn	Dec 31	-0.3
Uranus	Aug 24	6.1
Neptune	Aug 04	7.7

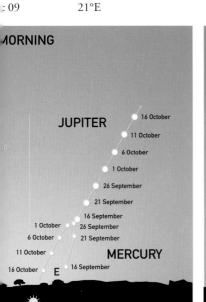

MORNING

JUPITER
16 October
11 October
6 October
1 October
26 September
21 September
16 September
1 October 26 September
6 October 21 September
11 October
16 October 16 September
E MERCURY

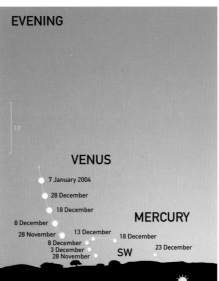

EVENING

VENUS
7 January 2004
28 December
18 December
8 December
28 November 13 December 18 December
MERCURY
8 December 23 December
3 December
28 November SW

2004

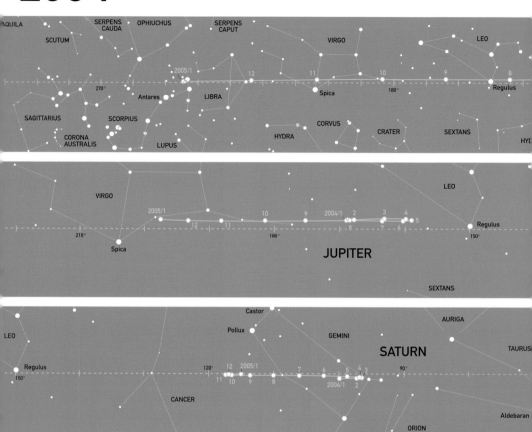

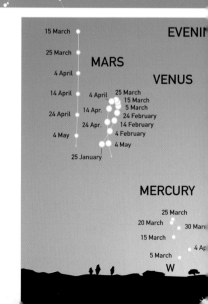

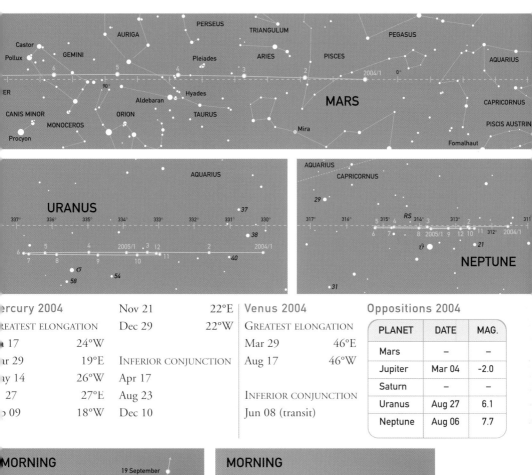

URANUS

337° 336° 335° 334° 333° 332° 331° 330°

2005/1 3 12 2 2004/1

NEPTUNE

317° 316° 315° RS 314° 313° 312° 2004/1

MARS

Mercury 2004			Venus 2004		Oppositions 2004		

Nov 21 22°E
Dec 29 22°W

Mercury 2004

GREATEST ELONGATION

17 24°W
ar 29 19°E INFERIOR CONJUNCTION
ay 14 26°W Apr 17
27 27°E Aug 23
09 18°W Dec 10

Venus 2004

GREATEST ELONGATION

Mar 29 46°E
Aug 17 46°W

INFERIOR CONJUNCTION

Jun 08 (transit)

Oppositions 2004

PLANET	DATE	MAG.
Mars	–	–
Jupiter	Mar 04	-2.0
Saturn	–	–
Uranus	Aug 27	6.1
Neptune	Aug 06	7.7

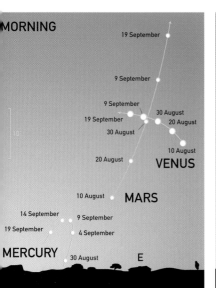

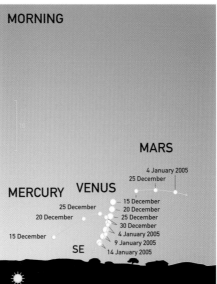

2005

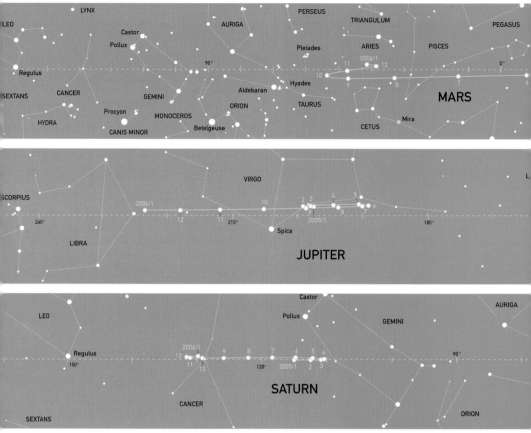

MARS

LYNX · PERSEUS · TRIANGULUM · PEGASUS · LEO · Castor · AURIGA · Pollux · Pleiades · ARIES · PISCES · 90° · 2006/1 · 11 · 12 · 0° · Regulus · 10 · 9 · 8 · 6 · SEXTANS · CANCER · Aldebaran · Hyades · GEMINI · TAURUS · HYDRA · Procyon · ORION · Mira · MONOCEROS · CETUS · CANIS MINOR · Betelgeuse

JUPITER

SCORPIUS · VIRGO · L · 2006/1 · 10 · 2 3 · 4 · 5 · 240° · 12 · 11 · 210° · 5 · 8 · 7 · 180° · LIBRA · Spica · 2005/1 · 6

SATURN

LEO · Castor · AURIGA · Pollux · GEMINI · Regulus · 2006/1 · 9 · 8 · 7 · 6 · 5 · 4 · 90° · 150° · 12 · 11 · 10 · 120° · 2005/1 · 2 · 3 · CANCER · SEXTANS · ORION

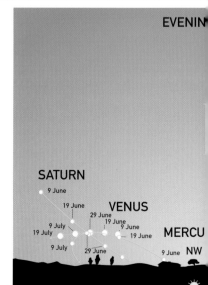

EVENIN

SATURN
9 June

19 June

VENUS

29 June · 19 June
9 June
9 July · 19 June · 9 June

19 July · 19 June

MERCU

9 July · 29 June · 9 June · NW

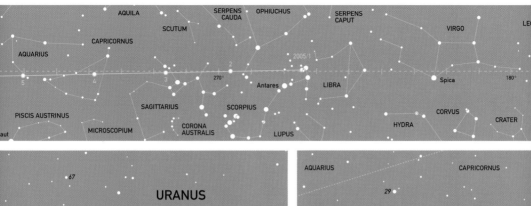

AQUILA · SERPENS CAUDA · OPHIUCHUS · SERPENS CAPUT · VIRGO · LEO · SCUTUM · CAPRICORNUS · AQUARIUS · 2005/1 · 270° · LIBRA · Antares · Spica · 180° · PISCIS AUSTRINUS · SAGITTARIUS · SCORPIUS · CORVUS · CRATER · MICROSCOPIUM · CORONA AUSTRALIS · LUPUS · HYDRA

URANUS

72 341° · 340° · 339° · 338° · 337° · 336° · 335° · 334° · λ · 67 · 2006/1 · 2005/1 · 64 · 58 · 54 · σ · 65

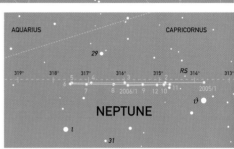

NEPTUNE

AQUARIUS · CAPRICORNUS · 29 · 319° · 318° · 317° · 316° · 315° · RS 314° · 313° · 2006/1 · 2005/1 · ι · 31 · ϑ

Mercury 2005

GREATEST ELONGATION		INFERIOR CONJUNCTION
Mar 12	18°E	Mar 29
Apr 26	27°W	Aug 05
Jul 09	26°E	Nov 24
Aug 23	18°W	
Nov 03	23°E	
Dec 12	21°W	

Venus 2005

GREATEST ELONGATION

Nov 03 47°E

INFERIOR CONJUNCTION

–

Oppositions 2005

PLANET	DATE	MAG.
Mars	Nov 07	-2.1
Jupiter	Apr 03	-2.0
Saturn	Jan 13	-0.2
Uranus	Sep 01	6.1
Neptune	Aug 08	7.7

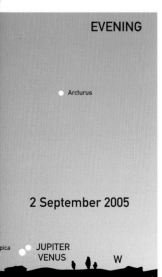

EVENING

Arcturus

2 September 2005

Spica · JUPITER VENUS · W

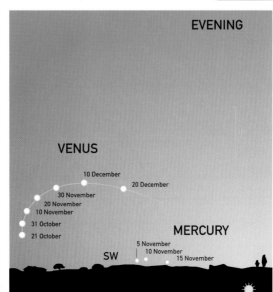

EVENING

VENUS

10 December · 20 December · 30 November · 20 November · 10 November · 31 October · 21 October

MERCURY

5 November · 10 November · 15 November · SW

2006

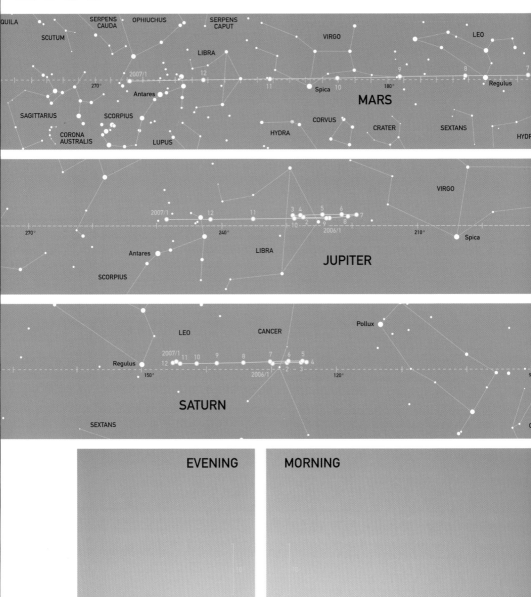

MARS

QUILA · SERPENS CAUDA · OPHIUCHUS · SERPENS CAPUT · SCUTUM · LIBRA · VIRGO · LEO · 2007/1 · 12 · 11 · Spica · 10 · 9 · 8 · 7 · Regulus · 270° · Antares · 180° · SAGITTARIUS · SCORPIUS · CORVUS · CRATER · SEXTANS · CORONA AUSTRALIS · LUPUS · HYDRA · HYDR

JUPITER

VIRGO · 2007/1 · 12 · 11 · 3 · 4 · 5 · 6 · 7 · 10 · 2 · 2006/1 · 8 · 270° · 240° · 210° · Spica · Antares · LIBRA · SCORPIUS

SATURN

LEO · CANCER · Pollux · 2007/1 · Regulus · 12 · 11 · 10 · 9 · 8 · 7 · 6 · 5 · 4 · 150° · 2006/1 · 3 · 120° · 9 · SEXTANS

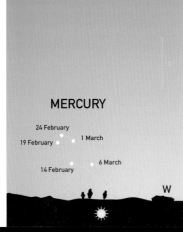

EVENING

MORNING

MERCURY

24 February
19 February · 1 March
14 February · 6 March

W

VENUS

5 March
15 March
25 March
4 April

MERCURY

15 March · 20 March · 25 March · 30 March
4 April

E

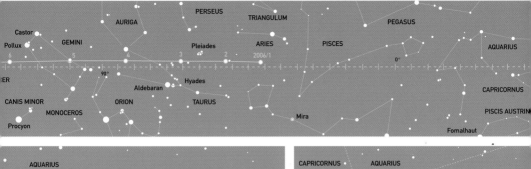

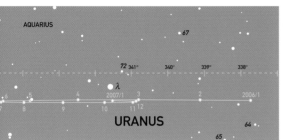

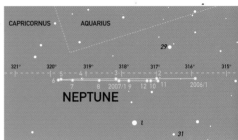

...ercury 2006

GREATEST ELONGATION		INFERIOR CONJUNCTION
...24	18°E	Mar 12
...r 08	28°W	Jul 18
...20	25°E	Nov 08 (transit)
...g 07	19°W	
...t 17	25°E	
...v 25	20°W	

Venus 2006

GREATEST ELONGATION

Mar 25 47°W

INFERIOR CONJUNCTION

Jan 13

Oppositions 2006

PLANET	DATE	MAG.
Mars	–	–
Jupiter	May 04	-2.0
Saturn	Jan 27	-0.0
Uranus	Sep 05	6.1
Neptune	Aug 11	7.7

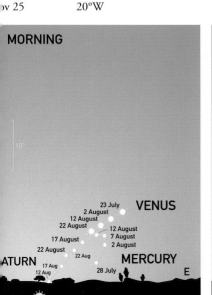

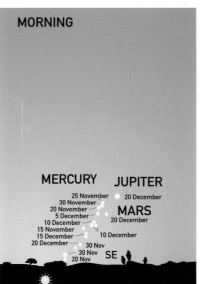

MINOR PLANETS

A few minor planets become bright enough around opposition to be detectable in binoculars or small telescopes. These are generally the first four minor planets that were discovered: Ceres, Pallas, Juno, and Vesta. However, not all of these come to opposition in any one year, and even then, the magnitudes at opposition vary considerably. The accompanying charts show the brightest oppositions and the paths indicate when the minor planets are above magnitude 9.0 (approximately).

On certain parts of the tracks it may be possible to recognize a minor planet from its position alone, but identification is normally a matter of detecting the body's motion against the background stars. Using just visual means, this usually means making observations on more than one night, preferably drawing the star-field each time, so that any changes may be detected. Photographic methods may also be used, but here the telescope is normally set to track the stars, so any minor planet will leave a trail. Nowadays, experienced amateurs with CCD cameras are achieving great success in obtaining images of faint minor planets that may be used to refine details of their orbits.

OPPOSITION DATES AND APPROXIMATE MAGNITUDES

Ceres	2002	Oct.04	7.6
Vesta	2003	Mar.26	5.9
Pallas	2003	Oct.13	8.2
Ceres	2004	Jan.09	6.8
Vesta	2004	Sep.13	6.1
Pallas	2005	Mar.23	7.1
Ceres	2005	May.07	7.0
Juno	2005	Dec.09	7.5
Vesta	2006	Jan.05	6.3
Ceres	2006	Aug.12	7.6

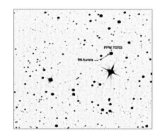

The minor planet 94 Aurora shows a trail in this long exposure. The star marked, PPM 70703, was used as a reference for determining Aurora's exact position.

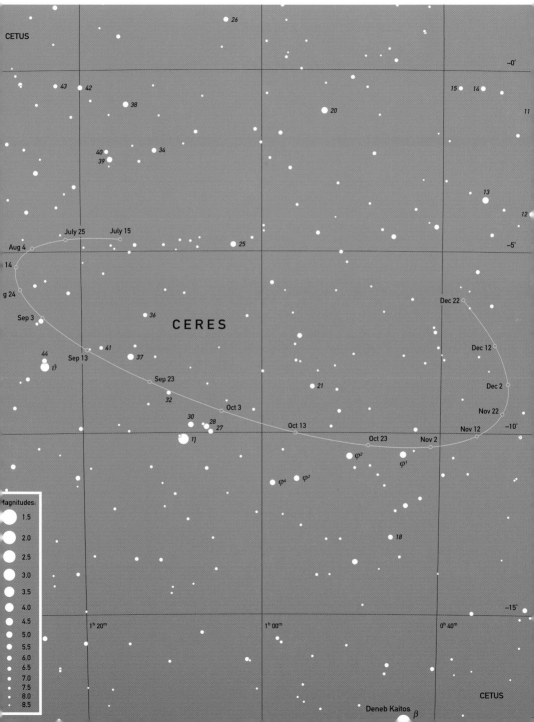

2002

CETUS

−0°

26

43 42

38

20

15 14

11

40
39

34

13

12

July 25 July 15

Aug 4

25

−5°

14

g 24

Dec 22

Sep 3

36

CERES

Dec 12

44
ϑ

41

Sep 13

37

Dec 2

Sep 23

21

Nov 22

32

Oct 3

Nov 12

−10°

30 28 27

η

Oct 13

Oct 23 Nov 2

φ²

φ¹

φ⁴ φ³

Magnitudes:

1.5

2.0

2.5

3.0

3.5

4.0

4.5

5.0

5.5

6.0

6.5

7.0

7.5

8.0

8.5

18

−15°

1ʰ 20ᵐ

1ʰ 00ᵐ

0ʰ 40ᵐ

CETUS

Deneb Kaitos β

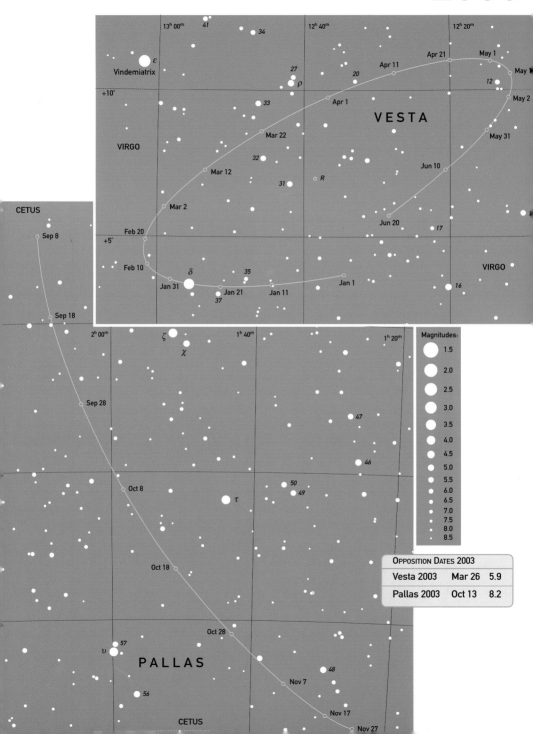

Magnitudes:

Magnitudes:
1.5
2.0
2.5
3.0
3.5
4.0
4.5
5.0
5.5
6.0
6.5
7.0
7.5
8.0
8.5

Opposition Dates 2003		
Vesta 2003	Mar 26	5.9
Pallas 2003	Oct 13	8.2

2004

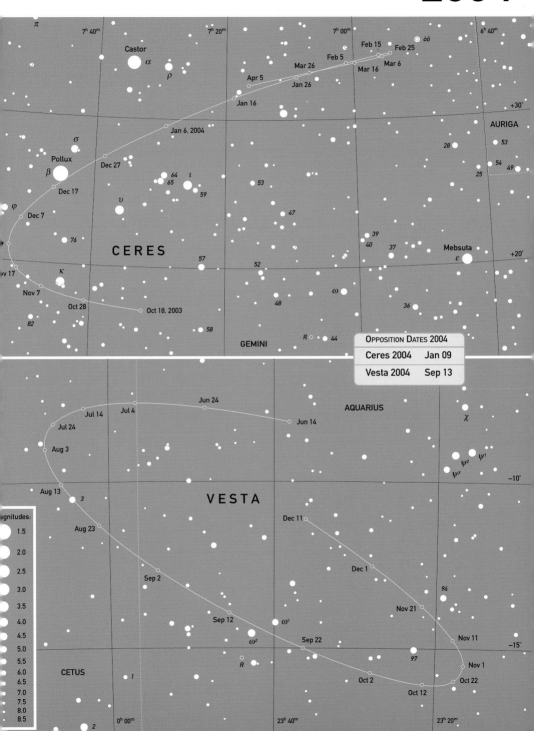

Castor α
ρ
Apr 5
Jan 16
Jan 6, 2004
Jan 26
Mar 26
Feb 5
Feb 15
Feb 25
Mar 6
Mar 16
δδ
+30°
AURIGA
28
53
54
49
25
σ
Pollux
β
Dec 27
Dec 17
Dec 7
φ
76
ν
64
65
ι
59
53
47
39
40
37
Mebsuta
ε
+20°
CERES
57
52
ω
36
Nov 17
κ
Nov 7
Oct 28
Oct 18, 2003
82
48
58
R
44
GEMINI

OPPOSITION DATES 2004	
Ceres 2004	Jan 09
Vesta 2004	Sep 13

Jun 24
Jul 4
Jul 14
Jul 24
Aug 3
Aug 13
3
Aug 23
Sep 2
Sep 12
ω²
Sep 22
R
CETUS
1
Jun 14
AQUARIUS
χ
ψ² ψ¹
ψ³
−10°
VESTA
Dec 11
Dec 1
94
Nov 21
Nov 11
97
Nov 1
Oct 22
Oct 12
Oct 2
−15°
ω¹

Magnitudes:
1.5
2.0
2.5
3.0
3.5
4.0
4.5
5.0
5.5
6.0
6.5
7.0
7.5
8.0
8.5
2

0h 00m 23h 40m 23h 20m

2005

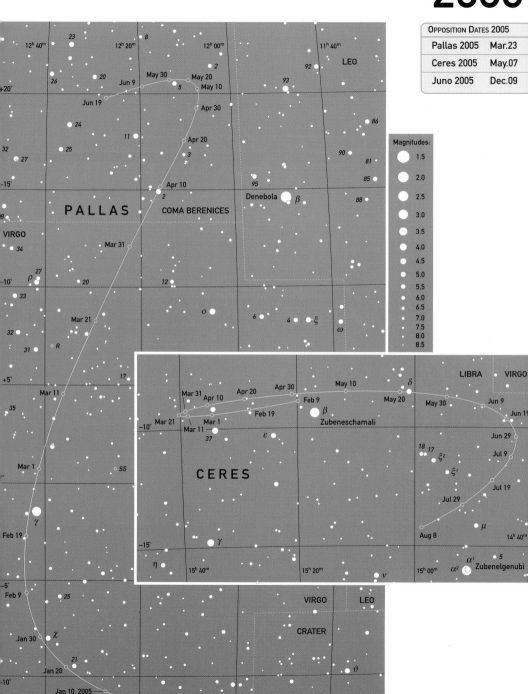

Opposition Dates 2005	
Pallas 2005	Mar.23
Ceres 2005	May.07
Juno 2005	Dec.09

Magnitudes:
1.5
2.0
2.5
3.0
3.5
4.0
4.5
5.0
5.5
6.0
6.5
7.0
7.5
8.0
8.5

PALLAS

LEO

COMA BERENICES

Denebola β

VIRGO

CERES

LIBRA VIRGO

Zubeneschamali β

Zubenelgenubi

CORVUS

CRATER

VIRGO LEO

2006

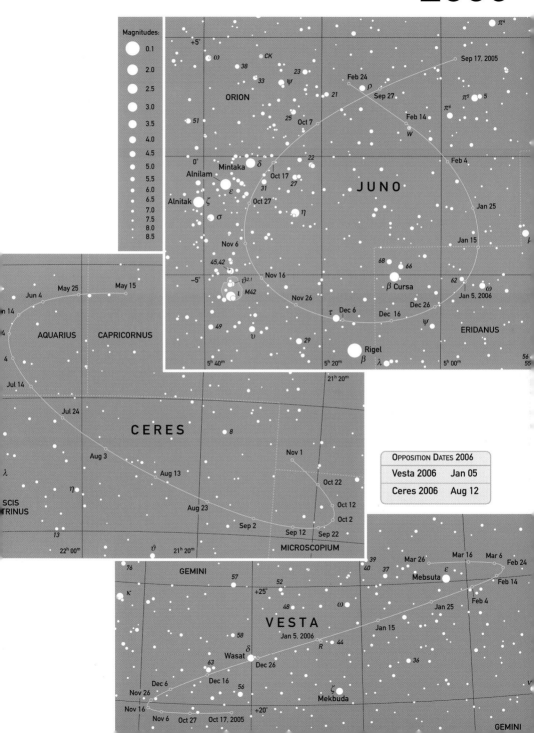

Magnitudes:
- 0.1
- 2.0
- 2.5
- 3.0
- 3.5
- 4.0
- 4.5
- 5.0
- 5.5
- 6.0
- 6.5
- 7.0
- 7.5
- 8.0
- 8.5

ORION

Sep 17, 2005

ω CK
38
33 23
ψ
51 21 Feb 24 ρ Sep 27 π⁵ 5
25 Oct 7 π⁶ Feb 14 W
Mintaka δ 22 Feb 4
Alnilam Oct 17 27 **JUNO**
ε 31 Jan 25
Alnitak ζ Oct 27 η
σ Jan 15
Nov 6
45,42 68 66
ϑ²,¹ Nov 16 β Cursa 62 ω
ι M42 Nov 26 Jan 5, 2006
49 τ Dec 6 Dec 16 Dec 26 ψ
υ 29 **ERIDANUS**
Rigel
β λ
5ʰ 40ᵐ 5ʰ 20ᵐ 5ʰ 00ᵐ 56
55

AQUARIUS May 25 May 15
Jun 4
Jul 14
CAPRICORNUS
Jul 24
λ
CERES 8
η
Nov 1
SCIS
TRINUS Aug 3
Aug 13 Oct 22
Aug 23 Oct 12
Oct 2
13 Sep 2 Sep 22
ϑ Sep 12
22ʰ 00ᵐ 21ʰ 20ᵐ **MICROSCOPIUM**
21ʰ 20ᵐ

OPPOSITION DATES 2006	
Vesta 2006	Jan 05
Ceres 2006	Aug 12

GEMINI
76 39 Mar 26 Mar 16 Mar 6
57 40 37 ε Feb 24
κ 52 Mebsuta Feb 14
48 ω Jan 25 Feb 4
VESTA Jan 15
58 Jan 5, 2006
δ R 44 36
Wasat Dec 26
63 ζ
Dec 6 Dec 16 56 Mekbuda
Nov 26
Nov 16 +20° ν
Nov 6 Oct 27 Oct 17, 2005
GEMINI

NACREOUS AND NOCTILUCENT CLOUDS

Certain unusual types of cloud are occasionally visible at twilight and during the night. These lie much higher in the atmosphere than normal clouds and are of considerable interest to scientists studying the upper atmosphere and climate change, because both types appear to have become more frequent in recent years.

The lowest type are the nacreous or mother-of-pearl clouds. Known technically as polar stratospheric clouds, they are seen at moderately high latitudes – roughly beyond 45°N or S – and occur in the stratosphere at altitudes of 15–30 km. Here they are illuminated by sunlight well after sunset or before sunrise, when lower clouds are in darkness. As their popular name suggests, they are extremely striking with beautiful iridescent colours, which normally run in bands along the clouds. The colours are produced by the diffraction of light around ice particles, and the purest colours occur where the particles are all the same size.

The highly coloured nacreous clouds occur when wave motion of the air causes rapid freezing of water vapour. A rare form, more frequently seen in the southern hemisphere than in the northern, appears white. This happens when temperatures slowly drop with the onset of winter, giving rise to fewer, larger particles, which appear white.

Noctilucent clouds (NLC) are the highest clouds of all, lying at about 80–85 km, in the atmospheric layer known as the mesosphere. They are found in two zones, lying between latitudes 45–60°N or S, approximately. Their occurrence in unpredictable, but they are visible for only a few weeks either side of midsummer, when twilight persists throughout the night. Unlike nacreous clouds, they have a distinctive bluish-white or slightly yellowish colour, and are most conspicuous about local midnight, when they appear in the twilight arch above the horizon towards the pole. They resemble the much lower cirrus and cirrostratus clouds but, like nacreous clouds, are produced by wave motion in the high atmosphere.

Noctilucent clouds are extremely tenuous and basically occur as a very thin, undulating sheet, which may be nearly invisible when overhead. Observers at a distance see brighter areas where, because of the undulations, they are looking at a greater number of cloud particles.

There are four main structural forms, known as Types:

- TYPE I: VEILS — TENUOUS FILMS, RESEMBLING CIRRUS OR CIRROSTRATUS, SOMETIMES WITH A SLIGHT FIBROUS STRUCTURE. OFTEN PRECEDE OTHER FORMS, OR OCCUR AS A BACKGROUND TO THEM.
- TYPE II: BANDS — LONG STREAKS, OFTEN IN APPROXIMATELY PARALLEL GROUPS, BUT SOMETIMES CROSSING AT A SHALLOW ANGLE. THEY MAY CHANGE IN BRIGHTNESS OVER A PERIOD OF 20–60 MINUTES.
- TYPE III: BILLOWS — CLOSELY SPACED, APPROXIMATELY PARALLEL, SHORT STREAKS. SOMETIMES APPEAR ON THEIR OWN, OR MAY CROSS THE LONGER BANDS. BILLOWS OFTEN CHANGE FORM AND PATTERN AND ALTER IN BRIGHTNESS WITHIN MINUTES.
- TYPE IV: WHIRLS — PARTIAL OR COMPLETE LOOPS OR RINGS OF CLOUD WITH DARK CENTRES. CLOSED RINGS ARE RARE.

When the Sun is low, nacreous clouds take on sunset colours

There are various subdivisions and more complex forms that experienced observers are able to recognize. Bright knots may occur, for example, where two sets of bands cross one another.

The easterly winds at this altitude generally carry the clouds towards the west, but the structures themselves often appear to move in the opposite direction. Displays are ephemeral, being quite strong one night, and completely absent the next. The reasons for the clouds' formation are poorly understood, which is why observations of their occurrence and structure are of great interest.

Noctilucent clouds may be photographed with great success. With a tripod-mounted camera, ISO 200 film, and an f/2.8 lens, try exposures of 5, 3 and 1 second. As exposures should be made at 0, 15, 30, and 45 minutes past the hour, so that photographs from different observers may be compared. Ideally, the camera position and viewing angle should be fixed, so that photographs from different sites may be used to triangulate the clouds and thus obtain the exact height.

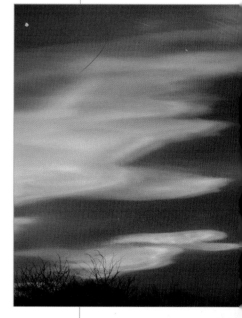

Characteristic silvery-white noctilucent clouds photographed around local midnight

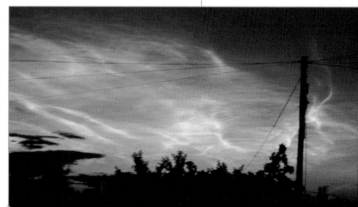

AURORAE

The polar aurorae (aurora borealis or Northern Lights, and aurora australis or Southern Lights) are some of the most beautiful of all natural phenomena. Although most frequently visible at high latitudes where they occur in ring-shaped regions (known as the auroral ovals) roughly centred on the Earth's magnetic poles, they may be seen, albeit on rare occasions, from almost anywhere on the globe.

A homogeneous arc, showing the characteristic auroral green coloration

Aurorae occur when charged particles emitted by the Sun are trapped, accelerated, and then channelled by the Earth's magnetic field so that they crash into the atoms of the upper atmosphere, normally over the polar regions, and at altitudes that generally range from 70 km to 300 km, although reaching 1000 km on occasions. The collisions excite the atoms or molecules of gas, which then radiate away the energy as light of very specific colours. The colours observers see depend greatly on their individual eyesight, but the most commonly reported colour is green, emitted by oxygen atoms, followed by red from nitrogen molecules. A violet colour is often seen when extremely long auroral rays extend high in the atmosphere and are illuminated by direct sunlight. Very weak aurorae may appear almost colourless, because the eye is unable to detect colour at low light levels.

The incidence of aurorae closely follows the so-called sunspot cycle, which is actually a cycle of solar activity, which waxes and wanes over a period of approximately 11 years. Most aurorae occur when the Sun is highly active and this can occur at any time of year. At high latitudes (Northern Europe, Siberia, Canada, and Antarctica), aurorae are, of course, invisible during the long summer twilight – but this is just the time when observers should be alert for the presence of noctilucent clouds.

There are several major auroral forms, and some (or all) of these may be seen during the course of a major display.

- **ARC (A):** AN ARCH-LIKE STRUCTURE, HIGHEST IN THE DIRECTION OF THE POLE, WITH A DISTINCT LOWER EDGE, BUT MORE DIFFUSE UPPER BORDER

- **BAND (B):** A DEEP RIBBON-LIKE STRUCTURE, FOLDED LIKE CURTAINS; OFTEN WITH RAPID MOVEMENT

- **CORONA:** A SERIES OF BROAD RAYS THAT APPEAR TO RADIATE FROM A POINT OVERHEAD

- **GLOW (G):** A WEAK GLOW ON THE POLAR HORIZON

- **PATCH (P):** A LUMINOUS AREA RESEMBLING A CUMULUS CLOUD; SEEN LATE IN A DISPLAY AND OFTEN PULSATES IN STRENGTH

- **RAY (R):** AN APPROXIMATELY VERTICAL STREAK OF LIGHT; FREQUENTLY SEEN WITH BOTH ARCS AND BANDS, BUT ALSO AS ISOLATED BUNDLES OF RAYS

- **VEIL (V):** A FAINT, EVEN GLOW OF LIGHT ACROSS A LARGE PART OF THE SKY

Arcs and bands may be:

- **HOMOGENEOUS (H):** WITHOUT STRUCTURE, BUT USUALLY WITH AN EVEN GRADUATION FROM A BRIGHT, DISTINCT LOWER EDGE TO A FAINT, DIFFUSE UPPER BORDER

- **RAYED (R):** DISTINCT, VERTICAL STRIATIONS, WITH INDIVIDUAL RAYS OFTEN EXTENDING BEYOND THE MAIN AREA OF LUMINOSITY

A homogeneous arc is thus reported as HA, and a rayed band as RB. Experienced observers also add codes to indicate colours, rapidity of motion, and include measurements of the altitude of parts of the display above the horizon. An approximate estimate of the altitude of the base of an arc or band may be made by eye, using the method described elsewhere.

You can photograph aurorae in a way similar to that described for noctilucent clouds, although it is best to use a faster film (ISO 400) because of the rapid changes that may occur. Again, make exposures at 0, 15, 30, and 45 minutes past the hour so that your images may be compared with those of other observers. Try a range of exposures (say 15–30 seconds at f/1.8). The brighter stars are often visible through an aurora, so these can be valuable reference points for estimating angles and altitudes.

SEE ALSO

measuring angles

noctilucent clouds

An early stage in the development of rayed structure in a red auroral band

ROCKETS AND SATELLITES

Not everything that is visible in the night sky is natural. Aircraft, rockets, satellites, and even meteorological balloons are often visible at twilight and may easily cause confusion, at least initially, although a short period of observation usually reveals their true nature.

SEE ALSO

fireballs (p.120)

meteors (p.116)

nacreous clouds (p.110)

noctilucent clouds (p.110)

Aircraft are usually the easiest to eliminate. When landing, and for practice purposes, both civilian and military aircraft may switch on brilliant landing lights which, if the plane is heading straight towards you, may resemble a bright, unmoving star. Usually, however, they will drift to one side or another and reveal their true nature. The red and green (port and starboard) wingtip lights and the brilliant flashing strobes carried by all aircraft can be detected at considerable distances with a pair of binoculars. Meteorological balloons are sometimes difficult to identify, and may appear light or dark, depending on their illumination and that of the background sky. They are usually slow-moving and visible for just a short period.

There are many thousands of man-made objects in orbit around the Earth, and large numbers of these are detectable, either with the naked eye, or with small instruments such as binoculars. The vast majority of satellites are visible only because they reflect sunlight, and so they tend to be seen at dawn and dusk, when they are in sunlight and the observer is in shadow. At high latitudes, where summer twilight persists even at midnight, they may be visible throughout the night. Visibility is also affected by the satellites' orbits, in particular to their inclination to the Earth's equator, which determines the range of latitudes over which the satellites are detectable.

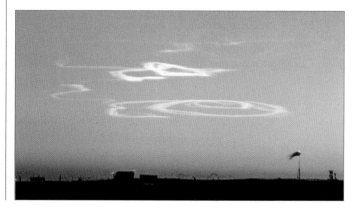

The trail, distorted by upper-atmospheric winds, left by a large meteor, seen looking south from the Falkland Islands towards the Antarctic Peninsula.

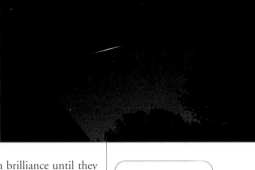

The light from some satellites may, rather than being steady, or slowly brightening and fading, consist of a series of bright flashes. This occurs when the satellite is tumbling, and occasionally presents large, highly reflective panels towards the Sun. The Iridium satellites (part of a now-abandoned mobile communications system) are not tumbling but have several extremely reflective surfaces. Their light slowly increases in brilliance until they are the brightest objects in the sky (apart from the Sun and Moon) and then slowly fades back into darkness. The International Space Station is also very bright – and getting brighter as more units are added. Predictions for such objects are often given in newspapers, and are readily available on the World Wide Web as are those for many of the fainter objects.

The satellite launchers and research rockets sometimes give rise to persistent trails that may be mistaken for high-altitude clouds. In particular, they may display brilliant iridescence (and thus resemble nacreous clouds) or show a wispy structure (looking somewhat like noctilucent clouds).

A brilliant flare, reaching magnitude -7 (far brighter than any planet), produced by one of the Iridium satellites.

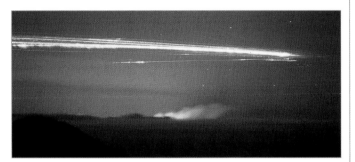

The re-entry of the large fuel tank, jettisoned by the Space Shuttle, seen from Hawaii, above the glow from an eruption of Mauna Kea.

Generally, however, upper-atmosphere winds swiftly distort the trails into highly characteristic loops and curves. Similar trails may be left by satellites as they re-enter the atmosphere and burn up. These trails resemble those left by brilliant meteors (especially fireballs) and it may sometimes be difficult to decide whether a trail has been caused by a satellite re-entry or a meteor, especially if you do not see the actual event. Again, predictions for re-entries may be found on the WWW, so satellites may sometimes be eliminated as possible candidates.

Many re-entries are highly spectacular events, particularly those of very large objects, such as the Mir space station. For those at suitably low latitudes, the re-entry of the large fuel tank that is jettisoned at each launch of the Space Shuttle is often extremely dramatic.

METEORS AND THE ZODIACAL LIGHT

Few people who have looked up into the night sky can have failed to see a meteor – a 'shooting star' – that flitted across the heavens. Some may have been lucky enough to see a really bright fireball illuminating the sky. Yet very few people will have ever seen (or noticed) the ghostly zodiacal light, which is actually closely related to meteors.

Most meteors arise when particles of cometary or minor-planetary material encounter the Earth's upper atmosphere at high speed. Friction with the atmospheric atoms and molecules causes intense heating of the outer layers and as these are blasted away, they produce the luminous trail. In the vast majority of cases, the particles are tiny – between the size of a grain of sand and that of a small pea – and are completely destroyed in the atmosphere at altitudes of approximately 70–100 km. Larger particles may survive and fall to the surface, where they may be recovered. These are known as meteorites. Most are of minor-planetary origin, but a number are known to have come from the Moon and Mars.

METEOR SHOWERS

The meteors seen on any fine night are known as sporadics. They appear at random times anywhere in the sky, and may travel in any direction. They are thus completely unpredictable. Depending on the clarity of the sky, and whether there is interference from moonlight, expect to see 5–10 sporadics every hour of continuous observing.

Far more interesting are meteor showers. These occur at regular periods each year, and arise because clusters of particles are travelling along similar orbits in space, so they encounter the Earth on essentially parallel paths. Because of perspective, however, their trails appear to originate from a single point in the sky, known as the radiant. Very occasionally, during a meteor shower, an observer looking directly at the radiant may see a meteor head-on, when it appears as a point of light that grows rapidly in brightness before fading away.

A meteor shower is named after the constellation in which its radiant lies: the Ursid radiant is in Ursa Major, for example, and the Perseid one in Perseus. One shower, the Quadrantids, is named after an obsolete constellation, Quadrans Muralis. This radiant lies in the northern region of the modern constellation of Boötes. Although a radiant position does change slightly from day to day during a shower, for our purposes it may be regarded as fixed. Radiant positions are shown on the individual constellation charts.

Because the orbits are relatively fixed in space, the Earth encounters each meteor stream at the same time every year. Most of these streams of particles have been shed by comets and, in many cases individual showers may be identified with particular comets: the Orionid meteors with Comet Halley, for example, and the Leonids with Comet Tempel-Tuttle. In the case of the Geminid meteors, visible in December, their paths are identical to the orbit of the minor planet Phaeton, from which they presumably originate.

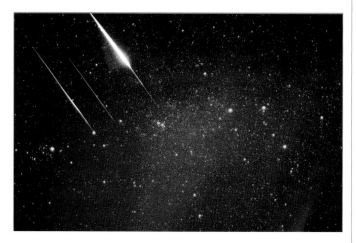

Four Leonid meteors, including one brilliant fireball. Note the 'W' of Cassiopeia, the Double Cluster, and the stars of Perseus.

Some streams are relatively compact, so the duration of the shower is very brief, but many streams consist of particles that have either been shed from comets over many orbits or have been dispersed by various forces. Such streams are often diffuse, so the shower lasts for a number of days. When the Earth encounters a stream, the number of meteors increases to a peak (the maximum), usually on a specific day. Some peaks are extremely sharp, with a rapid rise and an equally steep decline, and some may be defined to the nearest minute. Such narrow peaks may be poorly observed in certain years because they occur over the ocean, where there are few observers, or when there is bright moonlight.

METEOR SHOWERS					
NAME	MAXIMUM	NORMAL LIMITS	RADIANT		ZHR
			RA	DEC	
Quadrantids	Jan.04	Jan.01–06	15 28	+50	100
Lyrids	Apr.22	Apr.19–25	18 08	+32	10
η Aquarids	May.05	Apr.24–May.20	22 20	-01	35
δ Aquarids	Jly.28 (double radiant)	Jly.15–Aug.20 Aug.06	22 36 22 04	-17 +02	20 10
Perseids	Aug.12	Jly.23–Aug.20	03 04	+58	80
Piscids	Sep.08 (triple radiant)	Sep.–Oct Sep.21 Oct.13	00 36 00 24 01 44	+07 00 +14	10 5 ?
Orionids	Oct.21	Oct.16–26	06 24	+15	25
Taurids	Nov.03	Oct.20–Nov.30	03 44	+14	10
Leonids	Nov.17	Nov.15–20	10 08	+22	?
Geminids	Dec.13	Dec.07–15	07 28	+32	100
Ursids	Dec.22	Dec.17–25	14 28	+78	10

Extended streams may be particularly interesting, because often a core of large particles is surrounded by a more diffuse outer region of smaller ones. Tiny particles produce faint meteors, whereas larger ones give brighter meteors. Noting the brightness of meteors therefore gives an idea of how the different-size particles are distributed in space.

Calculating meteor numbers is slightly complicated, because faint meteors are difficult to see close to the horizon, where their light is absorbed by the atmosphere. In addition, a faint meteor may be missed if it appears at the edge of one's field of view, whereas a bright one attracts attention. In addition, more meteors are seen after midnight, because the Earth's orbital velocity, combined with its rotation, increase the relative velocity of the meteor and the atmosphere, and the numbers that are encountered. Organisations that collate amateur observations have developed methods to correct for these effects, and are able to calculate a zenithal hourly rate (ZHR),

which gives the rate that would be recorded in one hour by an ideal observer, under perfect conditions, if the radiant were at the zenith. The ZHR given in the table is, therefore, an idealized rate. In practice, expect to see fewer meteors per hour and to find considerable variation from year to year.

The Leonids normally have a ZHR of about 15, but occasionally the number increases dramatically to give a meteor storm. Leonids are associated with Comet Tempel-Tuttle, which has an orbital period of approximately 33 years. Leonid storms tend to occur at 33-year intervals, having been seen in 1799, 1833, 1866, and particularly in 1966, when the ZHR became so high that counts were impossible, but when it was estimated to have been at least 100,000 for about 40 minutes. High numbers are also often encountered in the years immediately preceding and following the main return. The peak Leonid rate in 1999 was about 2500–3000, lasting for about 15 minutes; in 2000 there was a broad plateau of about 200–250, with two narrow separate peaks of about 300 and 500. At the time of writing the 2001 return is expected to be similar to that in 1999.

OBSERVING METEORS

Ideally, the best conditions for seeing meteors are when the radiant is high in the sky, it is New Moon, and after local midnight. Naturally, ideal conditions rarely apply, and some years even major showers may be difficult to observe. It is best to watch an area of sky, away from the horizon and its atmospheric extinction, say at altitude of 45°, and 45° from the radiant. Note down the time, shower membership (or sporadic) and magnitude, either estimated to 0.5 mag, or relative to specific stars in the field (recording their identifications, so that you can check their magnitudes later).

How do you tell whether a particular meteor belong to a specific shower or is just a sporadic? For this you need to determine the track of the meteor, and extend it backwards. If the path originates from a circular area, with a radius of 4°, centred on the radiant, then the meteor is assumed to belong to the shower. It needs some experience to do this properly, because the paths are actually great circles on the celestial sphere. Dedicated meteor observers use special star charts, drawn with a particular projection, on which the paths of meteors are straight lines. Unfortunately, the constellations appear greatly distorted, so such charts are only suitable for meteor work.

It makes it easier if you hold a piece of string or a stick up to the sky along the visible track. You can then mentally extend the path backwards across the sky. It also helps that shower meteors tend to be similar. If you are observing in early January and see a bright bluish meteor that appears to come from the top of Boötes and another fainter reddish one that comes from lower in the same constellation, you can be fairly sure that the first is a Quadrantid, and the second a sporadic.

FIREBALLS

Fireballs are brilliant meteors that are brighter than magnitude -5, and thus brighter than even Venus or Jupiter. The very brightest may be brighter than the Moon and visible in daylight.

Observations of these objects are exceptionally important, because they may produce meteorites, and accurate knowledge of the track could help to pin-point where these might be found. Record the time, and the altitude and azimuth of the start and end points. (You can measure these with sufficient accuracy with a compass that also has a clinometer for measuring vertical angles.) Major fireballs may produce a sonic boom, so wait several minutes, and record the time if you hear anything. This will help to establish the distance to the track.

THE ZODIACAL LIGHT

Under clear conditions in spring, about 90 minutes after sunset, it is sometimes possible to see a faint cone of light stretching up from the western horizon. This is the zodiacal light, which is actually an elliptical area, centred on the Sun, with its long axis extending along the ecliptic. It is also visible above the eastern horizon in autumn some 90 minutes before sunrise. At these periods of the year the ecliptic makes the greatest angle with the horizon, and the zodiacal light is easiest to see. It arises through the scattering of light by tiny interplanetary particles that lie inside the orbit of the Earth.

On occasions when there are exceptionally good seeing conditions – nowadays normally found only from a high mountain site – a faint glow

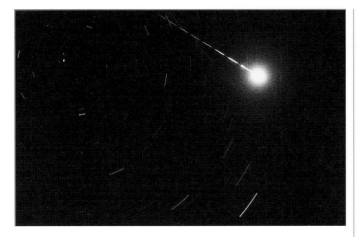

A special rotating shutter was used to create breaks in the trail of this brilliant, exploding fireball (a bolide), so that its speed could be determined.

is sometimes visible directly opposite the Sun in the sky. This is the gegenschein, which is also caused by the scattering of light from interplanetary particles, but this time ones that are outside the orbit of the Earth. On exceptionally rare occasions, with perfect seeing and dark conditions, people with keen eyesight may be able to make out an extremely faint band of light, running across the sky, linking the gegenschein with the zodiacal light.

The pale zodiacal light, photographed with a time exposure, during which slight fluctuations in the telescope's drive caused the star trails to appear irregular.

COMETS

Bright comets, like Comet Hale–Bopp, which was visible to anyone who cast a glance at the sky over a long period of 1997, are very rare. They may be expected just once or twice a century. Yet there are usually several comets in the sky at any time, but the majority are too faint to be readily visible with the naked eye.

Most comets follow highly elongated elliptical orbits around the Sun with orbital periods reckoned in hundreds or thousands of years. Some cometary orbits resemble an open-ended parabola or hyperbola, and such comets never return to the inner Solar System. Somewhat arbitrarily, comets with periods of less than 200 years are known as 'periodic'. Of these, only one, Comet Halley (period approximately 76 years), is normally bright enough to be readily seen at each return.

Cometary orbits have random orientations in space, unlike the orbits of the planets. As a result, non-periodic comets may appear at any time, anywhere in the sky. Because of these random orientations, comets may plunge rapidly across the sky never growing very bright, or linger in one or other hemisphere, like Comet Hale–Bopp, remaining a conspicuous object for weeks at a time.

Comets are colourfully described as 'dirty snowballs' – bodies consisting of ice and dust just a few kilometres across. When a comet approach-

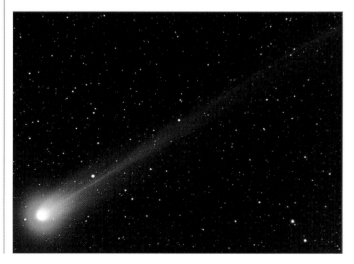

Comet Hyakutake, seen in 1996, had a straight blue gas tail and a spherical coma surrounding the invisible nucleus.

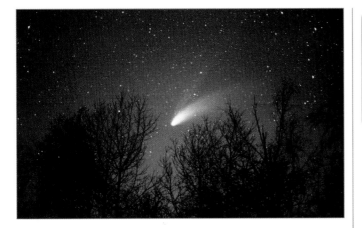

Comet Hale-Bopp, visible for months in 1997, showed two distinct tails: a blue gas tail and a yellowish dust tail.

es the Sun, the various ices sublime – turn directly into a gas, without a liquid phase – releasing jets of gas and dust from the cometary body.

The material released fills an approximately spherical region around the comet, brightest at the centre and becoming fainter and more diffuse towards the outside. This region is known as the coma, and is visible in all comets. In contrast to the tiny cometary body, the coma is generally thousands of kilometres in diameter. In binoculars or small telescopes the coma normally appears as a featureless fuzzy patch on the sky. In some comets, the jets of gas and dust are particularly bright, giving rise to a brilliant point of light (the nucleus) in the centre of the coma. Not even the largest telescopes reveal the nucleus as anything more than a point of light.

The tail is generally the most conspicuous and variable part of a comet. As a comet approaches the Sun, and heating becomes greater, more and more gas and dust are released. These are swept away by the solar wind – a flow of charged particles from the Sun – and form the tail. Because they are controlled by the solar wind, tails always point away from the Sun, so actually precede comets on their outward journey after perihelion.

Some comets have no tails at all or, at the most, extremely faint ones. One famous example is Comet IRAS-Araki-Alcock, which made an extremely close approach to the Earth in 1983, when it simply looked like a fuzzy spherical patch, some 2° in diameter (about four times the apparent diameter of the Moon), as it raced across the northern sky. Other comets may show one or more types of tail. Comet Hyakutake in 1996, for example, showed a single, straight, blue gas tail. Such gas tails are controlled by the solar wind and the Sun's magnetic field, and are generally straight, although changes in the magnetic field may lead to kinks (known as disconnection events) that travel outwards along the tail.

Some comets have just dust tails. Although many are merely small extensions of the coma, some are much more conspicuous than gas tails, and extend far across the sky. When bright, they usually show a yellowish colour, which is actually the colour of sunlight being reflected from the minute dust particles within the tail. Depending on the relative positions of the Earth, Sun, and comet, dust tails may appear as broad, curved, scimitar-shaped fans of material, or relatively straight streaks. The dust particles form a thin sheet lying in the comet's orbit. On occasion, our line of sight may pass through part of the tail, leading to the appearance that the comet has a sunward 'spike' or antitail.

Many comets have both types of tail, and although the colours are often difficult to detect with the eye, photographs (such as those of Hale-Bopp) frequently capture the striking difference between the gas and dust tails. The former is usually the narrower and, in some comets, may be doubled. Multiple dust tails are also observed occasionally.

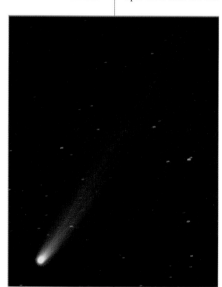

Comet Ikeya-Zhang, seen in 2002, had a bright coma and distinct blue rays within its tail.

Apart from the angle at which we see a comet's tail, its size depends strongly on the comet's activity. Comets that are making their first approach to the Sun, tend to be more active and have more striking tails, whereas periodic comets that complete many orbits lose much of their volatile ices and are relatively quiescent, or eventually become extinct. Some comets break up into fragments, creating families of comets that follow similar orbits around the Sun. The 'sun-grazing' group, which make very close approaches to the Sun at perihelion, appear to have arisen in just this way.

The individual dust particles shed by comets follows similar orbits to their parent comet. If the Earth encounters a relatively compact stream of dust, it gives rise to a meteor shower. Gradually, however, the particles become too widely dispersed for them to be obviously associated with any particular comet. This is the origin of the vast majority of sporadic meteors that may be seen on any clear night, and also of the minute particles that scatter sunlight and produce the zodiacal light.

The differences in activity of a cometary nucleus are largely the reason why it is notoriously difficult to predict how bright a comet is likely to become, as well as the prominence of any tail. Even for well-studied comets, any predictions of their likely magnitude should be treated with caution.

Making actual estimates of the brightness of a comet is also extremely difficult, because, unlike a star, it is an extended object. Predicted magnitudes normally take an integrated magnitude over the whole of the coma. (A similar problem arises with the magnitude of galaxies and other deep-sky objects.) Experienced observers are able to make reasonably accurate estimates by using defocusing techniques that make stellar images resemble the fuzzy outline of the coma, but an accuracy of about 0.5 magnitude is about the best that may be obtained by visual methods.

OBSERVING COMETS

Most handbooks and yearbooks carry ephemerides (predicted positions) for the brightest periodic comets. Most are, however, too faint to be visible in small telescopes or binoculars. Bright, non-periodic comets arrive without warning, but details are usually given in various astronomical journals, and the most spectacular – or those that are predicted to be so – may well make the newspapers or radio and television news. Serious amateurs subscribe to various early-warning services, which provide information on all major astronomical discoveries.

You can use any equipment for observation, but it is often easier to detect the extent of tail with the naked eye, binoculars, or wide-field telescopes rather than with larger telescopes. Ensure that you are properly dark adapted and remember that averted vision may also help. It is worth trying some photography. This will record both the actual position of the head, and may capture the tail or some of its structure when it is too faint to be seen by eye. Wide-field, fast lenses are required for this work, while telescopes or long-focus cameras are needed to record details of the coma. To obtain the best results the equipment should be guided to follow the motion of the comet itself, when the background stars will show as trails. Short-focus lenses may be driven to follow the stars.

Many advanced amateurs undertake comet searches, but this requires an immense degree of patience to learn the star patterns and possible confusing objects such as clusters and galaxies over a large area of the sky. Wide-field, large binoculars or short-focus telescopes are normally employed for this sort of work, and searches are often carried out in the region near the Sun where a comet may approach very close to the Sun and Earth without being detected.

SEE ALSO

averted vision (p.135)

dark adaption (p.8)

meteors (p.116)

zodiacal light (p.120)

STARS

To the untutored eye, stars are just points of light on the sky. About the only thing obvious to casual observers is the fact that they are of different brightness, and a few show different colours. In actuality, there are many different types of stars, of various colours, in a vast range of sizes, and which occur singly, as pairs or multiples, and in different types of clusters. Some – among them the most fascinating – show appreciable changes in magnitude.

R Leporis (a long-period variable) is one of the reddest stars in the sky.

The colours of stars are directly related to their surface temperature, and these temperatures are measured in Kelvins (K), as explained in the glossary. The hottest, blue-white stars have searing temperatures as high as 50,000 K; white stars, such as Vega, temperatures of about 10,000 K; yellow stars, like the Sun, temperatures about 6000 K; and the coolest, deep red stars temperature of 2500–3000 K. The temperatures of a few well-known stars are shown in the table.

STAR COLOURS AND TEMPERATURES		
Rigel	Blue-white	11,550 K
Vega	White	9,960 K
Sun	Yellow	5,800 K
Arcturus	Orange	4,420 K
Betelgeuse	Red	3,450 K

Stars also vary greatly in their physical size. For historical reasons they are divided into dwarfs (like the Sun), giants, and supergiants. The Sun is a medium-sized star about 1,400,000 km across. Giants are about 10 times that size, and the largest supergiants may be as much as 1000 times the diameter of the Sun. Some readily visible giant and supergiant stars are shown in the tables. At the other end of the scale are white dwarfs, red dwarfs, and brown dwarfs, which are just a few thousand kilometres across.

SUPERGIANT STARS			
α Aquarii	β Aquarii	η Aquilae	ζ Aurigae
α Camelopardalis	δ Cephei	α Cygni	μ Cephei
R Coronae Borealis	ζ Geminorum	α Herculis	α Orionis
β Orionis	ε Pegasi	α Scorpii	α Ursae Minoris

SEE ALSO
planetary nebulae
(p.139)

None of these small stars, nor the even smaller neutron stars (20–30 km across), are visible with amateur-sized telescopes, although some CCD images obtained with large amateur telescopes are able to show the white dwarfs at the centres of certain planetary nebulae.

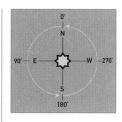

GIANT STARS			
α Aurigae	W Boötis	β Cancri	ι Cancri
α Ceti	o Ceti	ν Coronae Borealis	η Geminorum
ν Geminorum	α Hydrae	R Hydrae	U Hydrae
ζ Leonis	α Lyncis	δ² Lyrae	π Pegasi
94 Piscium	α Tauri	γ Ursae Minoris	α Vulpeculae

DOUBLE AND MULTIPLE STARS

Many stars that appear as single points of light to the naked eye or with small instruments prove to be double or even multiple when examined under higher magnification with larger instruments.

Sometimes the stars are at very different distances and merely happen to lie close to the same line of sight. Such objects are known as optical, or visual doubles. In many cases, however, the stars are actually bound together gravitationally and orbit their common centre of mass. These are known as binary (or multiple) systems. The relative positions of the stars on the sky alter extremely slowly, however, and only the most dedicated and experienced observers, using large instruments, would be able to detect any changes, even observing over decades.

Gamma Leporis is a wide double and its components have strikingly different colours.

Gravitationally bound, multiple systems containing 3, 4, 5, or even more stars are known. In binary systems, the brighter star is always known as the primary, and the fainter as the secondary, sometimes also known as the comes. Another method denotes the stars as the A and B components, respectively. For multiple systems the lettering sequence is continued. The positions of the secondary or other components relative to the primary are given by the position angle, measured in degrees from north, through east, south and west, and by the separation (usually seconds of arc).

VARIABLE STARS

Variable stars are some of the most fascinating objects in the sky. Their study is one field in which amateurs with any size of instrument – even low-power binoculars – may make an extremely important scientific contribution, so they are worth considering in some detail. There are, however, so many different types of variable that only a few may be discussed here.

Some variables change their magnitudes over periods of many years, others days, and yet others fluctuate too rapidly for the eye to see. Some, including various stars visible with binoculars, vary by several magnitudes, and are thus easy to see, whereas others have such minute variations that they are only detectable by the most sophisticated detectors used on giant professional telescopes. Supernovae, which are classed as variables, are titanic stellar explosions, in which the whole star is disrupted, and where, for a short period, a single star may be brighter than the whole of its parent galaxy, consisting of hundreds of thousands of millions of stars.

ECLIPSING VARIABLES

There are two broad types of variable star, and we may start with those known as extrinsic variables. These are stars, where the variations in magnitude largely arise through mechanical means: generally through orbital motion in binary systems. The most numerous are eclipsing binaries, which are binaries where the orbital plane more-or-less coincides with our line of sight. As the stars orbit one another, from time to time one star passes in front of the other, causing a drop in the combined light from the pair. The most famous such system is Algol, β Persei, where the fainter star (the secondary) passes in front of the brighter (the primary) every 2.87 days, causing a readily perceptible drop in magnitude. Such an eclipse is known as a primary minimum, because it is the primary that is eclipsed.

Depending on the relative size of the stars, the separation between them, and the orbital inclination, the brighter star may also eclipse the fainter

secondary, producing a small drop in the combined magnitude. These secondary minima do not occur in every eclipsing system, and are sometimes too faint to be readily detectable. A secondary minimum does occur in Algol, for example, but it too faint to be detectable by visual means.

In an Algol-type (or EA) system, the components are relatively far apart, and the stars are essentially spherical. This produces eclipses that begin and end relatively abruptly. If the secondary star completely hides the primary, in a total eclipse, the primary minimum has a flat bottom, during which the magnitude remains constant.

Many other eclipsing binaries, however, are so close together that the two stars are gravitationally distorted and are no longer spherical. They have equatorial bulges that point towards the companion star. A moment's thought will show that as the two stars revolve around their common centre of gravity, the visible surface area constantly changes. So even outside eclipses, the magnitude varies. Although primary and secondary eclipses occur, they show more gradual declines and rises than Algol-type systems. The type star for this class of variables (EB) is β Lyrae, which has a primary minimum every 12 days 22 hours, and there is a distinct secondary minimum half an orbital period later.

There is another class (known as EW), where the stars are extremely close together – in fact they share a common outer envelope – and a similar size. Apart from continuous variation, the primary and secondary

Comet Hale-Bopp and Perseus. The famous variable, Algol, β Persei, is the bright star above and left (north following) the head of the comet. The orange star south following Algol is ρ Persei, a semi-regular variable.

minima are of almost identical depth. These stars are generally studied by photoelectric methods. The type star is W Ursae Majoris, with a period of about 0.3336 days. (The periods of variable stars are often given in decimal days for ease of calculation.)

Intrinsic variables

Intrinsic variables form the other broad group. Here the magnitude variations arise because a star's luminosity actually changes. There are various mechanisms by which this can occur, so intrinsic variables are roughly sub-divided into eruptive, pulsating, and cataclysmic variables. (Note that there many minor classes of variables, some of which exhibit both extrinsic and intrinsic variations.)

Eruptive variables

Many of the variable stars that come under this heading are young stars that show irregular variations with very small amplitudes, which are difficult to study visually. Others are flare stars that have sudden outbursts that last a few minutes at the most. There is, however, one class, the R Coronae Borealis variables (RCB), which is extremely important. These stars are actually pulsating supergiants, but the pulsations are not the most important feature. At completely unpredictable intervals, the stars fade dramatically as the light is absorbed by a cloud of carbon particles close to the star. Depending on the star, the fades range from 1–9 mag. and their duration may be between a few tens of days and a few years. Amateur observers carry out an important job by keeping these stars under surveillance and issuing an alert when they begin to fade, warning the professional astronomers, who are then able to study them with large telescopes and sophisticated equipment.

Pulsating variables

Large numbers of stars change in luminosity because they pulsate – expanding and contracting like giant balloons. The most important class are the Cepheid variables, named after δ Cephei. These stars (described more fully under Cepheus) are highly luminous supergiants that may be detected in external galaxies, and used as distance indicators: an essential step in determining distances in the universe. There are several related classes, and the Pole Star, α Ursae Minoris, shows similar variations, but with a lesser amplitude, which is not detectable visually.

The long period variables (LPVs) are some of the most interesting stars to follow. Many have large amplitudes (2.5–10 mag.), so their vari-

SEE ALSO
binary stars
(p.127)

ations are easy to detect. They are red giants and their periods range between 100 and 1000 days. Unlike Cepheids, where the variations are exceptionally regular, these stars show fluctuations in both the magnitude at maximum and minimum, and also in their periods. Averaged over time, however, the periods remain consistent, with a typical period of about 300 days to a year. This is the case with the type star, Mira, otherwise known as o Ceti. It was the first variable star to be discovered, in 1638, when Holwarda realized that it brightened and faded with a period of 330 days. It has been under continuous study ever since. Although commonly called LPVs, the correct variable-star designation for these stars is class M.

Semiregular variables (SR) are similar to LPVs, in that they are red giants and supergiants. Although they show intervals of periodicity, and averaged

BELOW LEFT: Wide-field chart for Mira.
BELOW RIGHT: Large-scale chart for Mira.

COMPARISONS FOR o CETI (MIRA)					
A = α Ari	2.2	J = ξ² Cet	4.4	S	6.4
B = β Cet	2.4	K = μ Cet	4.6	T	6.7
C = α Cet	2.7	L = λ Cet	4.9	U	7.3
D = β Ari	3.0	M = ν Cet	5.1	W	8.0
E = γ Cet	3.6	N = 75 Cet	5.4	X	8.6
F = α Psc	3.8	P = 70 Cet	5.5	Y	8.8
G = δ Cet	4.1	Q	5.7	Z	9.2
H = ξ¹ Cet	4.3	R	6.1	AA	10.0

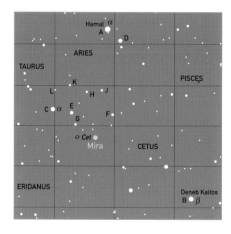

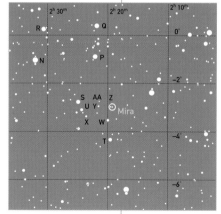

over a long time, mean periods may be obtained, they exhibit various degrees of irregularity. Many are bright, and their only partly predictable behaviour makes them ideal subjects for amateur study. V465 Cas and W Cyg are typical examples. There are various sub-classes, which cannot be described in detail here.

Corona Borealis, showing R CrB at maximum. The star and its comparisons may be identified from the chart and comparisons shown on pp.174-175.

Somewhat similar to the semiregulars are the RV Tauri stars (RV). These tend to show alternating primary and secondary minima, which occasionally interchange places. R Scuti is an excellent example of the RVa sub-class, with a mean period of 146.5 days. A second sub-class (RVb) shows a superimposed, longer, secondary period, affecting both maximum and minimum. RV Tauri itself is of this second type, but rather faint for small instruments. U Mon is a brighter example.

Cataclysmic variables

Another extremely varied group of variable stars show sudden outbursts. Most are close binary systems, where the eruptions arise from the flow of material from one star to the other. With the exception of novae and supernovae, most of these stars are unfortunately too faint to be studied with small instruments. One class, the dwarf novae or U Geminorum stars, is extensively studied by experienced amateurs, but the brightest, SS Cygni, is normally at magnitude 12.4, and reaches magnitude 7.7 at most during an eruption. A related class of stars, the symbiotic or Z Andromedae stars, are binaries consisting of one very hot star and one cool one. The brightest example, CH Cygni, is readily observed with binoculars and exhibits occasional long-lasting outbursts.

Novae

Novae are binary systems in which one star sheds material that falls onto the surface of the second star, a white dwarf. Eventually a layer of hydrogen reaches sufficient density and temperature for nuclear fusion to suddenly ignite, giving rise to an eruption. This typically causes the star to brighten,

typically by 7–11 magnitudes, or more, in just a few days. (The record is 19 magnitudes for Nova Cygni 1975.) Unfortunately, nova outbursts are completely unpredictable: no one knows where or when to look. Some dedicated amateurs carry out searching for novae, with considerable success, but such work requires great experience and a thorough knowledge of the sky.

Once novae have been found they are the subject of intense observation by both amateur and professional astronomers, and amateurs often monitor old novae for later behaviour. Novae (N) are sub-divided into three classes: fast novae (NA) with a rapid rise and fast decline, dropping by 3 mag. in 100 days or less; slow novae (NB), which take 150 days or more to decline 3 mag. from maximum and often show a distinct dip and recovery part-way into the fade; and very slow novae (NC) with very slow rises, perhaps lasting a decade, and extremely slow declines. One such NC object, which had an outburst in 1870, AG Peg may be observed with binoculars.

SEE ALSO ·
binary stars (p.127)

supernova
remnants (p.140)

Supernovae

As with novae, supernova explosions (SN), which cause a rise of 20 magnitudes or more, are unpredictable. During their outburst the star is completely destroyed.

There are two Types: in Type I, the white dwarf in a binary system is the site of explosive carbon burning, which completely destroys the star, and may disrupt the binary; in Type II, a single star, at least 10 times the mass of the Sun, exhausts its sources of nuclear energy. As a result, its core collapses, the outer layers initially fall inwards but then rebound, flinging the stellar material into space. Supernova explosions are rarely seen in the Galaxy, because they are obscured by the dust in the galactic plane, but are frequently observed in external galaxies. The nearest recent supernova, SN 1987A, occurred in the Large Magellanic Cloud, visible from the southern hemisphere.

Dedicated amateurs carry out searches for supernovae. In the past, great patience was required to conduct visual searches, but with the advent of affordable CCD cameras, amateurs have scored a remarkable number of successes. As with novae, these stars are a subject of intense interest for professional astronomers, so early notification of such an event is of great value.

OBSERVING VARIABLE STARS

Monitoring a star to see if it changes brightness might sound a boring thing to do, but once you start to detect variations, it can become fascinating. Finding a star blazing like a beacon after seeing it faint for weeks or, conversely, having seen R Coronae Borealis at maximum for months on end, suddenly realizing that it has completely disappeared, is both a shock and a thrill.

Detecting changes in the magnitude of a star requires it to be compared with comparison stars, of known (unchanging) magnitude in the vicinity. To prevent errors, variable-star organisations use a specific chart for each variable, showing the set of comparisons (known as a sequence) that is to be used. A number of such charts are shown here and in the descriptions of the individual constellations.

There are various methods of making an estimate, but the simplest for beginners is known as the 'Fractional Method'. Determine which pair of comparison stars bracket the variable in brightness, then estimate the ratio between the brightness intervals: 1:1 (halfway), 1:2, 1:3, 1:4, 2:3, 2:1, etc. This is then recorded as 'A(1)V(1)B', 'A(1)V(2)B', etc., where 'A' is the brighter star, 'B' the fainter, and 'V' the variable. Record this information, with the date and time (to the nearest minute). At a later stage, you can calculate the actual magnitude of the variable from the known magni-

COMPARISONS FOR **R Sct**:

A = λ Aql	3.41	E = 14 Aql	5.41	K	7.56
B = α Sct	4.05	F	6.23	L	8.00
C = β Sct	4.40	G	6.50	M	8.31
D = η Sct	4.99	H	7.07	N	8.62

Comparison chart for R Sct.

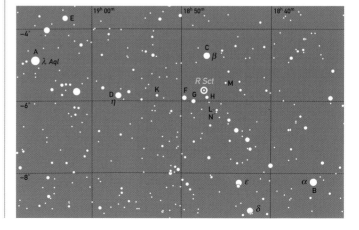

tudes of the comparison stars. Sequences often give magnitudes to two decimal places, but the estimate should be rounded to a single decimal place after calculation.

It is important to ensure that you always record the comparison stars, rather than making a direct estimate of the brightness, and just recording that. With details of the comparisons, it is always possible to correct the observation at a later date, if an error is discovered in a magnitude, or if a comparison turns out to be an unexpected variable itself – perhaps an eclipsing binary with an extremely long period.

This procedure is surprisingly accurate and even beginners soon learn to make estimates that are accurate to 0.1–0.2 mag. Accuracy is affected by the colour of a star, particularly in the case of red stars, which gradually seem brighter if you stare at them. Experienced observers avoid this by taking quick glances of the variable.

A trick for observing faint stars (and other objects such as nebulae and galaxies) is to use averted vision. Don't stare directly at the star (or where it should be). Look slightly to one side of it, and it may well come into view. This works because the region away from the centre of the retina is actually more sensitive to faint light.

JULIAN DATES

To avoid the problems caused by our civil calendar, and make it easier to calculate the periods of variable stars, and derive predictions, variable star observers use a different dating system, known as the Julian Date. This is continuous sequence of numbers from a starting date (January 1 of the year 4713 BC), chosen to predate any possible observations, and also when certain lunar, solar and civil calendars coincided. Note, however, that Julian Dates are reckoned from 12:00 UT (noon), not midnight. Handbooks and yearbooks usually give a table of Julian Dates for day zero of each month. That means that if you observe after 12:00 UT on the first of the month, you add 1 to the figure given; on the 5th, you add 5; etc. The JD for 2002 Jan.01, for example, is 2,452,276, often written '2452 276'.

Similarly, variable-star observers also use decimal days, converting the hours and minutes into a decimal fraction. Again, most handbooks give such a table. Calculating periods between minima or maxima now becomes a simple matter of subtracting one date from another.

CLUSTERS

Apart from binary and multiple systems, stars also occur in clusters. There are two distinct types: open clusters and globular clusters. These have very different characteristics.

OPEN CLUSTERS

Open clusters are loose concentrations of stars, which may number from about ten to a few hundred. These groups of stars have all formed in a single region of space, in one of the giant clouds of gas and dust that are the birthplaces of stars. A cluster of hot young stars is often found in the centre of a gaseous nebula, and the Trapezium stars that illuminate the great Orion Nebula are a typical example. Here the stars are so young that they have remained close to the site where they were born. Some groups, such as the Pleiades cluster in Taurus, have moved away from their birthplace, but retain some remnants of dust, whereas others consist of isolated stars with no signs of gas or dust.

M11, the 'Wild Duck' open cluster in Scutum, not far from the variable star R Sct.

The colours and luminosities of stars alter as stars age, and many older clusters may consist of a group of yellow (or even redder) stars and just one or two hot blue stars. Because the stars are weakly gravitationally bound to one another, however, open clusters gradually disperse, sheared apart by the rotation of the Galaxy, until eventually the stars mingle with the overall stellar population. Old clusters are therefore much looser than young ones. The relationships linking some groups of stars are not apparent on the sky, but only appear when their distances and motions within the

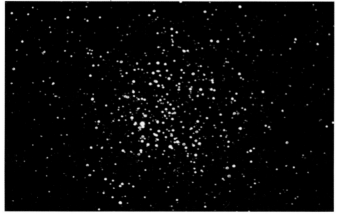

Galaxy are determined. Some of the brightest open clusters are listed in the table on p.233, and more details of many are given in the individual constellation descriptions.

GLOBULAR CLUSTERS

Globular clusters are a complete contrast to open clusters, because they consist of spherical concentrations of stars, often very compact, and containing hundreds or thousands of stars. All globulars therefore tend to look relatively similar. There are, of course, differences, in that some are more extended than others and the stars appear less densely packed together. Although the density of stars in globulars is very high, appearances are somewhat deceptive, and the very largest telescopes (including the Hubble Space Telescope) are able to detect stars as individual objects, even right in the heart of the clusters.

Also unlike open clusters, the stars in globulars are gravitationally bound to the cluster as a whole. Strangely, because of the interactions between all the different stars, over extremely long periods of time some stars achieve a high enough velocity to escape from the cluster, carrying some energy with them, and causing the cluster as a whole to shrink and become more compact.

Another basic difference is that the stars within globular clusters are some of the oldest in the Galaxy, around ten thousand million years old. Globulars occupy a gigantic spherical halo that extends far beyond the disk of the Galaxy, and the clusters are believed to be the earliest units to be formed when the Galaxy itself was created. Because high-mass, high-luminosity stars evolve much faster than low-mass stars, the majority of stars in globular clusters are ancient, faint, red, low-mass stars.

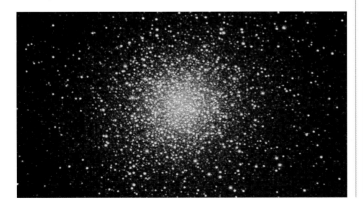

The globular cluster M13, in Hercules, is the brightest visible in the northern hemisphere of the sky.

NEBULAE

Some of the most beautiful objects in the sky are the glowing clouds of gas that are found in gaseous and planetary nebulae. Supernova remnants similarly consist of gas, but few are visible with amateur-sized instruments. Less spectacular are the dark nebulae created by dense clouds of dust.

GASEOUS NEBULAE

Gaseous nebulae (sometimes known as diffuse nebulae) are glowing clouds of hydrogen gas and are regions where new stars are being formed. These young stars are extremely hot and emit large amounts of ultraviolet light which excites the hydrogen gas and causes it to glow. In many cases the stars may be seen as an open cluster in the centre of the gaseous nebula itself. Some nebulae are only the visible part of a gigantic interstellar cloud of gas and dust. The Orion Nebula is one example of this, being just a tiny portion of a vast cloud, covering the whole of the constellation of Orion, which is detectable at infrared wavelengths.

Like open clusters, gaseous nebulae are concentrated towards the main plane of the Galaxy, and a similar situation is found in distant spiral galaxies, where the gaseous nebulae are conspicuous objects in the spiral

BRIGHT GASEOUS NEBULAE					
OBJECT	CONST.	RA	DEC	M	NAME OR NOTES
M 8	Sgr	18 03.8	−24 23	6.0	Lagoon Nebula
M 17	Sgr	18 20.8	−16 11	7.0	Omega Nebula
M 42	Ori	05 35.4	−05 27	4.0	Orion Nebula
NGC 2237	Mon	06 32.4	+04 52	4.8	Rosette Nebula
NGC 6960	Cyg	20 45.7	+30 43	−	Veil Nebula
NGC 6992	Cyg	20 56.4	+31 43	−	Veil Nebula
NGC 7000	Cyg	20 58.8	+44 20	-	North America

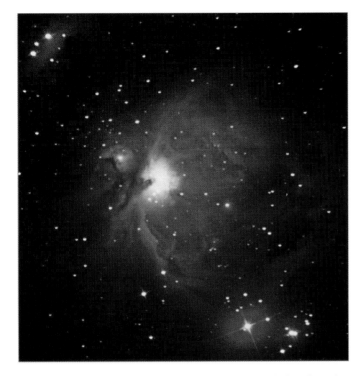

arms, easily detectable because of their distinctive pinkish colour that arises from hydrogen emission.

PLANETARY NEBULAE

Unlike gaseous nebulae, which are associated with star-birth regions, a planetary nebula is produced towards the end of a star's life. Stars that have similar masses to that of the Sun eventually become red giants. Towards the end of the red-giant phase, the stars shed shells of material into space. Subsequently, the star itself shrinks to a small white dwarf. Planetary nebulae are these shells of glowing gas, excited by the radiation from the stellar remnants at their centres. The name 'planetary nebula' was first suggested by Sir William Herschel in the 19th century, because in the telescopes of the time, they appeared as glowing disks, similar to those of the planets. Modern telescopes have revealed their often fantastic and beautiful structures, many of which are still poorly explained. Unfortunately most are rather faint, and thus difficult to

| BRIGHT PLANETARY NEBULAE | | | | | |
OBJECT	CONST.	RA	DEC	M	NAME OR NOTES
M 27	Vul	19 59.6	+22 43	7.4	Dumbbell
M 57	Lyr	18 53.6	+33 02	8.8	Ring
NGC 7293	Aqr	22 29.8	+07 58	–	Helix

The Dumbbell Nebula in Vulpecula, M27, is one of the brightest planetary nebulae, visible in binoculars.

see visually with amateur instruments. The Dumbbell Nebula (M 27) in Vulpecula and the Ring Nebula (M 57) in Lyra are the most famous examples in the northern hemisphere.

SUPERNOVA REMNANTS

SEE ALSO
red giant (p.126)

supergiant (p.126)

white dwarf (p.126)

Stars that are more than ten times as massive as the Sun may end their lives as enormous supergiants, having formed shells of different elements in their interiors. They reach a stage at which the forces within them become unbalanced, and the star explodes, releasing a flood of radiation, and creating yet heavier elements in the process. Most of the material from the star is ejected into space at tremendous velocities, although a stellar remnant (either a neutron star or a black hole) may remain at the centre. Certain binary systems may undergo a similar explosion. The intense radiation interacts with gas in the surrounding interstellar space, and the ejected material itself may be excited to emit radiation. The most

famous supernova remnant is M 1, the Crab Nebula, in Taurus, the remains of an explosion that occurred in 1054 AD. It is fairly faint, but detectable with small instruments under good conditions. NGC 6960 and 6962, both known as the Veil Nebula, are portions of the vast Cygnus Loop supernova remnant, created by a supernova explosion that took place thousands of years ago.

DARK NEBULAE

When large amounts of interstellar dust are concentrated in one place, they obscure the light from more distant stars. Small dark nebulae are often seen silhouetted against gaseous nebulae, and some represent dark 'globules' within which stars may later be born. The most extensive dark nebulae, however, are found along the plane of the Milky Way, particularly in the Great Rift which stretches down from Cygnus towards the galactic centre in Sagittarius, and which appears to divide the Milky Way in two for a large portion of its length.

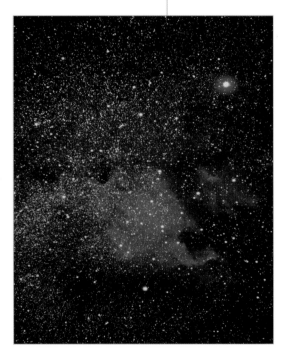

The North America nebula, near Deneb in Cygnus. The 'Gulf of Mexico' is caused by a dark nebula that blocks light from the glowing gas beyond.

SUPERNOVA REMNANTS					
OBJECT	CONST.	RA	DEC	M	NAME OR NOTES
M 1	Tau	05 34.5	+22 01	8.4	Crab Nebula
NGC 6960	Cyg	20 45.7	+30 43	–	Veil Nebula
NGC 6992	Cyg	20 56.4	+31 43	–	Veil Nebula

GALAXIES

Galaxies are the fundamental building-blocks of the universe. Although perhaps less familiar to us than stars, being much farther away, and difficult to study, we now know that they come in a wide range of sizes and are as varied as stars in the individual characteristics. (See also the table of galaxies on p.248.)

Our own galaxy appears to us as a band of light (the Milky Way) running right around the sky. Since the discovery of the telescope, we have known that it actually consists of millions of stars. In certain regions, particularly in Sagittarius (which is the direction of the galactic centre) and neighbouring constellations, the star clouds are particularly dense. It is well worth spending some time sweeping along the Milky Way using low-power binoculars or (even better) a pair of old-fashioned opera glasses.

Observers in more southern latitudes, where Sagittarius can be seen at the zenith, are even able to obtain some idea of the structure of the Galaxy. This consists of a flattened central bulge (actually consisting of old stars), surrounded by an extensive disk of stars, gas and dust. The Solar System is located in the outer part of this disk, and looking in the opposite direction (towards the edge), in Orion and neighbouring constellations, the Milky Way is far less conspicuous. The Galaxy's disk contains the spiral arms, along which young stars, open clusters, gaseous nebulae, and dark nebulae are concentrated. It is here that star formation continues to take place.

Spiral systems similar to our own contain some 100–200 thousand million stars. The nearest spiral galaxy, M31 in Andromeda, is somewhat larger than our own galaxy. Both are accompanied by smaller,

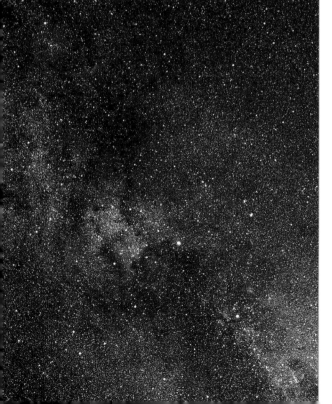

Part of the Milky Way in Cygnus, showing red emission nebulae, dark clouds and many thousands of individual stars.

satellite galaxies, with about two dozen galaxies of various shapes and sizes forming what is known as the Local Group. The Milky Way's satellites, the Large and Small Magellanic Clouds, are visible only from the equatorial regions, and you need to be in the southern hemisphere for them to rise well above the horizon.

The spiral galaxy M66 in Leo.

Many galaxies contain little gas and dust, and therefore have no young stars or spiral arms. These elliptical galaxies include some of the largest systems known. One giant elliptical, M87, lies at the heart of the Virgo Cluster. This, in turn, lies at the centre of the Local Supercluster, an even larger grouping of galaxies, at one edge of which lies our own Local Group.

M83, in Hydra, is one of the brightest spiral galaxies, detectable in binoculars.

Galaxies appear to be concentrated in regions of the sky where we are looking towards the galactic poles, at right-angles to the galactic plane, which contains large amounts of obscuring dust. The North Galactic Pole lies in Coma Berenices, which is the location of the Coma Cluster of galaxies. The neighbouring constellation of Virgo contains the much nearer, giant Virgo Cluster, while Leo and Canes Venatici are also host to many galaxies.

NGC 4565 is an edge-on spiral galaxy, clearly showing its dust lane in this photograph.

The majority of galaxies are so faint that they merely appear as pale fuzzy patches (at most) in small amateur instruments. Larger telescopes are required to see any detail. Locating them may sometimes be quite a challenge and, as described for variable stars, you may have to use averted vision to detect them at all. With the introduction of affordable CCD cameras, amateurs are able to obtain striking images of galaxies, even with relatively small telescopes. Do not, however, expect to see any great detail when observing visually.

CONSTELLATIONS

TThe constellations described in the following pages include certain southern constellations that are not normally readily visible from mid-northern latitudes, but which may be seen from countries around the Mediterranean, and from the southern United States. Some of these (such as Puppis and Columba) are partially shown on the monthly and seasonal charts, low on the southern horizon.

The constellations are generally arranged in alphabetical order, but for convenience, certain small, neighbouring constellations (such as Aries and Triangulum) are shown on a single chart. In general, the north-ernmost constellation is given in its correct place in the sequence. The page numbers for individual constellations that are not in alphabetical order are given in the table opposite.

Each constellation is shown in three forms: on a finder chart showing the surrounding constellations; as a detailed chart; and as a photograph. The orientation of all three is identical to make identification easier. It should be borne in mind, however, that the apparent magnitudes of stars may be somewhat altered during the photographic and reproduction processes. Visually, some stars may seem brighter or fainter than they appear on the photographs.

A selection of interesting objects is given, all of which are shown on the appropriate chart. Additional, larger-scale charts are given for a number of objects, including special charts to show variable stars and their comparisons.

The accompanying key shows the magnitude scale and the symbols that are used on the charts.

Legend Key Constellation Maps

Magnitudes	–1 0 1 2 3 · 4 · 5 · 6	
Double stars		Variable stars
Open cluster	Milky Way	Bright nebulae
Globular cluster		Galaxy
Planetary nebula	Constellation boundary	Meteor Shower Radiant

The brightest 'star' is Jupiter, here in Capricornus (p.168)

Aquarius (p.148), with the 'Water Jar' (top left centre) and the planet Saturn.

ANDROMEDA
ANDROMEDAE • And

Although none of the stars in this constella-
tion are particularly bright, it is easy to locate,
running northeastwards from the Great
Square of Pegasus. The star α Andromedae

SOUTH AT 22:00 local time: Nov 10

VISIBLE AT 22:00 local time: Jly–Dec

AREA: 722 sq. deg. (19th)

(Alpheratz) forms both the 'head' of Andromeda, and the fourth corner of the Square of
Pegasus. The popular names for this constellation include 'The Princess' and 'The Chained
Maiden', because mythologically it represents Andromeda, the daughter of Cepheus and
Cassiopeia, who, following the pronouncements of an oracle, was chained to a rock as a
sacrifice to Cetus, the sea monster that was ravaging the coast. She was rescued by Pegasus,
who turned Cetus to stone, using the head of Medusa, whom he had previously slain.

υ And (01^h37^m, +41°25') is a star (mag. 4.1) slightly more massive and brighter than the Sun. It has
been found to have a planet, with a minimum mass of 0.65 that of Jupiter, orbiting extremely close
to the star (at about 0.056 AU), with a period of just 4.61 days. Like the planets orbiting τ Boo and
51 Peg, it has been called a 'hot Jupiter'. There is evidence of two other large planets in this system.

56 And (01^h56^m, +37°16') is an optical double consisting of two unrelated stars: one an orange
giant, mag. 5.7, and the other a more distant red giant, mag. 5.9. The double is easily resolved in
binoculars.

M31 (00^h43^m, +41°16'), the Great Andromeda Galaxy, which is visible to the naked eye as a hazy
spot of light, is a giant spiral, somewhat larger and more massive than our own galaxy. It is simple
to find by following the line of stars from β And (Mirach), through μ, and on to just northwest
of ν. It has several satellite galaxies, the most prominent of which are M32, detectable in binocu-
lars, and M110 (00^h40^m, +41°41'), which requires a larger aperture.

M32 (00^h47^m, +40°52'), is a dwarf elliptical galaxy, which, although visible in binoculars, may be
mistaken for a star. Its magnitude is variously quoted as 8 or 9.

NGC 752 (01^h58^m, +37°41') is a large open cluster, northeast of 56 And. It is best observed with
binoculars, but sharp-eyed observers are said to be able to see it with the naked eye.

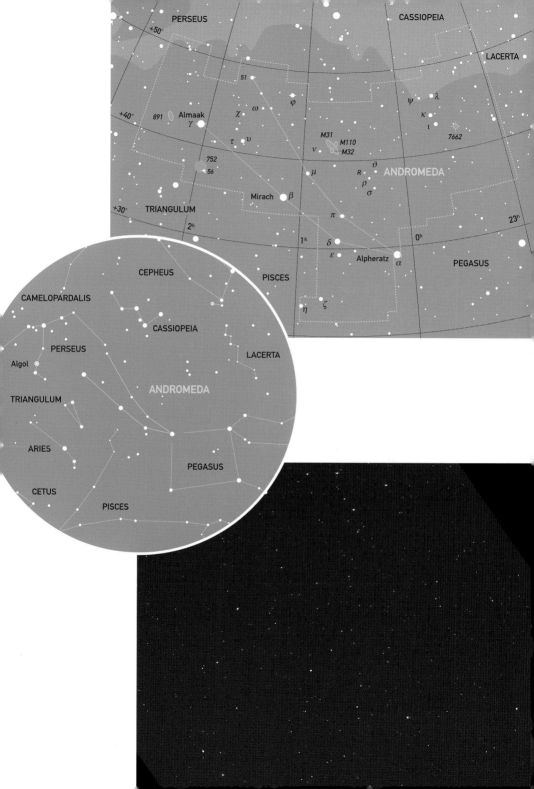

AQUARIUS

AQUARII • Aqr • THE WATER CARRIER

This ancient constellation represents a water carrier, pouring water from the mouth of a jar (the 'Water Jar' or 'Y of Aquarius' asterism consisting of the three stars around ζ Aqr).

SOUTH AT 22:00 Local time: Oct 10

VISIBLE AT 22:00 local time: Jly–Nov

AREA: 980 sq. deg. (10th)

The water is always shown flowing down towards Fomalhaut, α PsA, the brightest star in Piscis Austrinus. As seen from the Middle East, the bright star β Aqr, Sadalsud, appears in the east just before dawn at the start of the rainy season. This may be why the constellation is associated with life-giving water. The constellation was also supposed to represent Ganymede, who was carried off by Zeus, and became cup-bearer to the gods.

α Aqr (22^h06^m, $-00°19'$), Sadalmelik, is an extremely bright yellow supergiant, apparent mag. 2.9, which is actually about 30,000 times as luminous as the Sun, and has a similar surface temperature.

β Aqr (21^h32^m, $-05°34'$), Sadalsud, is remarkably similar to α Aqr, in that it is also a bright yellow supergiant. Despite being slightly closer to us, its apparent magnitude is almost the same (3.0). Both stars are about 120 times the diameter of the Sun.

M2 (21^h34^m, $-00°49'$), a large bright globular cluster, mag. 6.5, easily detectable in binoculars, but requiring a moderate-sized telescope to show any detail. It is best located by sweeping almost due north from β Aqr.

M72 (20^h54^m, $-12°31'$), is much fainter globular cluster than M2, with a magnitude of about 9.5, at the limit even for most good binoculars.

M73 (20^h59^m, $-12°38'$) is a 'Y'-shaped asterism of four stars, which are not thought to be associated, so do not even warrant being called a sparse open cluster. It is not clear why Messier included such a group in his catalogue.

NGC 7293 (28^h09^m, $-15°36'$), the Helix Nebula, is the closest planetary nebula to us, and the largest, with a diameter of approximately 0.25° (half the apparent size of the Moon). It may be found in binoculars, west of υ Aqr, but is rather faint, requiring extremely good conditions.

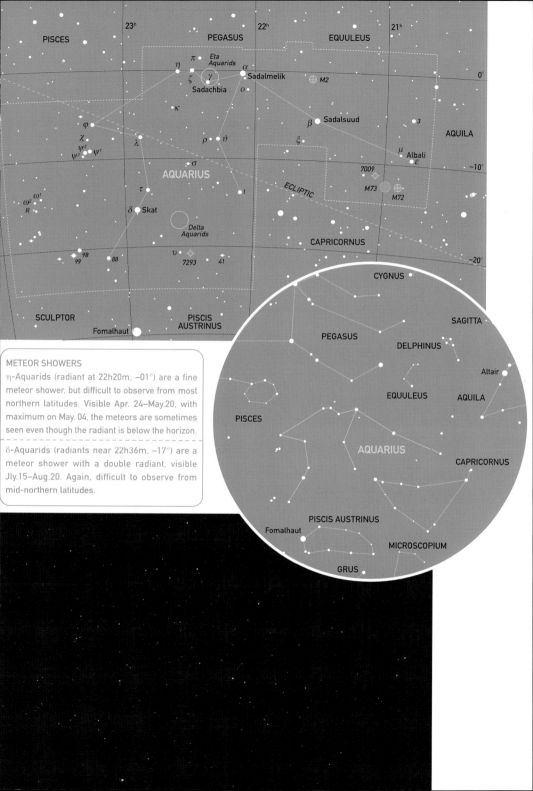

METEOR SHOWERS

η-Aquarids (radiant at 22h20m, −01°) are a fine meteor shower, but difficult to observe from most northern latitudes. Visible Apr. 24–May.20, with maximum on May. 04, the meteors are sometimes seen even though the radiant is below the horizon.

δ-Aquarids (radiants near 22h36m, −17°) are a meteor shower with a double radiant, visible Jly.15–Aug.20. Again, difficult to observe from mid-northern latitudes.

AQUILA

AQUILAE • Aql • THE EAGLE

Another ancient constellation, associated in Greek mythology with the eagle that held the thunderbolts belonging to Zeus. It was also said to be the eagle that kidnapped

SOUTH AT 22:00 local time:	**Aug 30**
VISIBLE AT 22:00 local time:	**Jun–Sep**
AREA:	**652 sq. deg. (22nd)**

Ganymede (Aquarius) and carried him to Olympus. α Aql, Altair, is one of the three prominent stars that form the Summer Triangle. It is also one of the closest to us, lying just 17 light-years distant.

η **Aql** (19^h53^m, $+01°01'$) was one of the very first variables to be discovered. It is a Cepheid variable (p.172) and, by coincidence, has exactly the same range, mag. 3.5–4.4, as δ Cep, after which the class is named, but with a longer period of 7.2 days.

COMPARISONS FOR η AQL			
A = ϑ Aql	3.21	D = ι Aql	4.36
B = δ Aql	3.36	E = ν Aql	4.67
C = β Aql	3.72		

R **Aql** (19^h04^m, $+08°09'$) is a long-period variable, which is easily visible with binoculars (and even with the naked eye) at its maximum of about mag. 5.5, but which fades to mag. 12.0 at minimum, requiring a moderately sized telescope to be detected. The Mira-type variations have a period of 284 days.

15 **Aql** (19^h05^m, $-04°02'$), close to l Aql, is a double star, with magnitudes of 5.4 and 7.1, which is just detectable under good conditions with binoculars, but which is a rather difficult object.

57 **Aql** (19^h55^m, $-08°13'$) is another double, generally regarded as somewhat easier than 15 Aql, with stars of magnitude 5.7 and 6.5.

NGC 6709 (18^h52^m, $+10°20'$) is an open cluster with a combined magnitude of about 7.5, but whose individual stars are too faint to be resolved in binoculars.

NGC 6755 (19^h08^m, $+04°14'$) is also an open cluster with an overall magnitude of about 8, lying north-northwest of δ Aql.

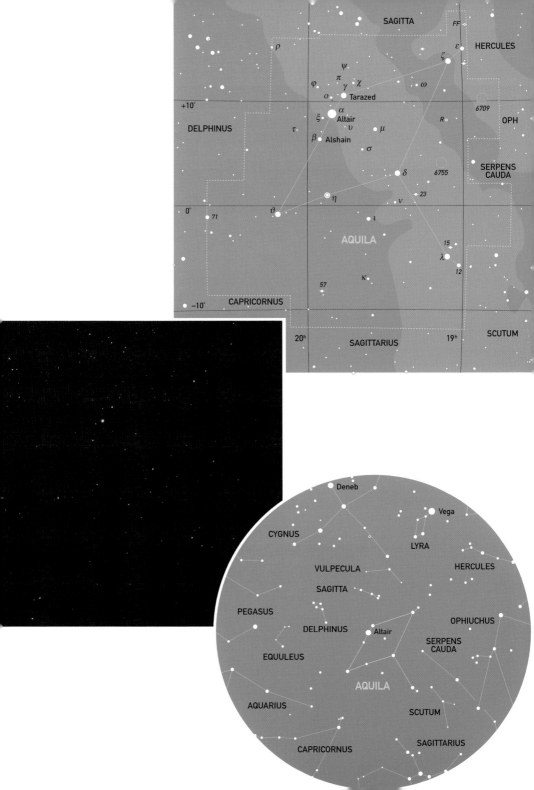

ARIES

ARIETIS • Ari • THE RAM

Mythologically, Aries represents the ram whose fleece later became the Golden Fleece, sought by Jason and the Argonauts. (In fact, the tale probably arose from the practice of staking woollen fleeces to the beds of streams in northern Asia Minor to trap flakes of gold washed from the river gravels.)

SOUTH AT 22:00 local time: **Nov 20**
VISIBLE AT 22:00 local time: **Aug–Mar**
AREA: **441 sq. deg. (39th)**

Unfortunately, although the three main stars of the constellation, α (Hamal), β (Sheratan), and γ (Mesarthim) are fairly easy to recognize, lying as they do in a fairly barren area between Pisces and Taurus, the constellation has little to offer in the way of observable objects.

γ Ari (01h54m, +19°18') is a double (one of the first to be discovered with a telescope by Robert Hooke in 1664), consisting of stars of magnitudes 4.6 and 4.7, generally held to require a small telescope, but sometimes stated to be just resolvable with good binoculars under very favourable conditions.

λ Ari (01h58m, +23°36') consists of a pair of stars, magnitudes 4.8 and 7.3, just visible in binoculars, although really requiring the use of a small telescope.

TRIANGULUM

TRIANGULI • Tri • THE TRIANGLE

A small constellation comprising three faint stars.

SOUTH AT 22:00 local time: **Nov 20**
VISIBLE AT 22:00 local time: **Jul–Mar**
AREA: **132 sq. deg. (78th)**

15 Tri (02h36m, +34°42') is a wide double, visible in binoculars, with red and white stars of magnitudes 5.4 and 6.8, respectively.

R Tri (02h34m, +34°03') is a long-period (Mira) variable, with a range of over 7 mags (5.4–12.6 m) and a period of 267 days. It is readily visible in binoculars for some weeks around max.

M33 (01h34m, +30°40') is a face-on spiral galaxy with a low surface brightness, making it more difficult to see than M31 in Andromeda, despite being larger. Said to be visible to people with keen eyesight under exceptionally clear conditions, it is the most distant object visible to the naked eye at approximately 2.6 million light years. Best observed with low-magnification binoculars.

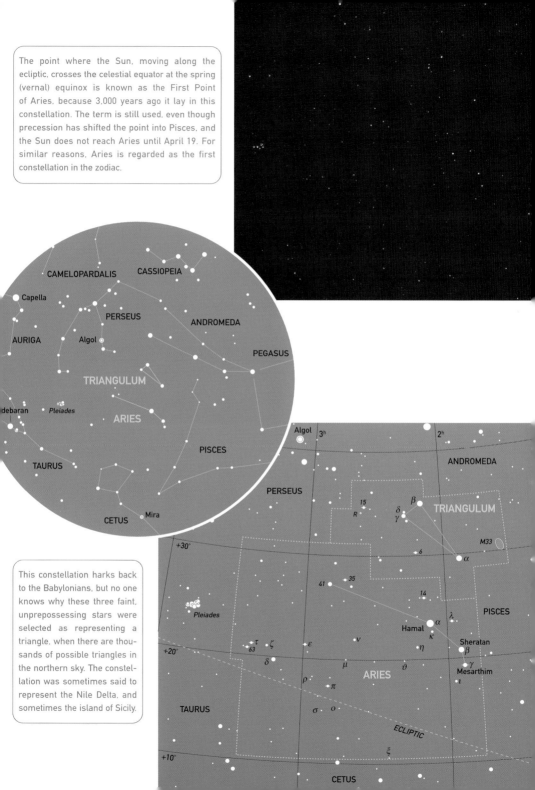

The point where the Sun, moving along the ecliptic, crosses the celestial equator at the spring (vernal) equinox is known as the First Point of Aries, because 3,000 years ago it lay in this constellation. The term is still used, even though precession has shifted the point into Pisces, and the Sun does not reach Aries until April 19. For similar reasons, Aries is regarded as the first constellation in the zodiac.

This constellation harks back to the Babylonians, but no one knows why these three faint, unprepossessing stars were selected as representing a triangle, when there are thousands of possible triangles in the northern sky. The constellation was sometimes said to represent the Nile Delta, and sometimes the island of Sicily.

AURIGA

AURIGAE • Aur • THE CHARIOTEER

The constellation is associated with a legendary Athenian king, Erichthonius, who was a cripple, like his father, the god Hephaestus (known to the Romans as Vulcan),

SOUTH AT 22:00 local time: ???
VISIBLE AT 22:00 local time: Sep–May
AREA: 657 sq. deg. (21st)

and invented the chariot. The constellation was thought to herald stormy winds, the word for which became corrupted to Capella ('she-goat'), and this word came to be applied to the brightest star in the constellation. By association, the three stars to the east of Capella were later named the 'Kids'. Two of these are remarkable in their own right.

Capella is circumpolar anywhere north of 50°N latitude, and the rest of the constellation is readily visible throughout most of the year. The Milky Way passes through it, so the area contains several open clusters.

ε Aur (05^h02^m, +43°50') is an amazing eclipsing binary, with the extremely long period of 27 years (9892 days). The visible star is a white supergiant (mag. 3.0), but the eclipsing body is a mystery. It may be a disk of dust surrounding an invisible pair of white dwarfs. It takes years for the star to fade and recover, with minimum (mag. 3.8) lasting about one year. The last eclipse was 1983–4, and the next will begin about 2006–2007.

ζ Aur (05^h03^m, +41°05') is another remarkable eclipsing binary, consisting of a pair of supergiant stars, 5 and 200 times the diameter of the Sun. Placed at the centre of the Solar System, the latter would nearly fill the orbit of the Earth. The orbital period is 972.16 days, and during an eclipse the stars' combined magnitude drops from 3.7 to 4.0.

M36 (05^h36^m, +34°08') is a small, bright (mag. 6.5) open cluster, readily visible in binoculars.

M37 (05^h52^m, +32°33') is a very large, 6th-magnitude open cluster, almost the diameter of the Moon, which appears as a hazy spot in binoculars, but which even the smallest telescope resolves into a large number of stars. The cluster has about 150 members.

M38 (05^h29^m, +35°50') is slightly fainter than M36 at mag. 7.0, but is larger, and may sometimes be resolved with binoculars.

NGC 2281 (06^h49^m, +41°03') is yet another open cluster visible in binoculars, appearing approximately the same brightness as M36 (mag. 6.5).

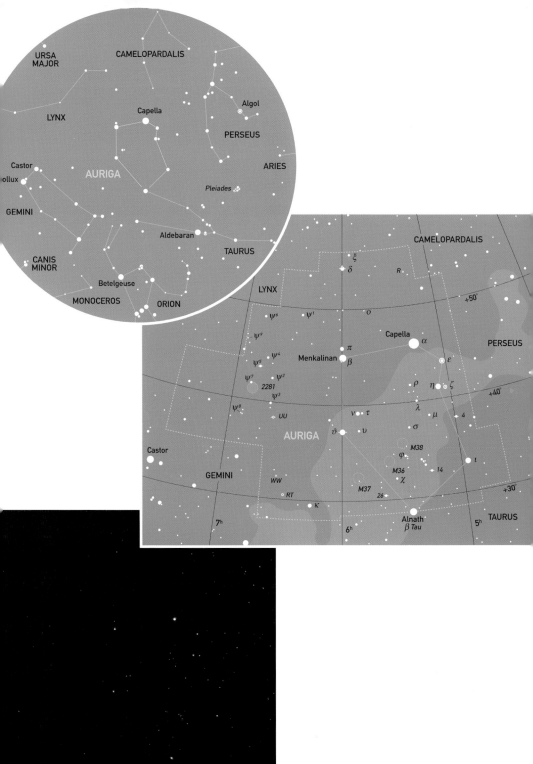

BOÖTES

BOÖTIS • Boo • THE HERDSMAN

There are various legends associated with this constellation. In one account Boötes was commemorated in the sky for having invented the plough. In another, he is holding two

SOUTH AT 22:00 local time: **May 30**

VISIBLE AT 22:00 local time: **Feb–Sep**

AREA: **907 sq. deg. (13th)**

hounds (Canes Venatici) on the leash, and pursuing the bear (Ursa Major). Yet another account says that he was a bear-keeper and the name Arcturus (meaning 'Guardian of the Bear'), was originally applied to the whole constellation, not just its brightest star. The constellation incorporates most of the area once associated with an obsolete constellation, Quadrans Muralis (the Mural Quadrant – an astronomical instrument), whose name survives in the Quadrantid meteor shower.

α **Boo** (14^h16^m, +19°11') Arcturus, is the brightest star in the northern sky at magnitude –0.05. It is an orange giant and to the naked eye, this colour causes it to appear fainter than α Lyrae (Vega), which actually has the slightly lower magnitude of 0.03.

ι **Boo** (14^h16^m, +51°22'), sometimes called Asellus Secundus, is a wide double visible in binoculars, with stars of magnitudes 4.8 and 7.7. (Asellus Primus and Asellus Tertius are θ Boo and κ Boo, respectively.)

μ **Boo** (15^h25^m, +37°22') Alkalurops, is a multiple star. Binoculars show a wide double, mags 4.3 and 6.5, which are sometimes plotted separately on star charts as μ^1 and μ^2 Boo. The fainter star is itself a binary system, but it requires a large telescope to be resolved.

ν **Boo** (15^h31^m, +40°50') is an optical double consisting of two 5th-magnitude stars of contrasting colours, one white, and a more distant orange giant.

τ **Boo** (13^h47^m, +17°27') is the central star of an extrasolar planetary system. The star itself (mag. 4.5) is slightly more massive and brighter than the Sun – very similar to ν And, also an extrasolar system. The planet is at least 3.7 times the mass of Jupiter and orbits just 0.045 AU from the star, with the extremely short period of just 3.31 days. It is an extreme case of a so-called 'hot Jupiter' planetary system.

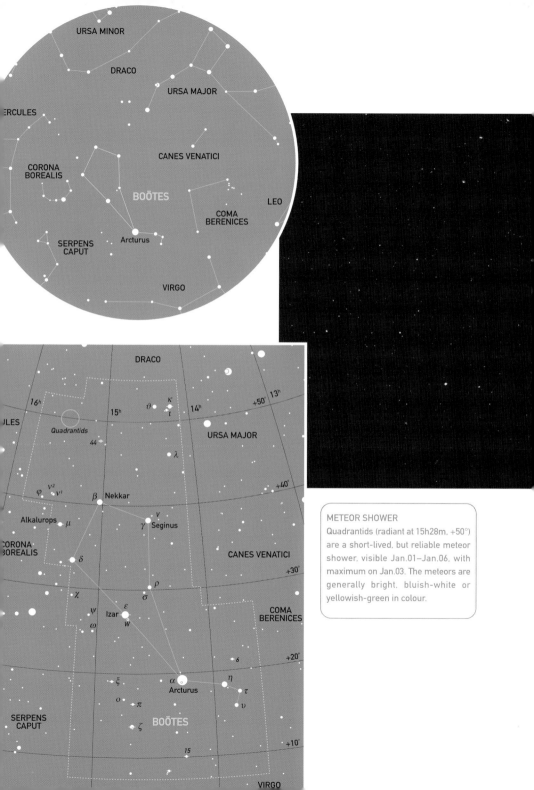

URSA MINOR

DRACO

URSA MAJOR

ERCULES

CANES VENATICI

**CORONA
BOREALIS**

BOÖTES

LEO

**COMA
BERENICES**

Arcturus

**SERPENS
CAPUT**

VIRGO

DRACO

16ʰ η κ ι
15ʰ 14ʰ +50° 13ʰ

Quadrantids **URSA MAJOR**

44 λ

+40°

φ ν² ν¹ β Nekkar

Alkalurops μ ν
γ Seginus

**CORONA
BOREALIS** δ **CANES VENATICI**

+30°

χ ρ
σ

ψ ε
ω Izar **COMA
BERENICES**

W

6 +20°

ξ α η
o Arcturus τ
π υ

**SERPENS
CAPUT** ζ **BOÖTES**

15 +10°

VIRGO

METEOR SHOWER

Quadrantids (radiant at 15h28m, +50°)
are a short-lived, but reliable meteor
shower, visible Jan.01–Jan.06, with
maximum on Jan.03. The meteors are
generally bright, bluish-white or
yellowish-green in colour.

CAMELOPARDALIS

CAMELOPARDALIS • Cam • THE GIRAFFE

This constellation was first proposed by the Dutch astronomer Petrus Plancius in 1613, mainly to fill a large, sparsely populated area in the northern circumpolar region.

SOUTH AT 22:00 local time: **Jan 01**

CIRCUMPOLAR: ALWAYS VISIBLE

AREA: **757 sq. deg. (18th)**

The first representation in an atlas was published by Jakob Bartschius in 1624.

β Cam (05h04m, +60°27') is the brightest star in the constellation at mag. 4.0, and is also a wide double, with a companion of mag. 7.4.

11 Cam (05h06m, +58°58'), at magnitude 5.1, forms an extremely wide double with 12 Cam, which is just below normal naked-eye visibility at mag. 6.3, but easily seen with an optical aid.

VZ Cam (07h31m, +82°25') is an irregular variable, always visible with the naked eye, that fluctuates between magnitudes 4.8 and 5.2. This small range makes it difficult to study accurately using just visual estimates.

NGC 1502 (04h08m, +62°20') is a small, but reasonably bright (6th-magnitude) open cluster, visible in binoculars.

NGC 2403 (07h37m, +65°35') is a spiral galaxy, reasonably easy to detect in binoculars under good conditions, despite its quoted magnitude of 8.5.

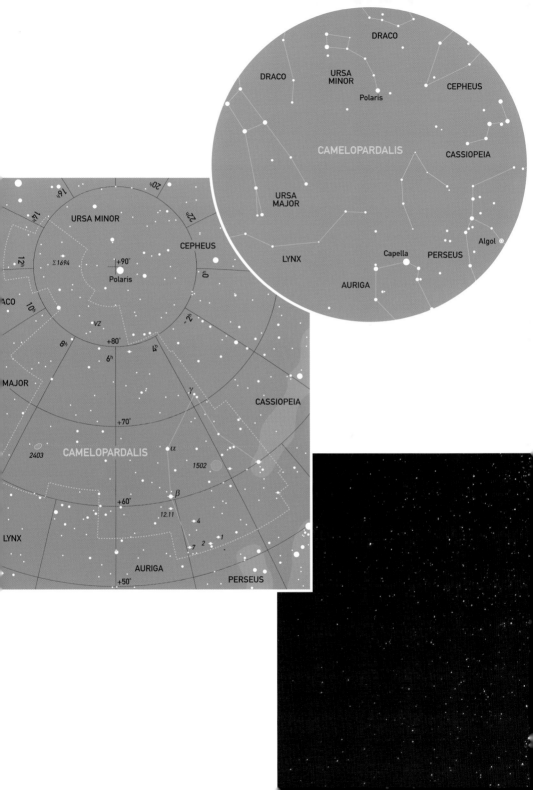

CANCER

CANCRI • Cnc • THE CRAB

Cancer is an extremely ancient constellation, which, although faint, was regarded as of particular importance because it marked the position of the (northern) summer solstice.

SOUTH AT 22:00 local time: **Mar 05**

VISIBLE AT 22:00 local time: **Nov–May**

AREA: **506 sq. deg. (31st)**

The name is perpetuated today in the Tropic of Cancer, the line of latitude at which the Sun is overhead at midsummer. Because of precession, the Sun now reaches its highest declination on the very border of Gemini and Taurus. Mythologically, the constellation is supposed to represent the crab that was sent by Hera to distract Hercules when he was fighting the Lernaean Hydra. It did not succeed, however, and was killed when he stepped on it. Hera set it in the sky, but without any bright stars, because it had failed in its purpose.

The open cluster M44, Praesepe, appears to the eye as a hazy spot and was once believed to be a thin area of the sphere of stars, through which souls passed to Earth. Galileo discovered that it consisted of a group of stars. Because these resemble a swarm of bees, the cluster is also known as the Beehive.

γ **Cnc** (08^h43^m, +21°28'), Asellus Borealis (the 'Northern Ass'). With δ Cnc, this star was regarded as one of the asses on which Dionysus and Silenus rode in the battle between the Gods and the Titans. The braying of the asses had such an effect on the Titans that the Gods were victorious.

δ **Cnc** (08^h45^m +18°09'), Asellus Australis (the 'Southern Ass'). Because the two stars are on either side of Praesepe, the latter is sometimes known as the Manger, from which the asses are feeding.

ι **Cnc** (08^h47^m, +28°45') is a moderately difficult binocular double, with one yellow star (mag. 4.0) and one white (mag. 6.6).

ρ^1 **Cnc** (08^h53^m, +28°20') is a wide double, consisting of yellow and red stars of magnitude 6.0 and 6.2, respectively.

R Cnc (08^h14^m, +11°53') is a long-period variable that is readily visible in binoculars around maximum. It ranges between magnitudes 6.1 and 11.8, and has a period of 361.6 days.

M44 (08^h40^m, +19°58'), Praesepe. There are actually about 200 stars in the cluster, spread over an area about 1.5° across, and lying at a distance of about 590 light-years.

M67 (08^h50^m, +11°48') is a relatively large open cluster (mag. 7) with about the same apparent size of the Moon (0.5°), readily visible in binoculars.

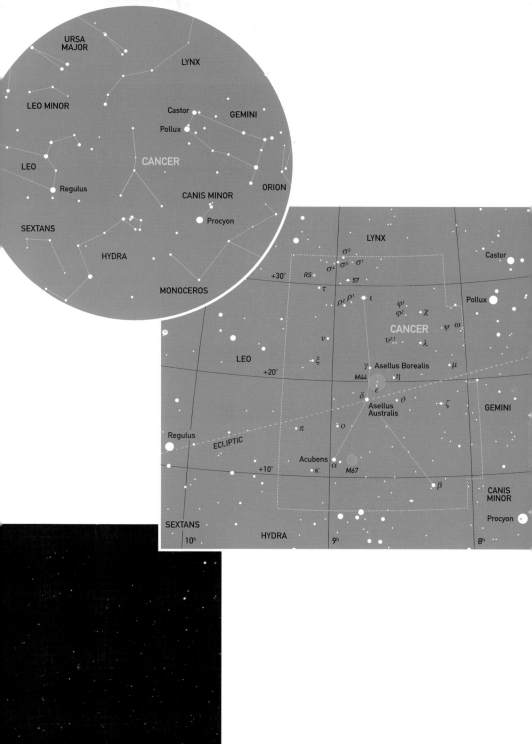

CANES VENATICI

CANUM VENATICORUM • CVn • THE HUNTING DOGS

This is a relatively recent constellation, which was proposed in 1687 by the astronomer Jan Helweke (generally known as Hevelius), the last great observer to use purely visual meth-

SOUTH AT 22:00 local time: **May 05**

CIRCUMPOLAR: ALWAYS VISIBLE

AREA: **465 sq. deg. (38th)**

ods rather than a telescope. It is conventionally represented as a pair of greyhounds held on the leash by Boötes. α CVn (Asterion) is more commonly called Cor Caroli ('Charles' Heart') commemorating the executed King Charles I of England. β CVn is sometimes known as Chara.

α **CVn** (12h56m, +38°18') is a very wide double with components of mags 2.9 and 5.6. The brighter (α2 CVn) is actually the prototype for a class of magnetic variable stars with very small amplitudes (about 0.1 mag.).

V CVn (13h20m, +45°32') is a semi-regular variable that shows intervals of reasonably well-defined periodicity of about 192 days.

COMPARISONS FOR **V cvn**			
A = F1 21 = 5.1		H = 7.8	
B =	5.9	K = 8.4	
E =	6.5	L = 8.6	
G =	7.1		

M3 (13h42m, +28°22') is a bright globular cluster, just below the limit of naked-eye visibility (mag. 6.3) that is readily seen in binoculars. It lies in a star-poor area, right on the border with Boötes.

M51 (13h30m, +47°15') is the Whirlpool Galaxy, made famous when Lord Rosse discovered its spiral structure in the late 19th century. It is detectable in binoculars, but requires a large telescope to reveal its full beauty.

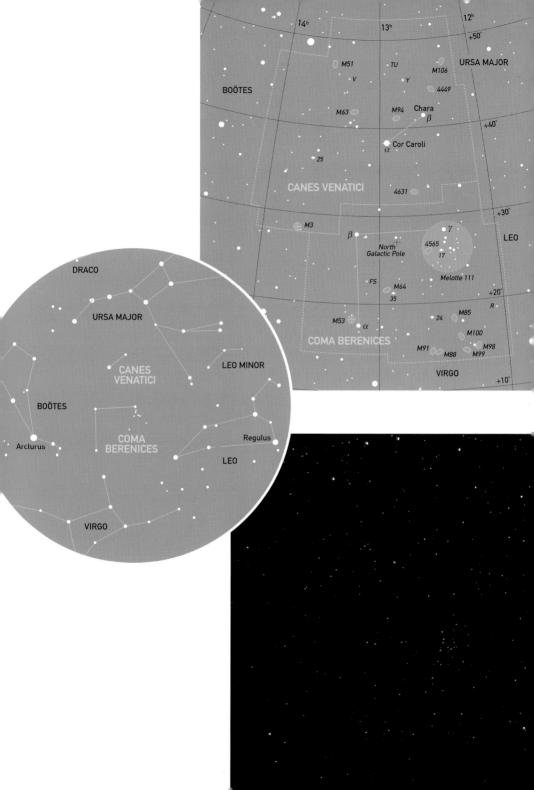

CANIS MAJOR

CANIS MAJORIS • CMa • THE GREAT DOG

Canis Major is an ancient constellation that seems to have been associated with practically every mythological dog at some time or other. It was probably most commonly

SOUTH AT 22:00 local time: Feb 05

VISIBLE AT 22:00 local time: Jan–Mar

AREA: 380 sq. deg. (43rd)

identified with one of the two dogs – the other being Canis Minor – that accompany Orion, The Hunter. A Greek tale said that the constellation represented Laeleps, the fastest of all dogs, who was placed in the sky after winning a race against a fox.

To the ancient Egyptians, Sirius (the Dog Star) marked an all-important date in their calendar, when it rose at dawn just ahead of the Sun, signalling the onset of the Nile floods. Even later, the 'dog days' of late summer, with oppressive weather, were thought to arise because Sirius added its own heat to that of the Sun when both were in the sky at the same time.

α CMa (06^h45^m, –16°43'), Sirius, is the brightest star in the sky (magnitude –1.44) partly because it is actually considerably more luminous than the Sun, but also because it is relatively nearby at about 8.6 light-years. Astronomically, it is important because it is a binary system in which the second component is a faint white dwarf star – the first to be discovered – only visible with a large telescope.

ζ CMa (06^h20^m, –30°04'), Furud, is a wide double, with white and orange stars that present a striking colour contrast. Their magnitudes are 3.0 and 7.6, respectively.

η CMa (07^h24^m, –29°18'), Aludra, is a wide double, visible in binoculars. The two white stars are of magnitudes 2.4 and 7.0.

M41 (06^h47^m, –20°43') is an open cluster, about the size of the Moon (0.5°) and consisting of about 50 stars. It is visible with the naked eye under good conditions.

NGC 2362 (07^h19^m, –20°42') is an open cluster that bears examination with the naked eye, binoculars, and a telescope. Its distance is about 5000 light-years, but appears to surround τ CMa, which is actually a foreground star at a distance of 3200 light-years.

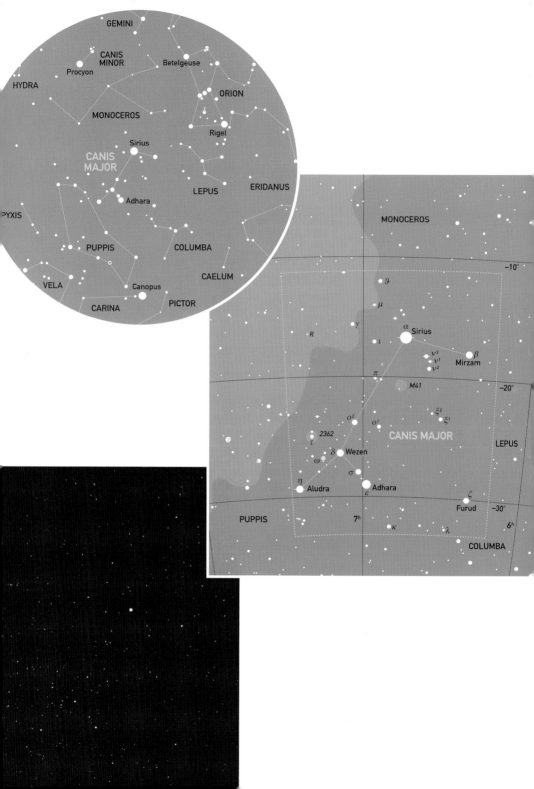

CANIS MINOR
CANIS MINORIS • CMi • THE LITTLE DOG

Mythologically, this small constellation was generally regarded as forming a pair with Canis Major, both representing Orion's hunting dogs. The constellation is so small that it consists of just a few stars, and no clusters, nebulae, or galaxies of note.

SOUTH AT 22:00 local time: **Feb 15**

VISIBLE AT 22:00 LOCAL TIME: **Nov–May**

AREA: **183 sq. deg. (71st)**

α CMi (07h39m, +05°13') is Procyon, a Greek word meaning 'before the dog', given to this star because it rose before Sirius. To the ancient Egyptians, in particular, it gave warning that Sirius – which was all-important for calendric purposes – was about to rise above the horizon. It is slightly farther away than Sirius (11.4 light-years) but still relatively close. By strange coincidence, like Sirius, Procyon is a binary system containing a white-dwarf companion. This orbits so close to the bright (mag. 0.4) yellow primary that it is even more difficult to detect than the companion to Sirius.

β CMi (07h27m, +08°17'), a white star of magnitude 2.8, is known as Gomeisa. This name was originally applied to the whole constellation, but for some unknown reason was erroneously transferred to the star.

CASSIOPEIA
(Continued from p.170.)

M103 (01h46m, +61°15') is an open cluster of magnitude 7.5, partially resolved in binoculars.

NGC 457 (01h19m, +58°20') is yet another open cluster, perhaps slightly brighter than the two Messier objects. The brightest stars are clearly resolved in binoculars.

NGC 663 (01h46m, +61°15') is another open cluster that is a fine object, even in binoculars. It consists of two irregularly shaped regions, with many individually visible stars.

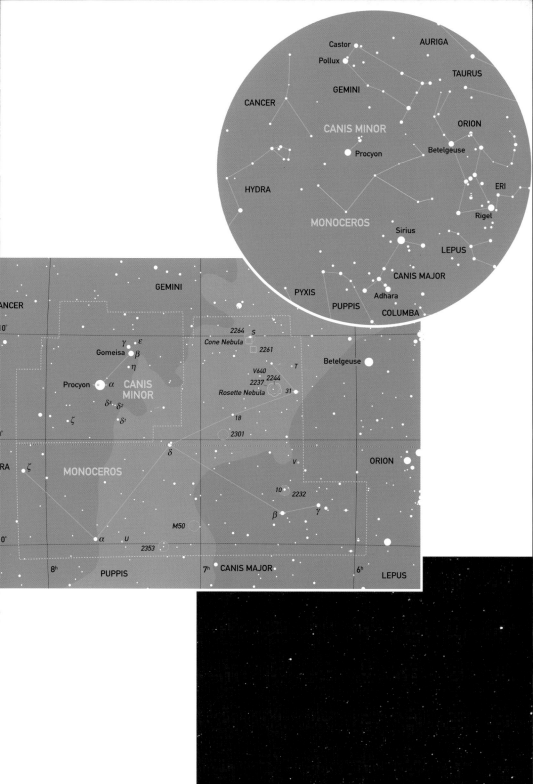

CAPRICORNUS

CAPRICORNI • CAP • THE SEA GOAT

Capricornus is an extremely ancient con-
stellation, dating back to Babylonian times
and suspected to have originated even ear-
lier. Slightly more than two thousand years

SOUTH AT 22:00 local time: **Sep 01**

VISIBLE AT 22:00 local time: **Jly–Oct**

AREA: **414 sq. deg. (40th)**

ago, it marked the southernmost declination that the Sun reached at the (northern) winter
solstice. Although precession has caused the Sun's position at the solstice to move into
Sagittarius, the connection is preserved in the name of the Tropic of Capricorn, the line of
latitude at which the Sun is overhead on December 21 or 22.

The constellation is so ancient that there are numerous different myths associated with it. Many
involve the sea or water, and there are several 'watery' constellations in the area (Aquarius, Cetus, Eri-
danus, Pisces, and Piscis Austrinus). To the Sumerians it was linked with the god Ea, who emerged
from the sea to bring civilization and culture to human beings. It was later identified with the the
goat-like god Pan, who, with other gods was bathing in the Nile when they were terrified by the mon-
ster Typhon. In trying to escape, Pan (in panic) leapt into the water as he tried to change shape. The
half underwater turned into a fish, but the part of his body above the surface remained a goat.

α^1 **Cap** (20^h18^m, $-12°30'$) Prima Giedi and α^2 **Cap** (20^h18^m, $-12°32'$) Secunda Giedi, form a very
wide visual double, readily visible to the naked eye. The pair are at distances of approximately 690
and 110 light-years, respectively, and both are actually close binary systems.

β **Cap** (20^h21^m, $-14°47'$) Dabih, is another double system, consisting of a pair of white stars of
magnitudes 3.1 and 6.1, respectively. They are moderately easy to separate with binoculars.

ρ **Cap** (20^h29^m, $-17°49'$) is a double, with white and orange stars of magnitudes 4.8 and 6.6. They
may be separated easily in binoculars.

M30 (21^h40^m, $-23°10'$) is a globular cluster, magnitude 7 or 7.5, that is detectable in binoculars,
but requires a larger instrument to show any detail.

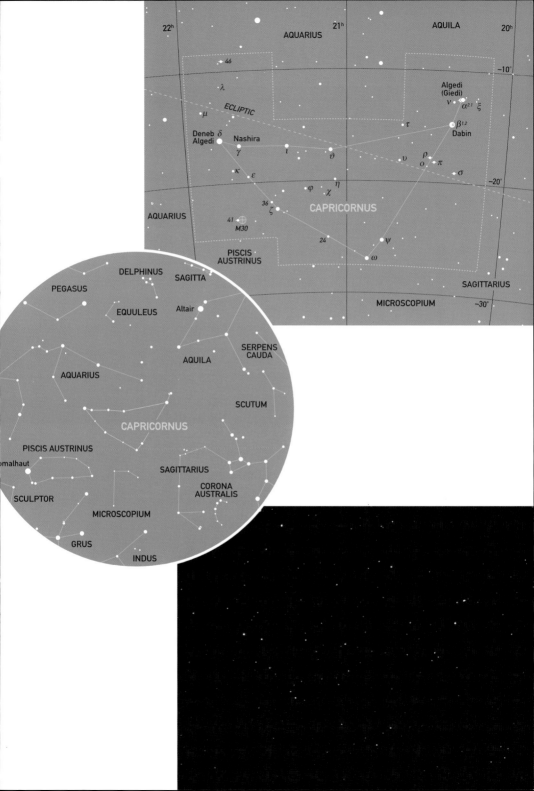

CASSIOPEIA

CASSIOPEIAE • Cas

According to Greek mythology, this distinctive constellation represents the consort of Cepheus and queen of Aethiopia (modern-day Joppa), who boasted that she was fairer than the Nereids, the sea nymphs. The Ner-

SOUTH AT 22:00 local time: **Nov 05**

CIRCUMPOLAR: ALWAYS VISIBLE

AREA: **598 sq. deg. (25th)**

ids complained to Poseidon, their father, who sent a monster (Cetus) to ravage the coast of Aethiopia. An oracle ordained that Andromeda should be sacrificed, but she was then saved by Perseus. In a later embellishment to the story, Cassiopeia was chained to her throne so that she would suffer the indignity of hanging upside down for half of the day.

The constellation is crossed by the Milky Way and contains many star clusters, some of which are difficult to distinguish from the background star clouds. The whole area is worth sweeping with low-power binoculars.

γ Cas (00^h57^m, +60°43') is an unusual variable star that is normally about mag. 2.5, but sometimes slight fainter, down to mag. 3. At unpredictable intervals it may shed a shell of material into space, brightening as it does so. It has reached mag. 1.6 in one of these episodes. It is rather difficult to estimate accurately, because suitable comparision stars are widely scattered across the sky.

COMPARISONS FOR γ CAS			
A = α Per	1.80	F = α Cep	2.43
B = α And	2.07	G = ε Cyg	2.46
C = γ Cyg	2.22	H = α Peg	2.48
D = β Cas	2.26	J = γ Peg	2.83
E = β UMa	2.36	K = η Peg	2.94

ρ Cas (23^h54^m, +57°30') is a strange semiregular variable, with a range normally between magnitudes 4.4 and 5.2 and a periodicity of about 320 days. It underwent an unusual (and poorly understood) fade between 1945 and 1947, when it reached 6.2 at minimum.

RZ Cas (02^h44^m, +69°26') is an unusual eclipsing system. The eclipse period varies in an irregular fashion, but is currently around 1.195247 days. The overall range is magnitude 6.2–7.7.

V465 Cas (01^h18^m, +57°48') is a semiregular variable with an approximate visual range of 6.2–8.1. It frequently displays regular periodicity of about 60 days, followed by intervals of more irregular activity.

M52 (23^h24^m, +61°35') is an open cluster, visible as a misty spot in binoculars. It has an overall magnitude of approximately 7.5 and has an orange 8th-magnitude star at one side.

(Continued on p.166.)

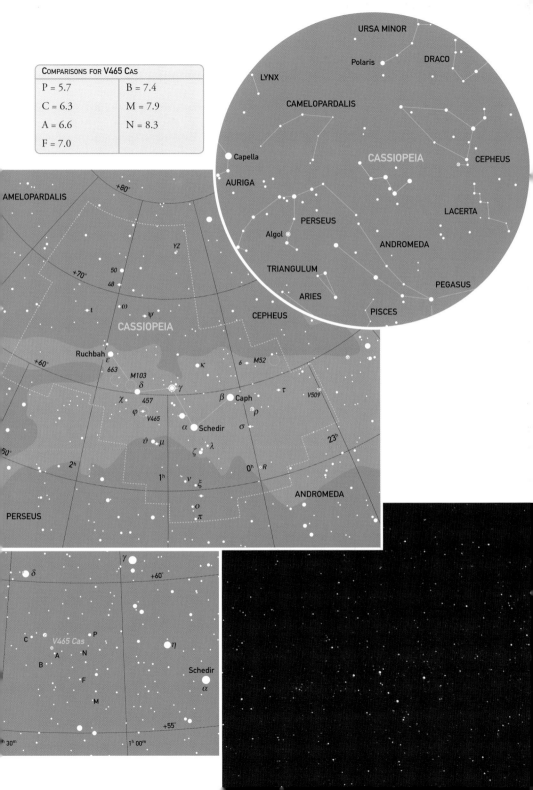

CEPHEUS

CEPHEI • Cep

This inconspicuous, circumpolar constellation extends nearly to the North Celestial Pole. Clear skies reveal the Milky Way crossing the southern portion, making it difficult to pick out some of the fainter stars in that area.

SOUTH AT 22:00 local time: **Sep 20**

CIRCUMPOLAR: ALWAYS VISIBLE

AREA: 588 sq. deg. (27th)

In mythology, Cepheus was king of Aethiopia – an early name for Joppa in Palestine – whose queen was the boastful Cassiopeia, and father of Andromeda. Although the constellation may be generally faint, two of its stars are of particular importance and interest.

δ **Cep** (22^h29^m, +58°25') is the type star for the important class of Cepheid variables. It varies between magnitude 3.5 and 4.4, with a period of 5.366341 days, and is a bright yellow supergiant at a distance of 982 light-years. These stars exhibit extremely regular periods and light-curves. There is a direct relationship between periods and luminosity: the longer the period, the greater the luminosity. By determining the period, it is possible to know the star's precise absolute magnitude, and hence the distance.

μ **Cep** (21^h43^m, +58°47') is also known as the Garnet Star, because of its strikingly red colour, readily visible in binoculars. It is a red supergiant and the largest star so far discovered, being about 2400 times the diameter of the Sun – about 22 astronomical units (AU). In our own Solar System it would thus extend way beyond the orbit of Saturn, which orbits at about 9.55 AU.

It is a semiregular variable, varying between magnitude 3.4 and 5.1, and exhibits periods of approximately 740 and 4400 days, although it also displays occasional invervals with little change. It is difficult to estimate visually because of its extreme colour and light-curves show extreme scatter.

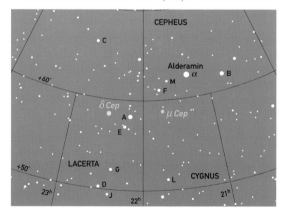

T **Cep** (21^h09^m, +68°17') is a long-period (Mira) variable, with a range of 5.2 to 11.3 mag. and a period of 388 days.

IC 1396 (21^h39^m, +57°30') is a sparsely populated open cluster, lying to the south of μ Cep, and is best seen with very low magnification.

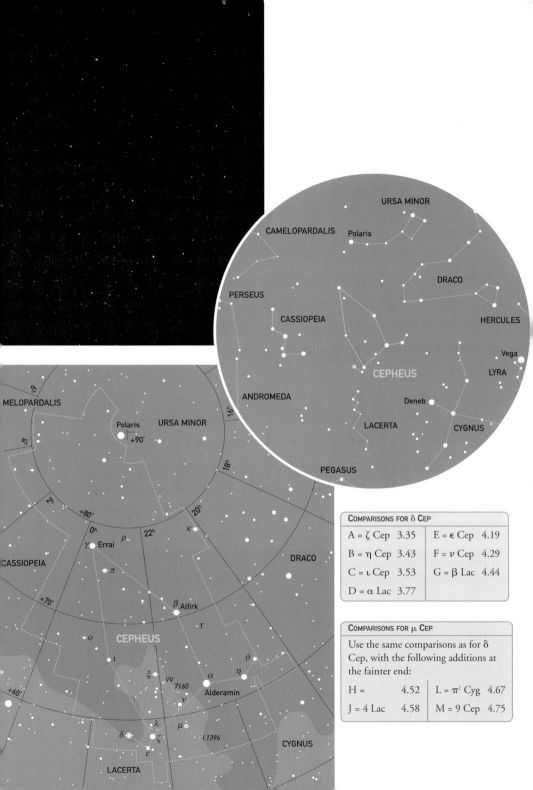

COMPARISONS FOR δ CEP	
A = ζ Cep 3.35	E = ε Cep 4.19
B = η Cep 3.43	F = ν Cep 4.29
C = ι Cep 3.53	G = β Lac 4.44
D = α Lac 3.77	

COMPARISONS FOR μ CEP
Use the same comparisons as for δ Cep, with the following additions at the fainter end:

H =	4.52	L = π¹ Cyg 4.67
J = 4 Lac	4.58	M = 9 Cep 4.75

CETUS

CETI • Cet • THE WHALE

This is a large constellation (the fourth largest in the sky), which has, unfortunately, few bright objects of interest. Although commonly called 'The Whale', it should, perhaps

SOUTH AT 22:00 local time: **Nov 20**

VISIBLE AT 22:00 local time: **Oct–Dec**

AREA: **1231 sq. deg. (4th)**

be known as 'The Sea Monster', because mythologically it represents the monster sent by Poseidon to ravage the coast of Aethiopia (Joppa in Palestine).

α Cet (03^h02^m, +04°06') Menkar, is actually fainter than 2^{nd}-magnitude β, Diphda (also known as Deneb Kaitos). It is a red giant, mag. 2.5, at a distance of about 220 light-years, which forms a wide optical double with a bluish star (mag. 5.6), almost exactly twice as far away (446 light-years).

o Cet (02^h19^m, –02°59') is the most famous variable star, and the first to be discovered. Initially seen by the Friesian astronomer Fabricius in 1596, it was thought to be a 'nova', a 'new' star that sudden came into being and then faded away. (Some earlier Chinese observations have subsequently been discovered.) In 1638, Holwarda realized its magnitude was changing in a regular rhythm, with a period of approximately 330 days. It was given the name Mira ('the Wonderful') and has become the prototype for a class of variables, the Mira stars (M), otherwise known as long-period variables (LPVs), the most numerous class of variable star. All are red pulsating giants or supergiants, and they are a late stage in stellar evolution. Mira has a considerable range, reaching 3.5 m (or even more) at maximum, easily visible to the naked eye, but dropping to 9.5 m or less at minimum. (Two charts and comparison stars for o Ceti are shown on p.131.)

T Cet (00^h22^m, –20°03') is a semiregular variable, with a range of 5.0–6.9 m, with occasional periodicity of about 159 days.

M77 (02^h43^m, 00°00') is a barred spiral galaxy, the nucleus of which is moderately easy to detect with binoculars. It is an example of a Seyfert galaxy, all of which are noted for bright nuclei and considerable activity at their centres, with the strong emission of radiation. This probably results from material that is falling into a large central black hole.

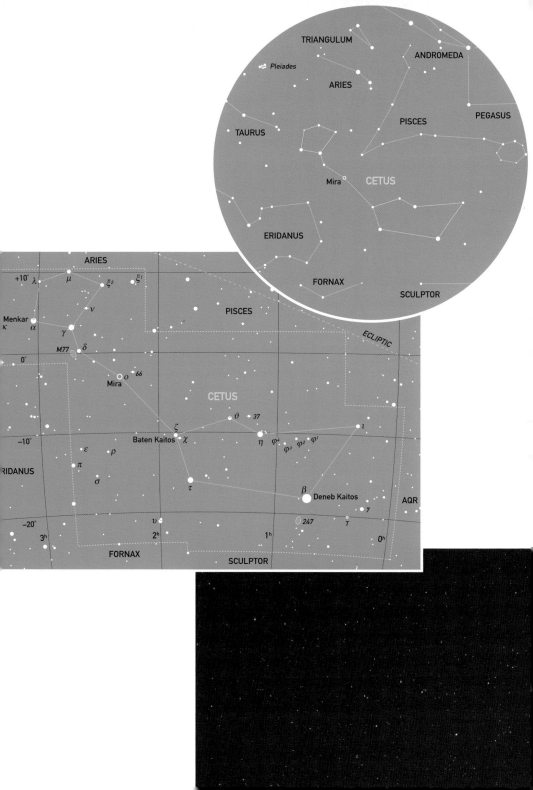

COMA BERENICES

COMAE BERENICES • Com • HAIR OF BERENICES

This area of sky was originally regarded as part of the neighbouring constellation of Leo, from which it was separated in 1551 by the Belgian astronomer and cartographer

SOUTH AT 22:00 local time:	**May 05**
VISIBLE AT 22:00 local time:	**Jan–Aug**
AREA:	**386 sq. deg. (42nd)**

Gerard Mercator. It supposedly represents the hair of the Egyptian Queen Berenices, which, in accordance with a vow, she offered in sacrifice upon the safe return of her husband, Ptolemy III Eugertes, from a military campaign.

The North Galactic Pole lies within Coma Berenices, which means that in this direction we are looking out of the Galaxy, at right-angles to the galactic plane, with its obscuring dust. Large numbers of external galaxies are found here, and in the neighbouring constellations. It contains the Coma Cluster of galaxies, concentrated near the southern border with Virgo, the majority of which are too faint for small amateur instruments.

Melotte 111, also known as the Coma Star Cluster, is a very loose open cluster, more than 5° across, and approximately centred on 12^h25^m, $+26°06^m$. It lies immediately to the south of 4th-magnitude γ Com. It is detectable with the naked eye, but best seen in very low-power binoculars (or old-fashioned opera glasses).

17 Com (12^h29^m, $+25°54'$) lies on the edge of the Star Cluster, and is a binary system consisting of a pair of blue-white stars, of magnitude 5.3 and 6.6.

R Com (12^h02^m, $+19°04'$) is a Mira-type variable that rises into the range of binoculars at maximum, when it reaches magnitude 7.1. Its period is 362.82 days, but declines to 14.6 at minimum, requiring a fairly large instrument to be visible.

M53 (13^h13^m, $+18°09'$) is a globular cluster with a total magnitude of 8. Its central region is detectable with binoculars.

M64 (12^h57^m, $+21°40'$) is a spiral galaxy that just about detectable with large binoculars under very favorable condtions, at a magnitude of about 8.5. The dark dust lane that gives it its popular name of the Black-Eye Galaxy is visible only in very large telescopes.

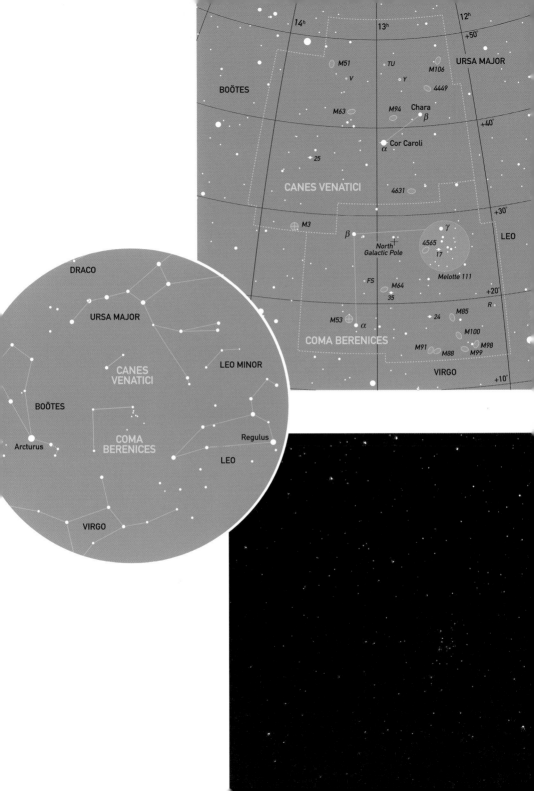

CORONA BOREALIS

CORONAE BOREALIS • CrB • THE NORTHERN CROWN

This small, highly distinctive constellation lies to the east of Boötes. It largely consists of a semicircular arc of seven stars. Six are 4th-magnitude stars, but one, α CrB (Alphecca,

SOUTH AT 22:00 local time: Jun 15

VISIBLE AT 22:00 local time: Feb–Oct

AREA: 179 sq. deg. (73rd)

or Gemma), at magnitude 2.2, is considerably brighter. Mythologically, it represents the crown of Ariadne, who, after being abandonned by Theseus – whom she had helped to defeat the Minotaur within the Cretan Labyrinth – became the wife of Dionysos and was granted imortality by Zeus.

ν CrB (16ʰ22ᵐ, +33°47'), on the eastern edge of the constellation, is a wide, optical binary, with two orange giant stars, magnitudes 5.2 and 5.4.

R CrB (15h49m, +28°09') is the type star for the remarkable, rare, orange-supergiant, R Coronae Borealis variables (RCB). It is normally bright, about magnitude 5.9, but fades suddenly

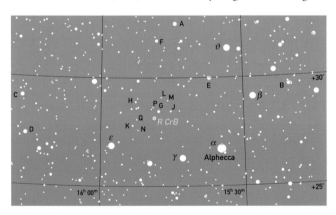

and unpredictably. The irregular decline may be between 1 and 9 magnitudes and take days or weeks, with a slow recovery over weeks or months. Fades occur when carbon condenses into solid particles in the star's outer atmosphere, absorbing its light.

Amateurs provide a useful service by monitoring these stars, and alerting professional astronomers when fades begin. R CrB is a particularly good candidate, easily visible in binoculars at maximum. There is always some variation, so alerts are usually triggered only when the star drops below magnitude 7.

T CrB (15ʰ57ᵐ, +26°04') is a recurrent nova, a form of cataclysmic variable. It is normally too faint for binoculars at magnitude 10.8, but erupted in 1866 and 1946, reaching magnitude 2.0, with smaller outbursts in 1963 and 1975. It is a binary system, with an orbital period of 227.6 days.

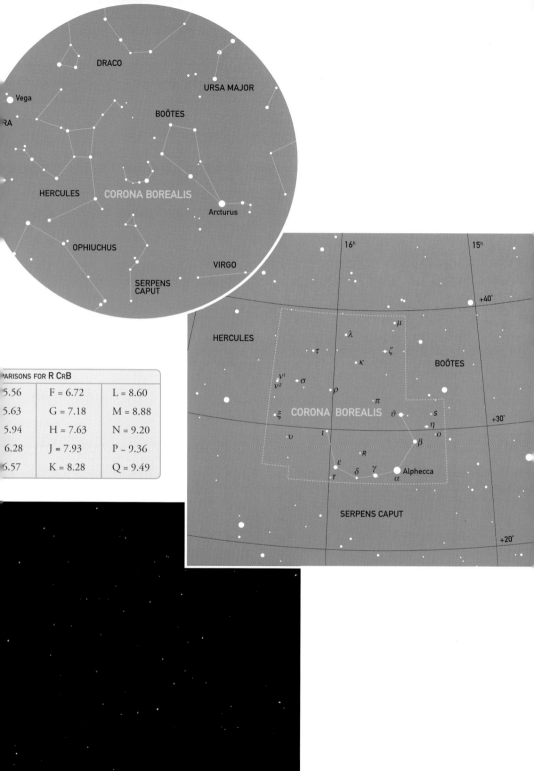

MPARISONS FOR **R CrB**

5.56	F = 6.72	L = 8.60
5.63	G = 7.18	M = 8.88
5.94	H = 7.63	N = 9.20
6.28	J = 7.93	P – 9.36
6.57	K = 8.28	Q = 9.49

CORVUS
CORVI • COR • THE CROW

The mythological tale has it that Apollo sent his bird, the crow, to fetch water in his drinking vessel (Crater). On its return, the crow stopped to eat figs, but returned bearing the serpent (Hydra) in its claws.

SOUTH AT 22:00 local time: Apr 25
VISIBLE AT 22:00 local time: Mar–Jun
AREA: 184 sq. deg. (70th)

When charged by Apollo with being late, the crow replied that the serpent had prevented it from getting to the spring. Apollo was furious with this lie, so set all three in the sky as punishment. All other crows have harsh croaks because they have a perpetual thirst.

There are few objects of interest in these two constellations, even for observers with large instruments. Immediately across the Corvus/Virgo border is M104, the Sombrero Galaxy, and this is probably easiest to find from Corvus. It lies almost exactly on the line from α Corvi (Alchiba) through δ Corvi (Algorab), extended towards the north. Similarly, M68, a globular cluster in Hydra, is best found from Corvus. It lies slightly to the east of a line from δ Corvi (Algorab) through β Corvi (Kraz), extended by about half their separation.

NGC 4361 (12h25m, −18°47') is a faint planetary nebula, that is just detectable with binoculars, but requires a large telescope to show any detail or the central star (mag. 13).

CRATER
CRATERIS • Cra • THE CUP

In mythological representations of the constellations, Crater is normally shown as a drinking vessel, resting on the back of Hydra (the Serpent). The outline formed by the stars

SOUTH AT 22:00 local time: Apr 10
VISIBLE AT 22:00 local time: Feb–May
AREA: 282 sq. deg. (53rd)

does actually resemble this type of wide-stemmed goblet, rather than the vessel known as a crater – a Greek, two-handled, mixing bowl for wine.

Crater contains no objects of interest that are visible with binoculars (or even small telescopes). There are a few variable stars, but these are either faint, or else show low-amplitude variations that are difficult to detect.

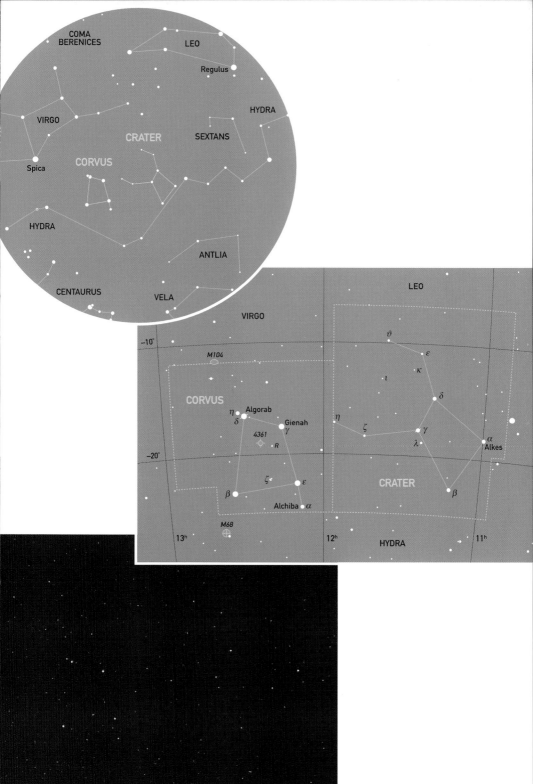

CYGNUS

CYGNI • Cyg • THE SWAN

Cygnus is a magnificent constellation that is fully visible for a large part of the year. Deneb (α Cygni) is so bright that it may be seen when close to the horizon, and is therefore circumpolar at any latitude greater than about 50°N.

SOUTH AT 22:00 local time: **Aug 25**

VISIBLE AT 22:00 local time: **May–Dec**

AREA: **804 sq. deg. (16th)**

Mythologically, many civilizations since the time of the Chaldeans have seen the constellation as a bird. In the Greek account, Cygnus represents the swan, whose appearance Zeus assumed to seduce Queen Leda of Sparta, who gave birth to Helen (of Trojan War fame) and Pollux, one of the Heavenly Twins.

α **Cyg** (20^h41^m, +45°17') is an exceptionally luminous blue-white, supergiant star, mag. 1.3. It is about 160,000 times as bright as the Sun, and lies at a distance of some 3230 light-years, farther away than any other first-magnitude star.

β **Cyg** (19^h31^m, +27°58') is a striking double (mags. 3.1 and 4.7) that may be separated with high-power binoculars, although a telescope is required to show the pair's striking colour difference. For many years it was unknown whether they formed a true binary system, but they are actually several light-years apart.

o¹ **Cyg** (20^h13^m, +46°49') is a wide double star, whose components are also known as Flamsteed 30 and 31 (mag. 4.8 and 3.8), respectively blue-white and orange in colour. Binoculars will also show a white 7th-magnitude companion.

61 Cyg (21^h07^m, +38°45') is a binary system, which powerful binoculars will reveal to consist of a pair of stars, mags. 5.2 and 6.1, that orbit their common centre of gravity once every 650 years. The fainter star, **61 Cyg B**, is the location of an extrasolar planetary system. The mass of the planet is about 1.7 times that of Jupiter, but the orbit is extremely eccentric. In the Solar System such an orbit would take the planet from the orbit of Venus nearly out to the orbit of Jupiter. It is possible that this exceptionally high eccentricity is related to the presence of the more massive star in the 61 Cygni binary system.

(*Continued on p.184.*)

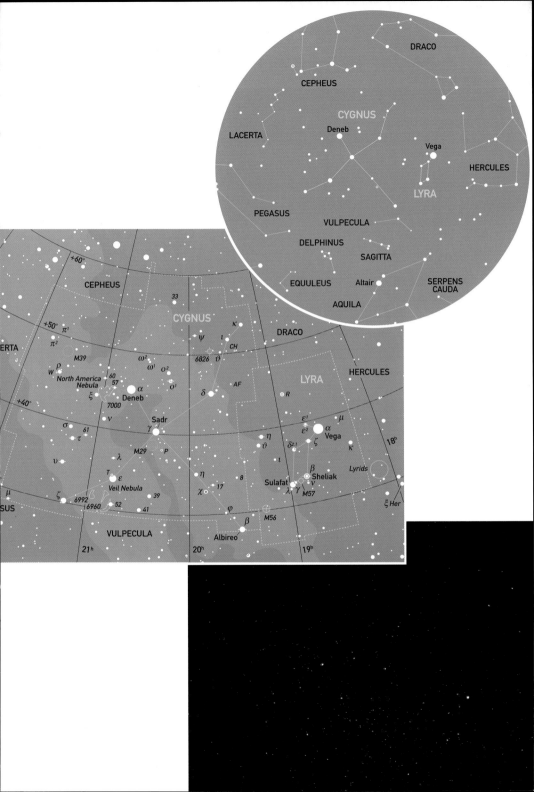

CYGNUS

χ **Cyg** (19^h49^m, $+32°47'$) is a remarkable long-period variable (Mira star) with a period of about 408 days. It has an exceptionally large range of at least 10 magnitudes (with extremes of about mag. 3.3 and 14.2). This means that its brightness varies by about 10,000 times between maximum and minimum. The chart (see right) and sequence cover the top of its range.

COMPARISONS FOR χ CYG					
β Cyg	3.11	Fl17 Cyg	5.06	G	7.32
γ Lyr	3.30	A	5.44	H	7.39
ξ Her	3.85	B	5.55	K	8.11
η Cyg	4.04	C	6.09	L	8.39
ϑ Lyr	4.41	D	6.40	M	8.68
φ Cyg	4.74	E	6.76	N	9.01
Fl8 Cyg	4.90	F	6.93	P	9.28

W Cyg (21^h34^m, $+45°09'$) is an interesting semiregular variable, always visible in binoculars, having a range of approximately mags. 5.0–7.6. It shows intervals with a relatively well-defined periodicity of about 126 days, interspersed with intervals of more irregular behaviour. (See chart right.)

COMPARISIONS FOR W CYG					
63 Cyg	4.88	F	5.54	K	6.82
E	5.09	A	6.12	5	7.20
D	5.38	I	6.60	L	7.52

CH Cyg (19^h23^m, $+50°09'$) is a fascinating system, because it exhibits several types of behaviour, with an overall magnitude range of approximately 5.0–10.7. It is a symbiotic binary, which occasionally brightens in an irregular fashion. The red component is a semiregular variable, and it also appears to be an eclipsing system. (See chart right.)

COMPARISONS FOR CH CYG					
A	6.5	H	9.2	R	10.8
B	7.4	J	9.4	S	11.0
F	8.5	P	10.1	T	11.7

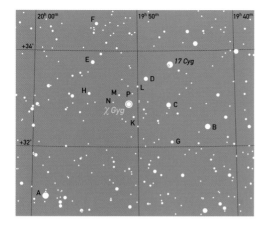

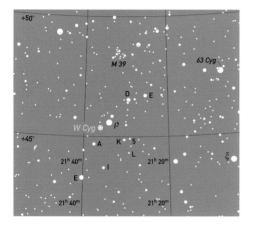

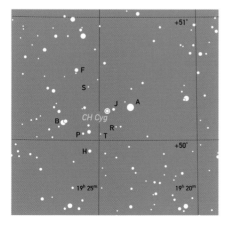

P Cyg (20h16m, +37°53') is an extremely bright supergiant star that is slightly variable and is ejecting shells of material. Around the year 1600 it brightened to about magnitude 3, but subsequently has varied irregularly between about mags. 4.6 and 5.6. The class of stars to which it belongs, now known as the S Doradus stars, includes the most massive and luminous stars in any galaxy.

M39 (21h32m, +48°27') is a sparse open cluster, roughly triangular in shape, and best observed with low magnifications.

NGC 6992 (20h56m, +31°43') is a gaseous nebula. Together with **NGC 6960**, it is known as the Veil Nebula. Both are parts of the much larger Cygnus Loop, which is the remnant of a supernova explosion that occurred about 15,000 years ago. A difficult binocular object, requiring excellent conditons.

NGC 7000 (21h02m +44°12'), the North America Nebula, is just detectable with the naked eye under perfectly clear conditions. It does not stand magnification particularly well.

DELPHINUS

DELPHINI • Del • THE DOLPHIN

This small, distinctive constellation has been identified with a dolphin (which it does somewhat resemble) since Greek times. In legend, it represents the dolphin that rescued the musician and poet Arion from drowning.

SOUTH AT 22:00 local time:	**Sep 01**
VISIBLE AT 22:00 local time:	
AREA:	**189 sq. deg. (69th)**

The two brightest stars, α and β Delphini, are sometimes known by the rather contrived names of Sualocin and Rotanev. Reversed, these read 'Nicolaus Venator', the Latinized name of Niccolo Cacciatore, who was assistant and successor to the famous Italian observer Guiseppi Piazzi (the discoverer of Ceres).

There are no interesting objects readily visible with binoculars or small telescopes. There are a few variable stars that are studied by amateurs, but none of highly individual interest.

EQUULEUS

EQUULEI • Equ • THE LITTLE HORSE

The very small constellation appears to have been introduced by Ptolemy, the famous Greek astronomer, who lived and worked in the 2nd century BC.

SOUTH AT 22:00 Local time:	**Sep 10**
VISIBLE AT 22:00 local time:	
AREA:	**72 sq. deg. (87th)**

Like its larger neighbour, Pegasus, Equuleus is generally shown, in pictorial representations, as just part of a horse – usually just the head. It is not associated with any tales from Greek mythology.

γ **Equ** (21^h10^m, $+18°08'$) is a wide optical double, consisting of a yellowish-white star of mag. 4.7, with a similarly coloured, companion of mag. 6.1.

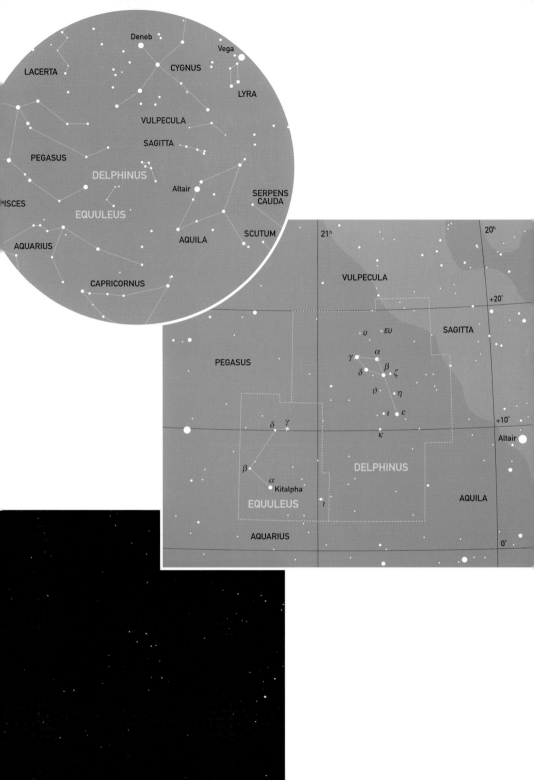

DRACO

DRACONIS • Dra • THE DRAGON

This is an ancient constellation, certainly dating back to the time of the Chaldeans. The Greeks associated it with at least two legends: one that it represented Ladon, the dragon that guarded the garden of the Hes-

SOUTH AT 22:00 local time: Jul 20

CIRCUMPOLAR: ALWAYS VISIBLE;
FULLY VISIBLE: 90°N t0 4°S

AREA: 1083 sq. deg. (8th)

perides, and that it was slain by Hercules, when he had to obtain the golden apples of the Hesperides as one of his twelve great labours. (In pictorial representations of the constellations, Hercules has one foot on the dragon's head.) In another account, it was supposed to be a dragon flung into the sky by Athena, during the battle between the gods and the Titans.

At the time when the Pyramids were erected (around 2800 BC), α Draconis (Thuban) was close to the North Celestial Pole, which, through precession, has since shifted to lie near Polaris. Airshafts within the Pyramids actually point towards the position of the pole.

v **Dra** (17^h32^m, +55°11') is an extremely fine, wide binocular double, consisting of a pair of almost identical white stars, both magnitude 4.9.

ψ **Dra** (17^h42^m, +72°09') may be resolved with binoculars under good conditions into a pair of yellowish-white and yellow stars of mags. 4.6 and 5.8.

16 Dra (16^h36^m, +52°54') and **17 Dra** (16^h36^m, +52°55') are a wide pair of stars, easily seen in binoculars, at magnitudes 5.1 and 5.5. 16 Dra itself consists of a pair of stars, mags. 5.4 and 6.4, but requires a small telescope to be resolved.

39 Dra (18^h24^m, +58°48') is a double star that may be resolved in binoculars into a pair of stars of magnitudes 5.0 and 7.2. The brighter of these has a 8th-magnitude companion that may be seen in large binoculars or a small telescope.

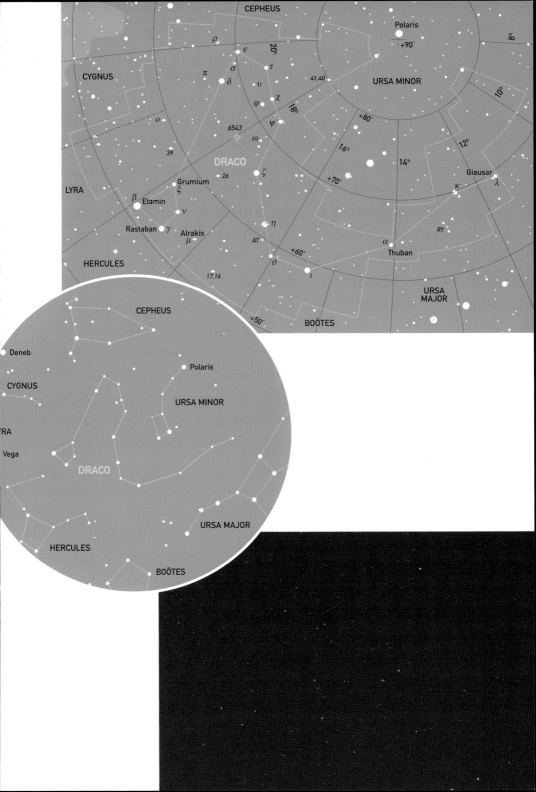

ERIDANUS

ERIDANI • Eri • THE RIVER ERIDANUS

Eridanus is a very large constellation, but one that is not often recognized, partly because many of the stars are relatively faint, but also because it extends over a

SOUTH AT 22:00 local time: Dec 20

VISIBLE AT 22:00 local time: Oct–Jan

AREA: 1138 sq. deg. (6th)

great north-south distance and may only be seen in its entirety from about 30°N to 90°S. In Greek mythology, it represented the river into which Phaeton fell after his unsuccessful attempt to drive the chariot belonging to his father, the sun-god Helios. It was also viewed as representing the River Nile and, later, even the River Po in Italy.

The constellation originally included the stars that now form Fornax, and ended at ϑ Eridani, Acamar (formerly named Achernar). The constellation was subsequently extended to the south, and the name transferred to what is now α Eridani, a blue-white star of mag. 0.5 in the far south. Both Acamar and Achernar arise from the same Arabic linguistic root, and mean 'End of the River'.

ε Eri (03^h33^m, –09°27') a yellow-orange star, magnitude 3.7, is still relatively young. It is one of the closest stars, lying at a distance of just 10.5 light-years, and was one of the stars chosen by Frank Drake in the first attempt at a Search for Extraterrestrial Intelligence (SETI), about four decades ago. It has recently been found to be the closest extrasolar planetary system. The planet that has been discovered is probably a gas giant, with a mass 0.8 times that of Jupiter, orbiting at a distance of about 3 AU from the star. (Jupiter orbits at 5.2 AU in our own Solar System.)

o² Eri (04^h15^m, –07°39') is slightly cooler than the Sun and appears as magnitude 4.4. It is actually a triple system, and fairly large telescopes reveal a white dwarf companion (magnitude 9.5). The white dwarf is the nearest such star to the Solar System, and the easiest to detect (with appropriate equipment). It also forms a binary pair with an 11th-magnitude red dwarf, with an orbital period of about 250 years.

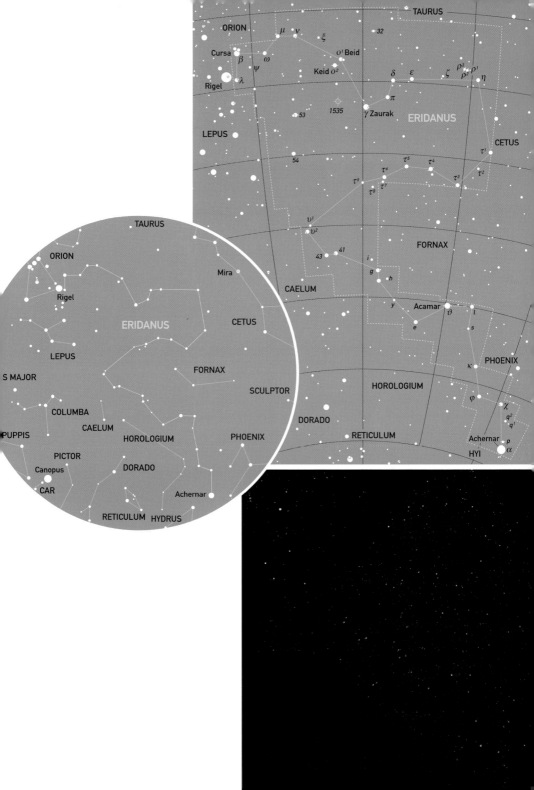

GEMINI

GEMINORUM • Gem • THE TWINS

In Greek mythology, this constellation repre-
sents Castor and Pollux, twins – more cor-
rectly half-brothers – born to Queen Leda of
Sparta. Castor was the mortal son of King

SOUTH AT 22:00 local time: **Feb 05**

VISIBLE AT 22:00 local time: **Oct–May**

AREA: **514 sq. deg. (30th)**

Tyndareus, and Pollux the immortal son of Zeus, ruler of the gods (*see* Cygnus). The twins
accompanied Jason on his search for the Golden Fleece (*see* Aries), and later became the
patron saints of sailors.

As with human twins, people often find it difficult to remember which star is which. Castor (α
Geminorum) comes earlier in the alphabet, slightly precedes Pollux, and is farther north. Pollux
(β Geminorum) is 'lower', closer to Procyon (α Canis Minoris) in the sky. It is actually the brighter
of the two stars.

Fittingly, Gemini contains numerous double and binary stars. Unfortunately few of them are
visible in binoculars or small telescopes.

α Gem (07^h35^m, +31°53') is a remarkable multiple star, regrettably only resolved in a moderate-
sized telescope. The blue-white star (mag. 1.6) proves to consist of two components (mags. 1.9
and 3.0), with an orbital period of 470 years. Each component is a close binary system. A red-
dwarf companion is an eclipsing binary, so the overall system consists of six individual stars.

COMPARISONS FOR ζ AND η GEM	
A = μ Gem 2.86	E = λ Gem 3.59
B = ε Gem 2.98	F = ν Gem 4.14
C = ζ Tau 3.03	G = 1 Gem 4.15
D = χ Gem 3.34	

ζ Gem (07^h04^m, +20°34') is both a double star and a vari-
able. Binoculars readily show that it is a wide double, con-
sisting of a yellow star and an unrelated companion of mag.
7.1. The yellow supergiant is a Cepheid variable, ranging
between mags. 3.6 and 4.2, with a period of 10.2 days.

η Gem (06^h15^m, +22°30') is a red semiregular variable, with a magnitude range of approximate-
ly 3.2 to 3.9, with intervals showing a moderately well-marked periodicity of 233 days. It is also
an eclipsing binary with a period of 2938 days.

M35 (06^h09^m, +24°19') is a large open cluster, visible to the naked eye, and with some stars
resolved in binoculars.

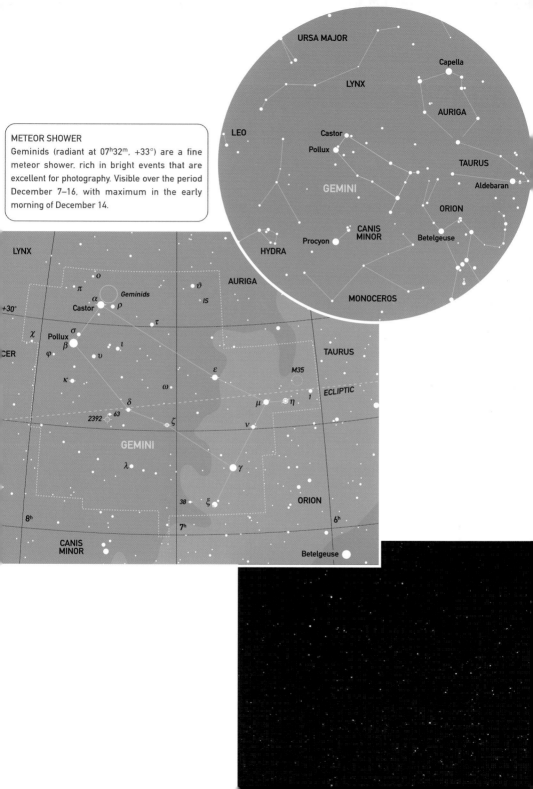

METEOR SHOWER
Geminids (radiant at 07h32m, +33°) are a fine meteor shower, rich in bright events that are excellent for photography. Visible over the period December 7–16, with maximum in the early morning of December 14.

GRUS

GRUIS • Gru • THE CRANE

This is relatively modern constellation, having been introduced by two Dutch navigators, Pieter Keyser and Frederick de Houtman, and was first shown in Bayer's *Uranometria* atlas of 1603.

SOUTH AT 22:00 local time: Sep 20

VISIBLE AT 22:00 local time: Aug–Oct

AREA: 366 sq. deg. (45th)

β Gru (22^h43^m, $-46°53'$) is a red giant that is an irregular variable, difficult to observe visually, fluctuating between magnitudes 2.0 and 2.3

$δ^1$ Gru (22^h29^m, $-43°29'$) is a yellow giant star that forms a wide optical double with $δ^2$ Gru (22^h30^m, $-43°45'$), which is a red giant. Visible as double with the naked eye.

$μ^1$ Gru (22^h15^m, $-41°20'$) and $μ^2$ Gru (22^h17^m, $-41°37'$) form another naked-eye double, where both stars are yellow giants.

π Gru (22^h23^m, $-45°56'$) is a wide optical double, consisting of a deep-red semiregular variable ($π^1$ Gru) that varies between mags. 5.4 and 6.7, with a periodicity of approximately 150 days. It lies at a distance of some 500 light-years. The second star ($π^2$ Gru) is a blue-white star of mag. 5.6 that is much closer at about 130 light-years.

PISCIS AUSTRINUS

PISCIS AUSTRINI • PsA • THE SOUTHERN FISH

This small constellation is ancient, being recognized by the Greeks. Pictorial representations show it as the fish into whose mouth Aquarius is pouring water. It was sometimes said to be the parent of the fish represented in the constellation of Pisces.

SOUTH AT 22:00 local time: Oct 01

VISIBLE AT 22:00 local time: Sep–Oct

AREA: 245 sq. deg. (60th)

The constellation contains few objects of interest even to observers with large instruments. It is mainly notable because of α Piscis Austrini (Fomalhaut), a blue-white star of magnitude 1.2. The name means 'mouth of the fish' in Arabic. It is actually a relatively close neighbour, lying at a distance of almost exactly 25 light-years. Because this area of the sky is relatively sparsely populated, the star was also sometimes known as 'The Solitary One'.

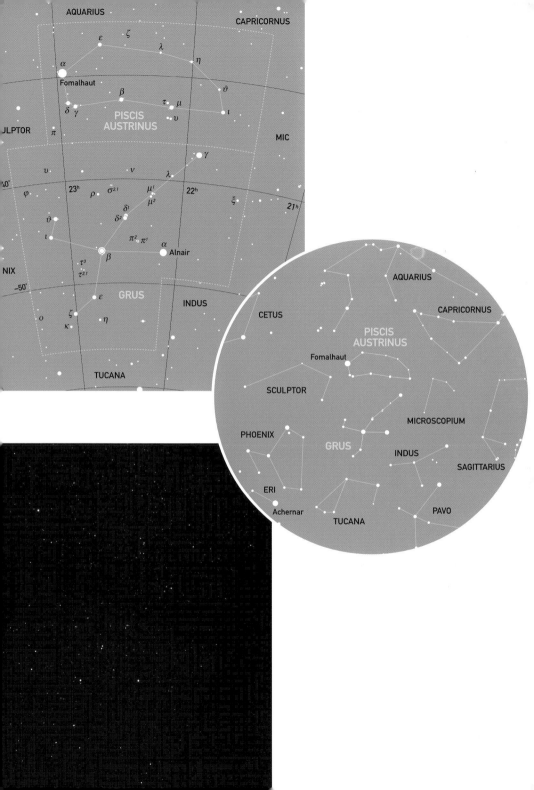

HERCULES

HERCULIS • Her

There is some suggestion that this constella-
tion was associated with the Sumerian hero
Gilgamesh, but in Greek and Roman mythol-
ogy it represents Herakles, later known as

SOUTH AT 22:00 local time: Jly 05

VISIBLE AT 22:00 local time: Mar–Oct

AREA: 1225 sq. deg. (5th)

Hercules, who was famous for undertaking twelve 'impossible' labours, several of which are
linked with other constellations. Pictorial representations show Hercules as kneeling (upside-
down) in the sky, with one foot on the head of Draco to the north. The star known as Ras Algethi
(Arabic for 'head of the kneeler'), α Her, lies to the south, on the border with Ophiuchus.

α Her (17^h15^m, +14°23') Ras Algethi, is a red supergiant that varies irregularly between about 2.7
and 4.0.

κ Her (16^h08^m, +17°03') is a fairly close double, visible in binoculars, with yellow-orange com-
ponents of mags. 5.0 and 6.3.

u Her or 68 Her (17^h17^m, +33°06') is an eclipsing binary that shows continuous changes in bright-
ness, varying between mags. 4.7 and 5.4 with a period of slightly more than 2 days.

X Her (16^h03^m, +47°14') is a semiregular variable that is always within binocular range (mag 5.5
to 7.7), and exhibits periodicity of 95 days. Chart and comparisons shown on p200.

AC Her (18^h30^m +21°52') is an interesting semiregular variable of the RV-Tauri type. Its range is
mags 6.6 to 9.1, and the period is 75 days. Chart and comparisons shown on p200.

M13 (16^h42^m, +36°27') the brightest globular in the northern sky (about mag. 5.8), visible with the
naked eye and readily seen in binoculars, when it is about half the apparent width of the Moon. It is
just over 25,000 light-years away and is approximately 100 light-years across.

M92 (17^h17^m, +43°08') is a slightly fainter globular cluster than M13 (about mag. 6.5), which
appears as a fuzzy object in binoculars. It is farther away (approximately 26,750 light-years) and
has an estimated age of about 14,000 million years, making it the oldest globular cluster known.

(Continued on p.200.)

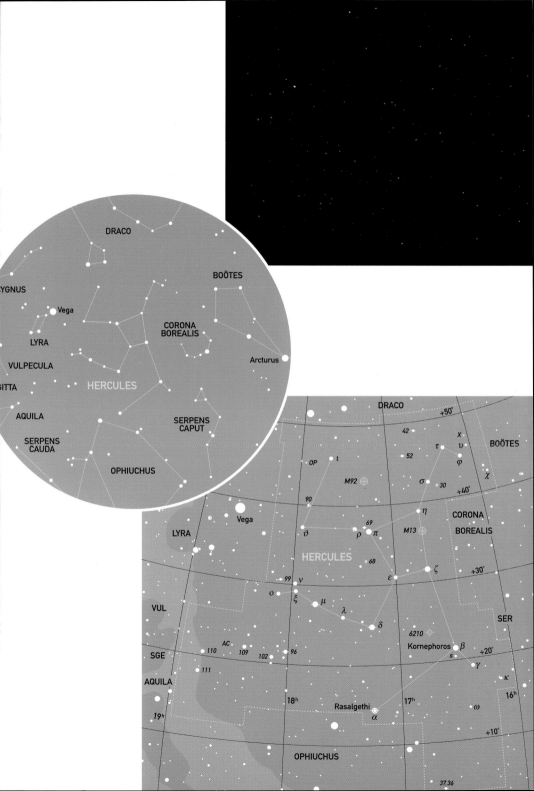

HYDRA

HYDRAE • Hya

Rather than depicting the Ler-
naean Hydra, slain by Hercules
as one of his twelve labours,
mythologically, this constellation

SOUTH AT 22:00 local time: **Mar 10 (Alphard)**

VISIBLE AT 22:00 local time: **Jan–May (Head & Alphard)**

AREA: **1303 sq. deg. (1st)**

represents a snake that was guarding a spring to which Apollo sent his crow (Corvus) to obtain water. It is the largest of all the constellations and covers nearly seven hours in right ascension.

The head of Hydra is a chance association of six stars that actually lie at very different distances, ranging from 135 to 466 light-years. The northernmost star, ε Hya, is unusual, because it consists of five components, bound together gravitationally – it is a quintuple system.

27 Hya (09^h21^m, $-09°34'$) near α Hya (Alphard) is a wide double, easily detectable in binoculars as a white star, mag. 4.8, and a yellowish companion, mag. 7.0.

R Hya (13^h30^m, $-23°17'$) is a red-giant, long-period variable that reaches mag. 3.5 at maximum, 10.9 at minimum, and has a period of 389 days.

U Hya (10^h38^m, $-13°23'$) is an interesting semiregular variable, with a range of mags. 4.7 to 5.2, and a periodicity of 450 days, and other intervals of more irregular activity.

M48 (08^h14^m, $-05°47'$) is a very large open cluster, just visible to the naked eye and a fine object in binoculars.

M68 (12^h40^m, $-26°45'$) is an 8th-magnitude globular cluster, detectable in binoculars.

M83 (13^h37^m, $-29°52'$) is an 8th-magnitude, face-on spiral galaxy, easily seen in binoculars.

NGC 3242 (10^h25^m, $-18°39'$) is a planetary nebula, known as the 'Ghost of Jupiter' from its resemblance to the planet. It is detectable at low magnifications, but requires a large telescope to show its greenish disk.

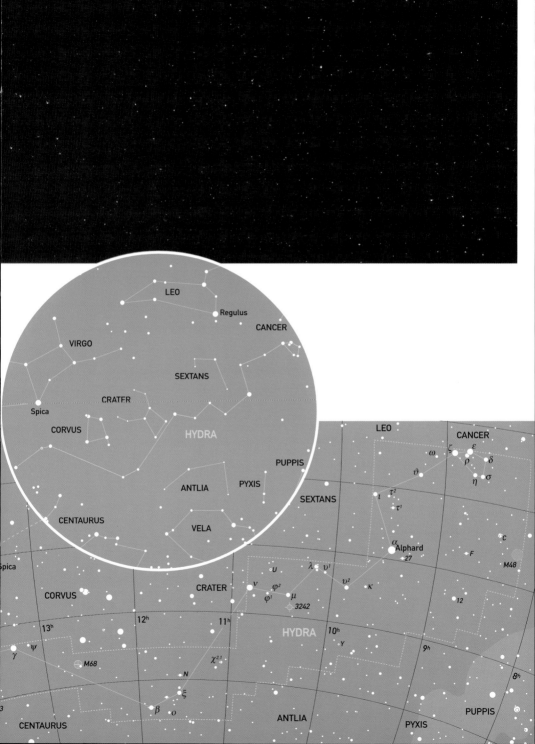

LACERTA

LACERTAE • Lac • THE LIZARD

This small constellation was introduced in 1687, like Canes Venatici, by Hevelius. It consists of a zig-zag of moderately faint stars lying between Cygnus and Andromeda. The northern portion of the constellation lies in the Milky Way.

SOUTH AT 22:00 local time: **Sep 25**
VISIBLE AT 22:00 local time: **May–Feb**
AREA: **201 sq. deg. (68th)**

8 Lac (22h36m, +39°38') is a double star, consisting of two white stars, mags 5.7 and 6.5, which may be resolved with binoculars under good conditions.

NGC 7209 (22h05m, +46°30') is an open cluster in which binoculars show just a few stars against an apparently nebulous background.

NGC 7243 (22h15m, +49°53') is an irregularly shaped, sparse open cluster, visible in binoculars.

HERCULES
(*Continued from p.196.*)

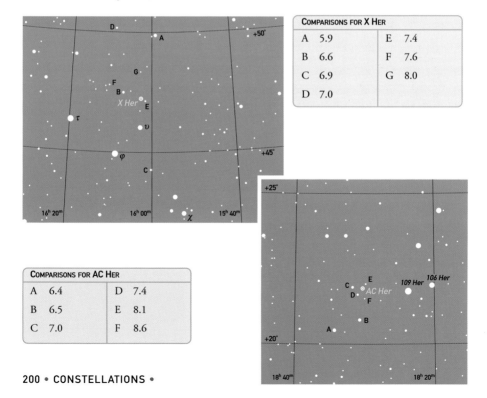

COMPARISONS FOR **X HER**			
A	5.9	E	7.4
B	6.6	F	7.6
C	6.9	G	8.0
D	7.0		

COMPARISONS FOR **AC HER**			
A	6.4	D	7.4
B	6.5	E	8.1
C	7.0	F	8.6

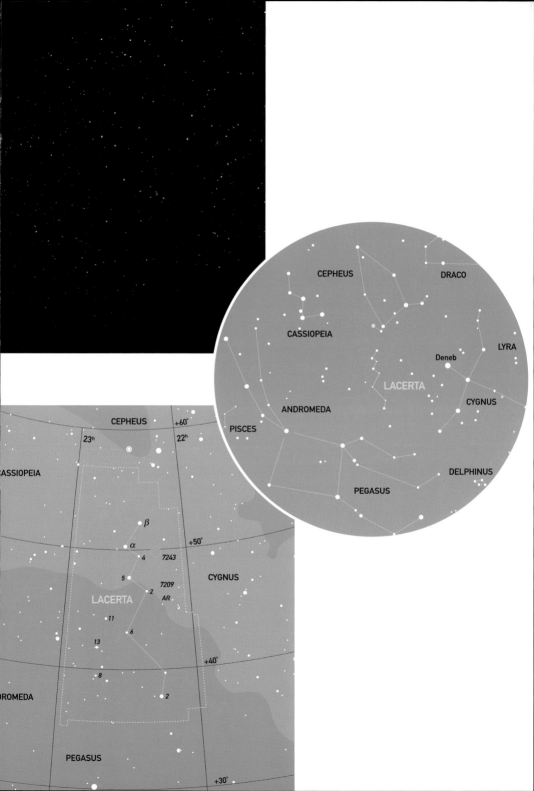

CEPHEUS

DRACO

CASSIOPEIA

LYRA

Deneb

LACERTA

CYGNUS

ANDROMEDA

PISCES

DELPHINUS

PEGASUS

CEPHEUS +60° 22ʰ

23ʰ

CASSIOPEIA

β

α

4 7243 +50°

5 CYGNUS

7209

2 AR

LACERTA

11

13 6

8 +40°

ANDROMEDA

2

PEGASUS

+30°

LEO

LEONIS • Leo • THE LION

This ancient constellation has been associated with a lion ever since the Sumerian and Babylonian periods. When those early civilizations flourished, the Sun was in Leo at the time of the summer solstice.

SOUTH AT 22:00 local time: Apr 01

VISIBLE AT 22:00 local time: Jan–Jun

AREA: 947 sq. deg. (12th)

Because of precession, the solstice now occurs in Gemini, and the Sun is in Leo throughout the last half of August and the beginning of September. The Greeks saw the constellation as the Nemean Lion, which was slain by Herakles (Hercules) as the first of his twelve labours.

α **Leo** (10^h08^m, +11°58') Regulus, is a blue-white star of mag. 1.4 that forms a wide double with a mag. 7.7 companion.

ζ **Leo** (10^h17^m, +23°25') Adhafera, appears as a wide triple in binoculars. The stars are unrelated to one another: ζ is mag. 3.4; 35 Leo to the north is mag. 6.0; and, slightly farther to the south, 39 Leo is mag. 5.8.

R Leo (09^h48^m, +11°24') is a long-period (310 days) variable of the Mira type. It rises to mag. 5.9 at normal maxima, but may occasionally become much brighter, reaching as much as mag. 4.4, when it appears strongly red. At minimum it is generally about mag. 10, but may go even lower.

M65 (11^h19^m, +13°05') is a 10th-magnitude spiral galaxy, just detectable in large binoculars under good conditions.

M66 (11^h20^m, +12°59') is also a spiral galaxy, slightly easier to detect than M65.

LEO MINOR

LEO MINORIS • LMi • THE LITTLE LION

This small constellation was another that was introduced by Hevelius in 1687 (p.200).

SOUTH AT 22:00 local time: Apr 01

VISIBLE AT 22:00 local time: Jan–Jun

AREA: 232 sq. deg. (64th)

It is extremely inconspicuous, and contains no objects of interest that are visible with binoculars or small telescopes. Because of an error, when the stars were given designations, α was omitted, so the brightest star is actually 46 LMi (mag. 3.8), and the second brightest is β (mag. 4.2).

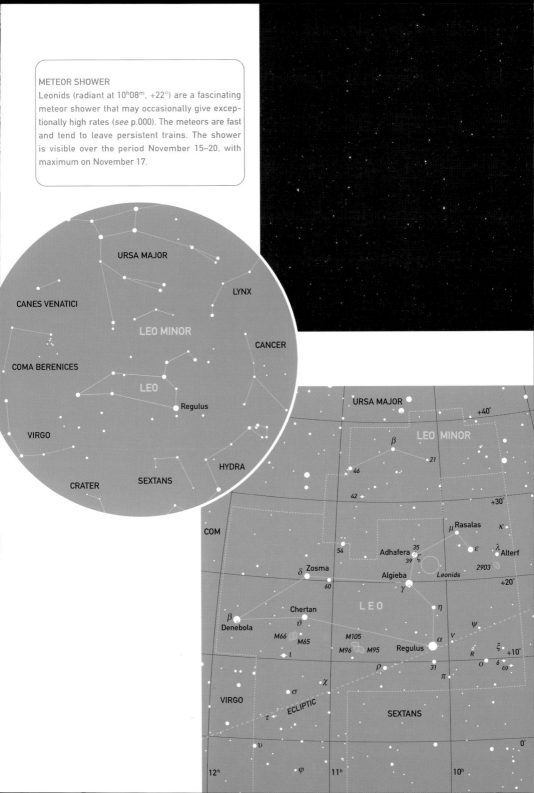

LEPUS

LEPORIS • Lep • THE HARE

Since the time of the Greeks, this small constellation has been associated with a hare, crouching at the feet of Orion, the great hunter. The name Arneb for the brightest star, α Leporis, is Arabic for 'the hare'.

SOUTH AT 22:00 local time:	**Jan 15**
VISIBLE AT 22:00 local time:	**Nov–Feb**
AREA:	**290 sq. deg. (51st)**

γ **Lep** (05^h35^m, $-22°27'$) is a wide double star, consisting of two yellow stars, mags. 3.6 and 6.2, readily visible in binoculars.

R Lep (05^h00^m, $-14°49'$) is a long-period (Mira-type) variable, that ranges between magnitudes 5.5 and 11.7, with a period of 427 days. At maximum, when it is just visible to the naked eye, it appears intensely red. It was called the Crimson Star by the 19th-century British observer John Russell Hind, who described it as 'a drop of blood on a black field'.

M79 (05^h24^m, $-24°31'$) is a faint globular cluster that may be detected in binoculars under favourable conditions. It is actually extremely distant, lying well over 42,000 light-years away.

COLUMBA

COLUMBAE • Col • THE DOVE

This constellation is another of those proposed by Petrus Plancius, the Dutch astronomer. Although sometimes said to represent the dove that the Argonauts used

SOUTH AT 22:00 local time:	**Jan 20**
VISIBLE AT 22:00 local time:	**Dec–Feb**
AREA:	**270 sq. deg. (54th)**

to help them pass the Clashing Rocks at the entrance to the Black Sea, Plancius, who was also a theologian, intended it to commemorate the dove that Noah sent out from the Ark to search for dry land.

T Col (05^h17^m, $-33°46'$) is a long-period (Mira) variable, with a period of about 226 days, which reaches 6.7 at maximum, easily visible in binoculars. Its minimum is about 12.7, however, requiring a moderate-sized telescope.

NGC 1851 (05^h14^m, $-40°02'$) is a 7th-magnitude globular cluster that may be glimpsed in binoculars.

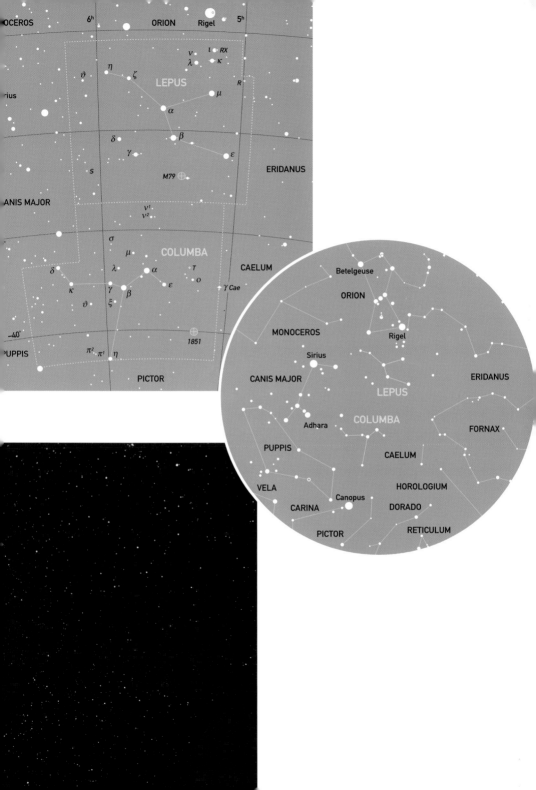

LIBRA

LIBRAE • Lib • THE SCALES

This constellation originally formed part of Scorpius, the next zodiacal constellation to the east, and was regarded as forming the animal's claws. It was not until Roman

SOUTH AT 22:00 local time: **Jun 10**

VISIBLE AT 22:00 local time: **Apr–Jly**

AREA: **538 sq. deg. (29th)**

times that two separate constellations were formed. The association with Scorpius persists in the Arabic names for α, β, and γ Lib (Zubenelgenubi, Zubeneschamali, and Zubenalakrab, meaning 'southern claw', 'northern claw', and 'scorpion's claw', respectively). Subsequently, Libra came to be associated with the scales of justice, which were often regarded as being held by Virgo, the zodiacal constellation to the west.

At one time the autumnal equinox lay in this region of the sky, another reason for it to be associated with a balance (between summer and winter). Although precession caused the equinox to move into Virgo in the 8^{th} century BC, by analogy with the First Point of Aries, the autumnal equinox is occasionally known as the First Point of Libra.

α **Lib** (14^h51^m, −16°03') Zubenelgenubi, is a wide double star, consisting of a blue-white star of mag. 2.7, and a fainter (white) companion of mag. 5.2.

δ **Lib** (15^h01^m, −08°31') is an eclipsing variable, similar to Algol (β Per). It has a period of approximately 2 days 8 hours and varies between mags. 4.9 and 5.9.

ι **Lib** (15^h12^m, −19°48') at mag. 4.5, forms a wide binocular double with 25 Lib, which is mag. 6.1. The pair are sometimes known as $ι^1$ and $ι^2$ Librae. ι Lib is actually a multiple star, but only two components may be seen even with moderate-sized instruments.

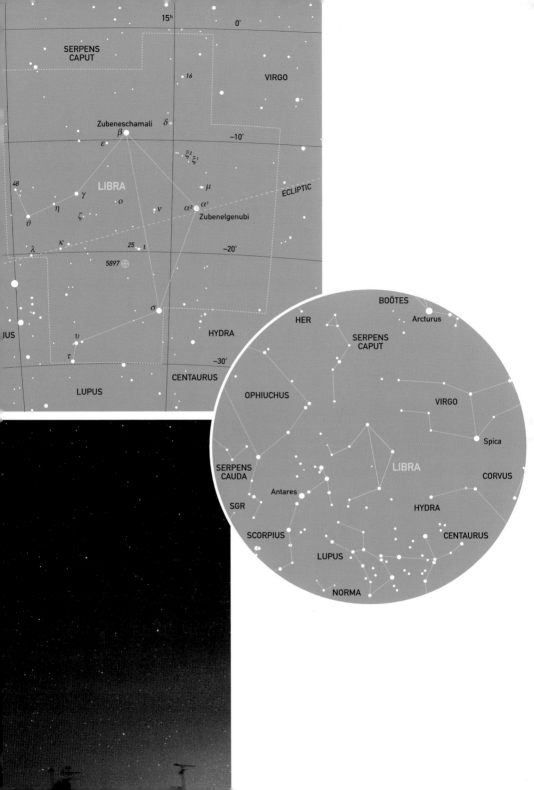

LYNX

LYNCIS • Lyn • THE LYNX

This is yet another constellation introduced in 1687 by Johannes Hevelius to fill the large, relatively blank area between Ursa Major, Auriga, and Gemini. It is actually larger than Gemini, but is very poorly known to most

SOUTH AT 22:00 LOCAL TIME: Feb 20

CIRCUMPOLAR ABOVE 57°N

VISIBLE AT 22:00 local time: Oct–Jly

AREA: 545 sq. deg. (28th)

astronomers and was reputedly named because it required keen eyesight to see it. (Hevelius himself being noted for his excellent eyesight.)

Because the original representations of constellations did not have any rigid boundaries, when these came to be fixed by the International Astronomical Union in 1930, some stars, previously given specific designations, were found to lie on the 'wrong' side of the boundaries. In this area of the sky, the stars 10 UMa and 41 Lyn are cases in point, because they now lie within Lynx and Ursa Major, respectively.

5 Lyn (06h27m, +58°25') is a binocular double, consisting of a pair of yellow and orange stars, mags. 5.2 and 7.8.

41 Lyn (09h29m, +45°36') over the border inside Ursa Major, is a wide binocular double, with stars of mags. 5.4 and 7.9.

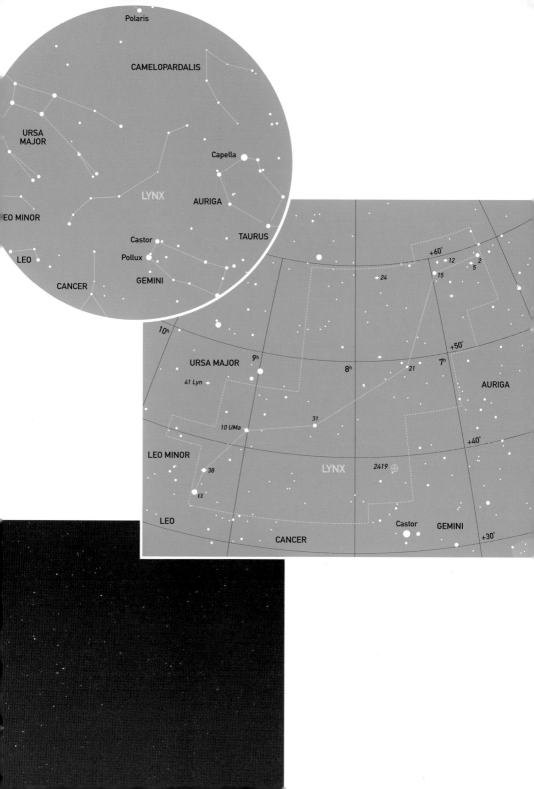

LYRA

LYRAE • Lyr • THE LYRE

In Greek mythology, this small constellation was envisaged as the lyre that belonged either to the musician Arion (p.186), who was rescued by a dolphin, or to Odysseus,

SOUTH AT 22:00 local time: **Aug 01**

VISIBLE AT 22:00 local time: **Mar–Dec**

AREA: **286 sq. deg. (52nd)**

an even greater musician. Arab astronomers, however, envisaged it and the constellations of Cygnus, and Aquila as representing three birds, and the name Vega for α Lyrae means 'swooping eagle'. The brightest stars of these three constellations: Vega, Deneb (α Cygni) and Altair (α Aquilae) form the prominent Summer Triangle. Vega is circumpolar at a latitude greater than about 52°N.

β Lyr (18h50m, +33°22') Sheliak, is the type star for eclipsing stars that show continuous variations, even outside eclipses. It has a period of 12 days 22 hours and varies between mags. 3.3 and 4.3.

COMPARISONS FOR β LYR		
A = γ Lyr 3.23	D = ϑ Her 3.86	G = κ Lyr 4.34
B = μ Her 3.42	E = ζ Lyr 4.09	H = ν Her 4.41
C = ξ Lyr 3.71	F = ρ Her 4.17	J = η Lyr 4.46

δ Lyr (18h55m, +36°54') is a wide double visible with the naked eye or binoculars and consists of a pair of unrelated stars of mag. 4.3 (δ² Lyr) and 5.7 (δ¹ Lyr). The brighter star is a red supergiant that is slightly variable.

ε Lyr (18h44m, +39°37') the Double Double, may sometimes be seen as double by people with keen eyesight and is readily revealed with binoculars. The brighter star, ε² Lyr, is of mag. 5.2, and the fainter, ε¹ Lyr, mag. 6.1. With larger apertures (60–75 mm), each star proves to be a binary system.

ζ Lyr (18h45m, +37°36') is yet another double visible in binoculars, with components of mags. 4.4 and 5.7.

R Lyr (18h55m, +43°57') is a semiregular variable that varies between mags. 3.9 and 5.0, with intervals showing a periodicity of approximately 46 days.

Comparisons as for β Lyr, with the following additions at the fainter end:

K = μ Lyr 5.00
L = 16 Lyr 5.10

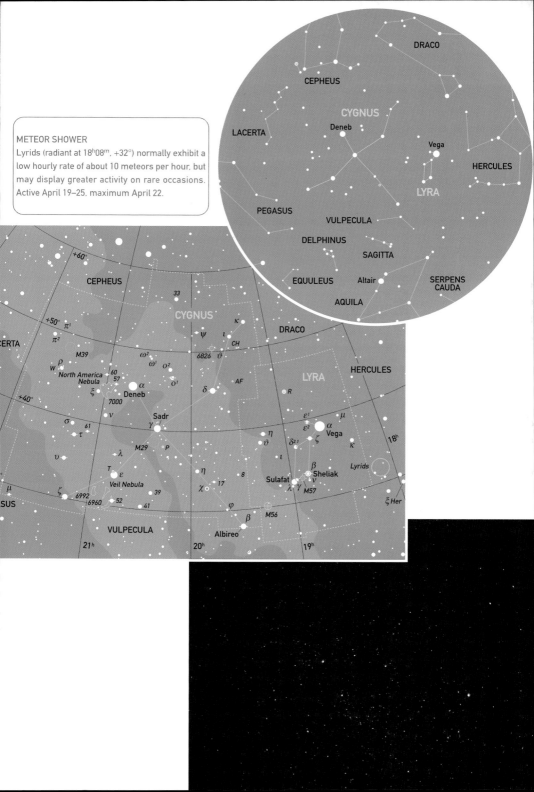

METEOR SHOWER
Lyrids (radiant at 18h08m, +32°) normally exhibit a low hourly rate of about 10 meteors per hour, but may display greater activity on rare occasions. Active April 19–25, maximum April 22.

DRACO

CEPHEUS

CYGNUS

Deneb

Vega

LACERTA

HERCULES

LYRA

PEGASUS

VULPECULA

DELPHINUS

SAGITTA

EQUULEUS Altair

SERPENS CAUDA

AQUILA

+60°

CEPHEUS

33

+50° π¹

κ

ψ ι

DRACO

π²

CH

CERTA

M39 ω² ω¹ 6826 ϑ

ρ O²

W 60 O¹ HERCULES

North America 57 δ AF R LYRA

Nebula ξ α μ

+40° 7000 Deneb ε¹ α

ν Sadr ε² Vega

σ γ η κ 18h

τ 61 ϑ δ²·¹ ζ

υ λ M29 P δ ι β Lyrids

τ ε η Sheliak

υ ε Veil Nebula χ 8 Sulafat ν ξ Her

ζ 6992 17 λ γ M57

SUS μ 6960 52 39 φ M56

41 β

VULPECULA Albireo

21h 20h 19h

MONOCEROS

MONOCEROTIS • Mon • THE UNICORN

Monoceros is another of the constellations (like Camelopardalis) that were introduced by Petrus Plancius. It straddles the Milky Way and thus contains a large number of clusters.

SOUTH AT 22:00 local time: **Feb 05**

VISIBLE AT 22:00 local time: **Dec–Apr**

AREA: **482 sq. deg. (35th)**

U Mon (07^h31^m, $-09°47'$) is an interesting semiregular variable of the RV Tauri type. Its extreme range is mag. 5.4 to 8.5, with a primary period of 91 days, and a superimposed secondary period that seems to have increased from the catalogue value of 2320 days to about 2500 days in recent years.

COMPARISONS FOR U MON			
A = 20 Mon	5.02	F	6.62
B = 25 Mon	5.17	G	6.97
C	5.57	H	7.51
D	5.85	K	7.81
E	6.00	L	8.03

V640 Mon (06^h37^m, $+06°08'$), Plaskett's Star, is an extraordinary system, being the heaviest binary known. It has an apparent magnitude of 6.1 (which is slightly variable), and consists of two blue supergiants, with masses currently estimated at 43 and 51 times that of the Sun.

M50 (07^h03^m, $-08°20'$) is an open cluster, consisting of nearly 100 stars. The brightest may be resolved in binoculars.

NGC 2232 (06^h27^m, $-04°44'$) is a loose open cluster, consisting of about 20 stars, readily visible in binoculars.

NGC 2244 (06^h32^m, $+04°51'$) is an open cluster that is just detectable with the naked eye under good conditions, and excellent in binoculars. It is surrounded by NGC 2237, the Rosette Nebula.

NGC 2264 (06^h41^m, $+09°52'$) is another open cluster that is associated with nebulosity, in this case with what is known as the Cone Nebula, only detectable in long-exposure photographs with large telescopes. The cluster may be picked up by eye, especially because it contains the bright, blue-white star S Mon, at about mag. 4.7, which is slightly variable.

NGC 2237 (06^h33^m, $+04°57'$) is the Rosette Nebula, surrounding the open cluster NGC 2244. Under good conditions the bright outer region of the nebula is detectable in binoculars.

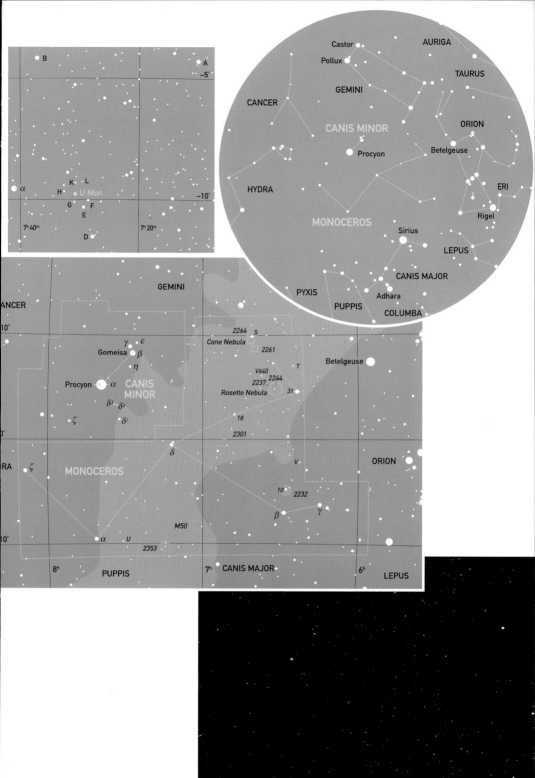

B

A

−5°

α

K L

H U Mon

G F

E

D

7h 40m 7h 20m −10°

Castor
Pollux AURIGA

GEMINI TAURUS

CANCER CANIS MINOR ORION

Procyon Betelgeuse ERI

HYDRA Rigel

MONOCEROS LEPUS

Sirius

PYXIS CANIS MAJOR

PUPPIS Adhara

COLUMBA

GEMINI

CANCER

10°

γ ε 2264 S
Gomeisa β Cone Nebula 2261
η
Procyon α CANIS V640 T Betelgeuse
MINOR 2237 2244
δ³ δ² Rosette Nebula 31
ζ δ¹ 18
2301
δ
ζ ν ORION
MONOCEROS
10 2232
β γ
M50
α U LEPUS
2353

8h PUPPIS 7h CANIS MAJOR 6h

OPHIUCHUS

OPHIUCHI • Oph • THE SERPENT BEARER

Ophiuchus is an ancient constellation generally identified with the legendary figure of Aesculapius, the god of healing. He carries the snake that was a source of his knowl-

SOUTH AT 22:00 local time:	Jul 10
VISIBLE AT 22:00 local time:	May–Sep
AREA:	948 sq. deg. (11th)

edge, and the cauduceus, consisting of a snake that is entwined about a staff, symbolizes the medical profession to this day. Ophiuchus includes a considerable length of the zodiac, although before constellation boundaries were fixed in 1930, the southernmost portion containing the ecliptic was generally regarded as part of Scorpius. Lying as it does fairly close to the Milky Way, Ophiuchus contains several open and globular clusters that are detectable with binoculars.

ρ Oph (16h26m, –23°27') not far from Antares, is one of the few multiple systems visible in binoculars, which reveal a star of mag. 5.0, and two wide companions of mags. 6.7 and 7.2. The 5th-magnitude star is itself double, but the mag. 5.7 companion is visible only with a moderate-sized telescope. (*Continued on p.216.*)

SERPENS (CAPUT)

SERPENTIS • Ser • THE SERPENT

Serpens is the only constellation that is divided into two parts, separated by Ophiuchus. Serpens caput (the Head of the Serpent) is shown here, and the chart for

SOUTH AT 22:00 local time:	Jun 20
VISIBLE AT 22:00 local time:	Mar–Sep
AREA (WHOLE CONST.):	637 sq. deg. (23rd)

Serpens Cauda (the Tail of the Serpent) appears with Scutum (p.236). Mythologically the whole constellation represents the snake born by Aesculapius, the god of healing.

β Ser (15h46m, +15°25') is a blue-white star of mag. 3.6, which forms a wide double with an unrelated star of mag. 6.7 just to its north.

R Ser (15h51m, +15°08') is a long-period (Mira) variable, with a range of mags. 5.2–14.4, and a period of 356 days. At maximum, it is visible for quite a long time in binoculars.

M5 (15h19m, +02°04') is a 6th-magnitude globular cluster, detectable with the naked eye under good conditions.

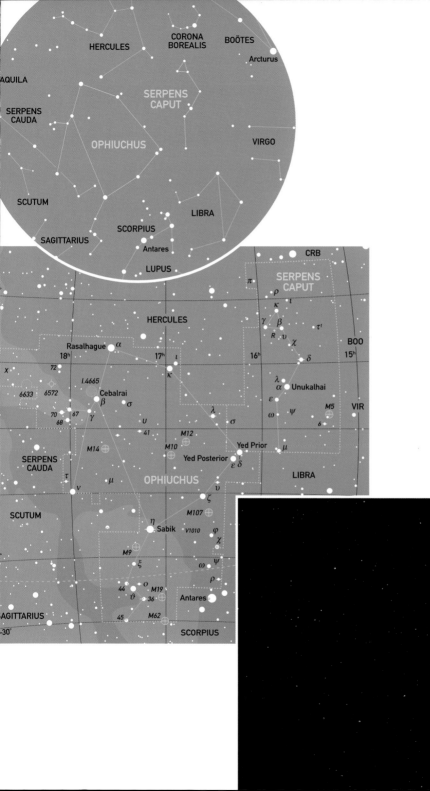

OPHIUCHUS

(Continued from p.214.)

X Oph (18h38m, +08°50') is a long-period (Mira) variable with a range of mags. 5.9 to 9.2 (and thus visible for most of the time with binoculars). It has a period of 329 days.

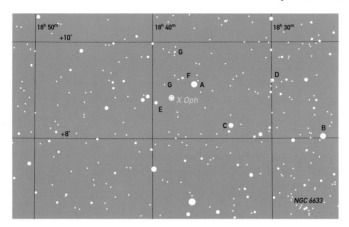

Comparisons for X Oph	
A = 5.4	E = 7.3
B = 5.7	F = 8.2
C = 6.3	G = 9.8
D = 6.8	H = 9.5

M9 (17h19m, −18°31') is a globular cluster with a combined magnitude of about 7.7 that lies on the edge of the star clouds of the Milky Way.

M10 (16h57m, −04°06') and M12 (16h47m, −01°57') are 7th-magnitude globular clusters visible in binoculars, and both of which appear about half the diameter of the Moon.

M14 (17h38m, −03°14') is a globular cluster, slightly fainter than M10 and M12 (about mag. 7.6), that appears slightly elongated in binoculars.

M19 (17h03m, −26°16') in the southern part of the constellation at nearly the same declination as Antares, is a 7th-magnitude globular cluster, that appears distinctly elongated in binoculars.

M62 (17h01m, −30°06') on the southernmost border of the constellation, and within the Milky Way, is a mag. 6.5 globular cluster.

NGC 6633 (18h28m, =06°34') is a 5th-magnitude open cluster visible with the naked eye, and well worth examining with binoculars.

IC 4665 (17h46m, +05°42') not far from β Oph, is a large, sparse open cluster that is readily seen in binoculars (and even with the naked eye), but which does not bear magnification.

U Ori (05h56m, +20°10') at the tip of Orion's 'club', is a long-period (Mira) variable that reaches mag. 4.8 at maximum, but sinks to mag. 13.0 at minimum. Its period is slightly greater than 368 days.

M42 (05h35m, −05°26' approx.) is the great Orion Nebula, classed as a diffuse nebula, and visible even to the naked eye, and as a hazy spot in binoculars and small telescopes. The visible region, illuminated by the stars of the Trapezium (ϑ1 Ori) is actually just a tiny part of a vast interstellar cloud of gas and dust. The glowing hydrogen gas has a highly distinctive pinkish colour that is evident in any photographs, even those taken with exposures of just a few seconds. Visually, however, the colour is not detectable.

M43 (05h36m, −05°16') is a small patch of nebulosity just north of M42 and visible under good conditions in binoculars. In fact it is merely part of the whole Orion Nebula complex.

NGC 1981 (05h35m, −04°26') is a sparse open cluster that is detectable with the naked eye, but has so few stars that it does not bear much magnification.

NGC 2024 (05h41m, −01°24') is a bright open cluster, but is so close to ζ Ori (Alnitak) that it is difficult to detect. It is best if Alnitak is kept just outside the binocular field of view.

NGC 2169 (06h08m, +13°57') is a fairly small open cluster consisting of about 30 stars.

METEOR SHOWER
Orionids (radiant at 06h24m, +15°) are a moderately active meteor shower, with a peak hourly rate of about 25. They are active Oct.16–27 and come to a flat maximum on Oct.20.

ORION

ORIONIS • Ori

In Greek mythology, Orion was a great hunter, the son of Poseidon, who fell in love with the Pleiades, nymphs whom he pursues across the sky. (He simultaneously

SOUTH AT 22:00 local time: **Jan 30**

VISIBLE AT 22:00 local time: **Nov–Mar**

AREA: **594 sq. deg. (26th)**

raises his club to ward off Taurus.) Orion was killed by a scorpion's sting, so lies on the opposite side of the sky to Scorpius. He is accompanied by his two hunting dogs (Canis Major and Canis Minor), and Lepus (the Hare) is hiding beneath his feet.

Orion is the finest of all the constellations, with its bright stars Betelgeuse and Rigel (α and β Ori), the three stars that form the 'belt', δ, ε and ζ Ori (Mintaka, Alnilam and Alnitak, respectively) and the great Orion Nebula (M42). From its its position straddling the celestial equator, the constellation may be seen in its entirety from most of the Earth, and dominates the winter skies in the northern hemisphere.

α Ori (05^h55^m, $+07°24'$) Betelgeuse, is a red supergiant, about 800 times the diameter of the Sun, at a distance of 427 light-years. It is slightly variable, ranging from about mag. 0.3 to 1.2, and occasionally shows intervals with a periodicity of about 2335 days (which is approximately 7 years). It is difficult to estimate visually, because of its colour, and also because comparision stars are some distance away, and of different colours. The following may be used:

A = α Aur 0.09	E = α Tau 0.80	L = α Leo 1.35
C = α CMi 0.36	G = β Gem 1.15	

β Ori (05^h15^m, $-08°12'$) Rigel, is a complete contrast to Betelgeuse, being a much hotter blue supergiant star. It always appears brighter, being of mag. 0.2, despite lying farther away, at 773 light-years, but it is actually exceptionally luminous, being about 50,000 times as bright as the Sun.

ϑ Ori (05^h35^m, $-05°24'$) is a wide, bright double consisting of $ϑ^1$ and $ϑ^2$, both of which have magnitudes of about 5.1. A telescope shows that $ϑ^1$ is actually a multiple (quadruple) system, known as the Trapezium, that illuminates the centre of the Orion Nebula. The four stars have mags. of 5.1, 6.7, 6.7 and 8.0, and there are, in fact, another two 11th-magnitude stars in the same cluster. In binoculars, $ϑ^2$ is double, with stars of mags. 5.1 and 6.4.

ι Ori (05^h36^m, $-05°55'$) is a double star, but one resolved only through a telescope. It lies in the same field, however, as another object, known as Struve 747, which binoculars reveal to be a pair of stars of mags. 4.8 and 5.7. (*Continued on p.217.*)

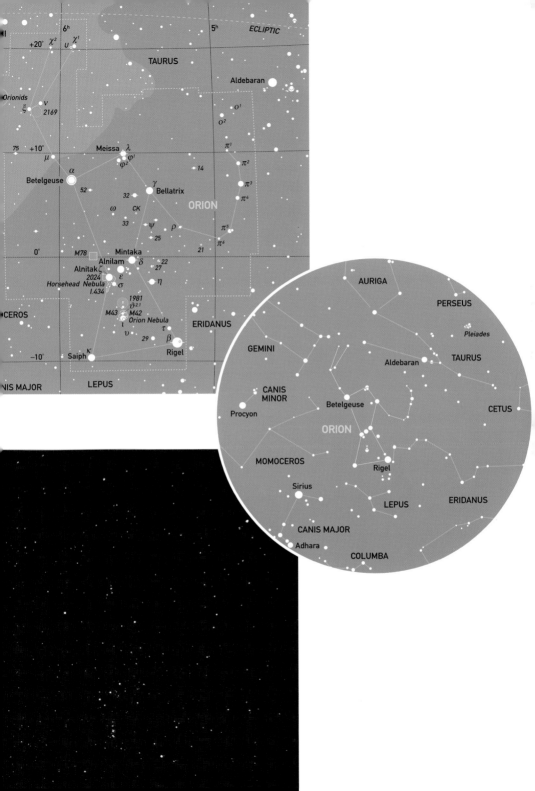

GEMINI

6ʰ

5ʰ ECLIPTIC

+20° χ² χ¹
U

χ¹

TAURUS

Aldebaran

Orionids
ξ ν
2169

O¹

O²

75 +10°
μ

Meissa λ
φ² φ¹

π¹

π²

14

α
Betelgeuse

52

γ Bellatrix

32

ω CK

33

ψ ρ
25

π³

π⁴

ORION

π⁵

π⁶

21

0° M78
 Mintaka
Alnilam δ 22
Alnitak ζ 27
2024 ε
Horsehead Nebula σ
I.434
 1981
 ϑ²·¹
M43 M42
 ι Orion Nebula τ
 υ 29 β
Saiph κ Rigel

η

22
27

ERIDANUS

CEROS

−10°

NIS MAJOR LEPUS

AURIGA

PERSEUS

Pleiades

GEMINI Aldebaran TAURUS

CANIS
MINOR Betelgeuse CETUS

Procyon ORION

MOMOCEROS Rigel

Sirius ERIDANUS

CANIS MAJOR LEPUS

Adhara

COLUMBA

PEGASUS

PEGASI • Peg

This constellation represents the winged horse that in Greek myth, sprang from the drops of blood spilt on the ground when Perseus beheaded the Gorgon, Medusa.

SOUTH AT 22:00 local time: Oct 20

VISIBLE AT 22:00 local time: Jly–Jan

AREA: 1121 sq. deg. (7th)

Subsequently, when Pegasus landed on Mount Helicon, a hoof struck the ground and opened up the famous Hippocrene spring, reputedly a source of inspiration for poets.

For such a large constellation, Pegasus has relatively few interesting objects, and it is instructive to see how many stars are visible to the naked eye within the Great Square of Pegasus (formed by α, β, and γ Peg and α And). Less than perfect conditions (or light pollution) may cause the Square to appear completely empty.

β **Peg** (23^h04^m, $+28°05'$) Scheat, is an irregular red variable that ranges between mags. 2.3 and 2.7.

ϵ **Peg** ($21^h 44^m$, $+09°53'$) Enif, is a wide double star, which is just detectable with good-quality binoculars under good conditions. One star (actually a yellow supergiant) is of mag. 2.4 and the second is approximately mag. 8.0.

AG Peg (21^h51^m, $+12°38'$), not far from Enif, is an interesting variable star readily visible in binoculars. Classed as a very slow nova, it had an outburst in 1870 and slowly declined, but has shown erratic behaviour ever since, including intervals when the binary system's orbital period of 820 days is detectable.

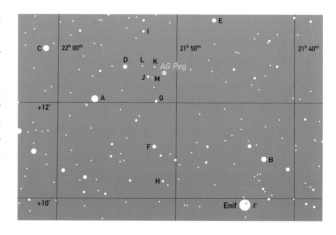

51 Peg (22^h58^m, $+20°47'$) is a faint (mag. 5.5) star very similar to the Sun. It is an extrasolar planetary system, of the 'hot Jupiter' type, with a large planet (0.45 the mass of Jupiter) orbiting just 0.05 AU from the star, and with an orbital period of only 4.23 days.

M15 (21h30m, $+12°10'$) is one of the finest northern globular clusters, easily visible in binoculars.

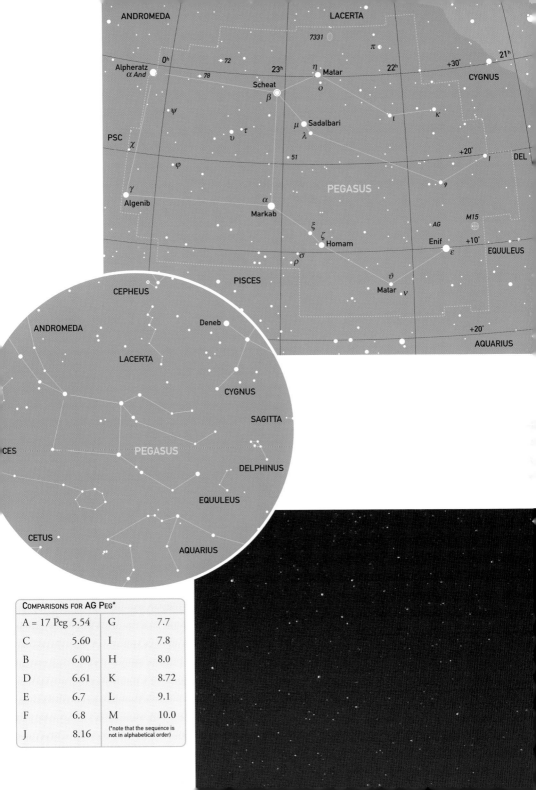

ANDROMEDA

LACERTA

7331

π

CYGNUS

21ʰ

0ʰ

72

23ʰ

η · Matar

22ʰ

+30°

Alpheratz
α And

78

Scheat

o

ι

κ

ψ

β

μ · Sadalbari

λ

ι

DEL

PSC

χ

υ τ

51

+20°

φ

9

γ

PEGASUS

Algenib

α

Markab

ξ

ζ

AG

M15

Homam

Enif

+10°

ρ σ

ε

EQUULEUS

PISCES

ϑ

Matar ν

+20°

AQUARIUS

CEPHEUS

ANDROMEDA

Deneb

LACERTA

CYGNUS

SAGITTA

CES

PEGASUS

DELPHINUS

EQUULEUS

CETUS

AQUARIUS

COMPARISONS FOR AG PEG*			
A = 17 Peg	5.54	G	7.7
C	5.60	I	7.8
B	6.00	H	8.0
D	6.61	K	8.72
E	6.7	L	9.1
F	6.8	M	10.0
J	8.16	(*note that the sequence is not in alphabetical order)	

PERSEUS

PERSEI • Per

This constellation represents the hero of the best-known of all Greek myths, involving Andromeda, Cassiopeia, Cepheus, Cetus, and Pegasus, who slew the Gorgon Medusa.

SOUTH AT 22:00 local time: **Dec 30**	
VISIBLE AT 22:00 local time: **Aug–Apr**	
AREA: **615 sq. deg. (24th)**	

Her glance would turn mortals to stone, but Perseus used Athena's shield as a mirror, thus avoiding the fatal sight. In pictorial depictions of the constellation, Perseus is conventionally shown holding the severed head of Medusa, marked by the star β Persei, or Algol. The constellation straddles the Milky Way and thus contains various clusters and is well worth scanning with low-power binoculars.

β Per (03h08m, +40°58') Algol, is one of the most famous variable stars, and the prototype for one class of eclipsing variable. Its name derives from the Arabic *Al Ghul*, meaning 'the Demon' and refers to the star's identification with the head of Medusa, not its variability. This appears to have been unknown until discovered by the deaf-mute, John Goodricke, in 1782. During primary eclipse, which occurs

COMPARISONS FOR β PER	
α Per = 1.80	β Tri = 3.00
γ And = 2.10	δ Per = 3.03
ζ Per = 2.86	α Tri = 3.44
ε Per = 2.89	ν Per = 3.77
γ Per = 2.94	κ Per = 3.81

every 2.87 days, Algol drops from mag. 2.1 to mag. 3.4. Each eclipse last approximately 10 hours.

ρ Per (03h05m, +38°50') is an interesting semiregular red giant variable. It varies between mags. 3.3 and 4.0, and occasionally exhibits periodicity of about 50 days.

X Per (03h55m, +31°03') on the very border with Taurus, is an unusual variable of extreme interest to professional astronomers. It consists of an unequal binary with a young supergiant star and a tiny neutron star, perhaps 20–30 km across. There are outbursts somewhat like those of g Cassiopeiae from the supergiant, but also X-ray outbursts from the neutron star.

M34 (02h42m, +42°47') is a fine open cluster, visible with the naked eye, but an excellent binocular object.

h & χ Per (02h19m, +57°09' & 02h23m, +57°07', respectively) the Double Cluster, also known as NGC 869 and NGC 884. Although both of these open clusters are large (roughly the size of the Moon), they are not particularly easy to pick up with the naked eye, but are a magnificent sight in binoculars. h (NGC 869) – the closer to Cassiopeia – is slightly brighter, contains about 200 stars and is about 6 million years old. χ (NGC 884) consists of about 150 stars, and is younger, at about 3 million years old. Their distances are 7,500 and 7,100 light-years, respectively.

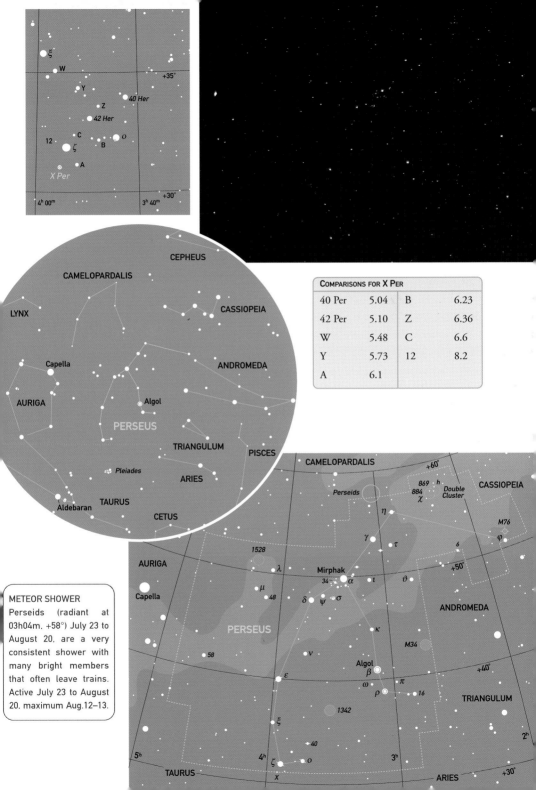

ξ
W
Y
Z 40 Her
42 Her
12 C O
ζ B
A
X Per

+35°
+30°
4ʰ 00ᵐ 3ʰ 40ᵐ

CEPHEUS
CAMELOPARDALIS
CASSIOPEIA
LYNX
ANDROMEDA
Capella
AURIGA
Algol
PERSEUS
TRIANGULUM
PISCES
Pleiades
ARIES
TAURUS
Aldebaran
CETUS

Comparisons for X Per			
40 Per	5.04	B	6.23
42 Per	5.10	Z	6.36
W	5.48	C	6.6
Y	5.73	12	8.2
A	6.1		

METEOR SHOWER
Perseids (radiant at 03h04m, +58°) July 23 to August 20, are a very consistent shower with many bright members that often leave trains. Active July 23 to August 20, maximum Aug.12–13.

CAMELOPARDALIS +60°
Perseids
869 h
884 Double
χ Cluster
CASSIOPEIA
η
γ τ
M76
6 φ
1528
λ
Mirphak +50°
34 α ι ϑ
AURIGA
μ
48 δ ψ σ
Capella
PERSEUS
κ
ANDROMEDA
M34
58
ν
Algol
β +40°
ε ω π
ρ 16
TRIANGULUM
1342
ξ
2ʰ
40
5ʰ 4ʰ ζ o 3ʰ +30°
χ
TAURUS ARIES

PISCES

PISCIUM • Psc • THE FISH

SOUTH AT 22:00 local time: **Nov 05**

VISIBLE AT 22:00 local time: **Aug–Jan**

AREA: **889 sq. deg. (14th)**

This zodiacal constellation originated with the Babylonians and was subsequently adopted in Greek mythology, where is supposedly represented Aphrodite and her son Eros, who, when pursued by the monster Typhon, turned themselves into fish as they jumped into a river to escape, but tied themselves together so that they would not become parted. Pictorial representations show the two fish tied by the tail with two ribbons, which are knotted together at α Piscium, Alrescha. The Circlet, a ring of five stars below the Great Square of Pegasus, represents one fish, with the other formed by several very faint stars to the east of α Andromedae, Alpheratz.

The spring (vernal) equinox – still known as the First Point of Aries – now lies in this constellation, south of the star ω Psc.

ζ Psc (01^h14^m, +07°35') is a moderately wide double that may be glimpsed in binoculars if conditions are favourable. There are two stars of mags. 5.2 and 6.3.

κ Psc (23^h27^m, +01°16') is a wide binocular double, consisting of unrelated stars of mags. 4.9 and 6.3. ρ Psc (01^h26^m, +19°11') at mag. 5.4, forms a similar double with orange giant **94 Psc**, mag. 5.5.

ψ1 Psc (01^h06^m, +21°29') is another double star that may be detected with binoculars under good conditions, but really requires a small telescope. The stars are of mag. 5.3 and 5.6.

TX Psc (23^h46^m, +03°29') is a very red irregular variable, which ranges between mags. 4.8 and 5.2. Its colour is readily seen with binoculars.

M74 (01^h37^m, +15°47') a faint galaxy (mag. 9.5), that may sometimes be glimpsed with suitable binoculars under favourable conditions.

PUPPIS

PUPPIS • Pup • THE POOP

This constellation was regarded by Greek astronomers as forming part of Argo, the ship in which Jason and the Argonauts sailed to seek the Golden Fleece (see Aries).

SOUTH AT 22:00 local time: Feb20

VISIBLE AT 22:00 local time: Jan–Mar

AREA: 673 sq. deg. (20th)

The large constellation of Argo Navis that was drawn and lettered by Bayer was later subdivided into three sections: Puppis, Carina (the Keel), and Vela (the Sails). The last two constellations are southern ones not described here. The brightest stars with Greek-letter designations in the original constellation now lie in Carina. Puppis lies across the Milky Way and thus contains numerous clusters and other objects of interest.

ξ **Pup** (07h49m, –28°58'), Aspidiske, is a very wide binary, consisting of two yellow stars, of magnitudes 3.3 and 5.3.

L^2 Pup (07h14m, –44°39') is a semiregular variable with a range of 2.6 to 6.2 and a periodicity of 140.5 days. It forms a wide double with **L^1 Pup**, a blue-white star of mag. 4.9.

v^1 and **v^2 Pup** (07h18m, –36°44' and 07h19m, –36°45') form a very wide double, detectable with the naked eye, consisting of stars of mag. 5.1 and 4.7, respectively.

V Pup (07h58m, –49°15') in the extreme southeast of the constellation, is a naked-eye eclipsing binary that varies between mags. 4.4 and 4.9. with a period of 1 day 11 hours.

M46 (07h42m, –14°48') is a mag. 6.5 open cluster that is a large unresolved glow in binoculars.

M47 (07h37m, –14°29') is a bright (mag. 4.3) open cluster that is visible to the naked eye, and a magnificent object in binoculars.

M93 (07h45m, –23°51') is a moderately bright (mag. 6.5), but sparse, open cluster with a few bright stars that are resolved in binoculars.

NGC 2451 (07h45m, –37°57') a sparse open cluster (mag. 3.7), visible with the naked eye, and resolved in binoculars.

NGC 2477 (07h52m, –38°32') an open cluster of mag. 5.7, which contains an exceptionally large number of stars, but these are unresolved in binoculars, so that it appears more like a globular, rather than open, cluster.

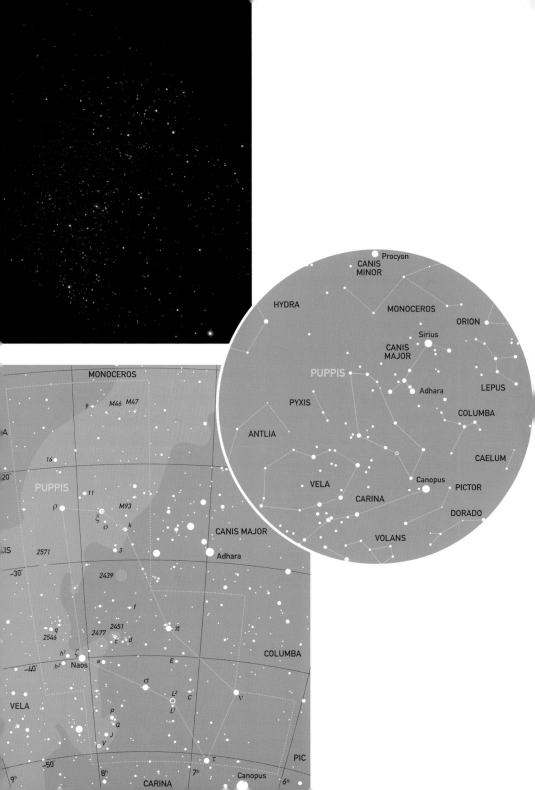

SAGITTA

SAGITTAE • Sge • THE ARROW

This tiny constellation has been envisaged as an arrow since Greek times. It is so small that although it lies in the Milky Way, there are few objects of interest.

SOUTH AT 22:00 local time: Aug 20

VISIBLE AT 22:00 local time:

AREA: 80 sq. deg. (86th)

15 Sge (20^h04^m, +17°04') is a wide double, visible in binoculars, with stars of mags. 5.8 and 6.8.

M71 (19^h54^m, +18°46') is a faint globular of about mag. 8.5, visible in binoculars.

VULPECULA

VULPECULAE • Vul • THE FOX

This is another of the small constellations introduced by Hevelius (*see* p.162), who originally named it 'Vuplecula et Anser', the 'Fox and Goose'. Like Sagitta to the south,

SOUTH AT 22:00 local time: Aug 15

VISIBLE AT 22:00 local time:

AREA: 268 sq. deg. (55th)

although Vulpecula lies across the Milky Way it contains few objects of interest.

M27 (20^h00^m, +22°43'), the Dumbbell Nebula, is a relatively bright (mag. 8) planetary nebula. The shape is detectable with binoculars, but telescopes are required to show much detail.

NGC 6940 (20^h45^m, +28°19') is a large open cluster of about mag. 7, which is, however, unresolved in binoculars, appearing like a nebulous patch.

Brocchi's cluster (19^h25^m, +20°11'), Collinder 399 is also known as the Coathanger, readily visible in binoculars. It is a loose cluster of stars, six of which form the 'bar' of the 'coathanger' with another four forming the 'hook'.

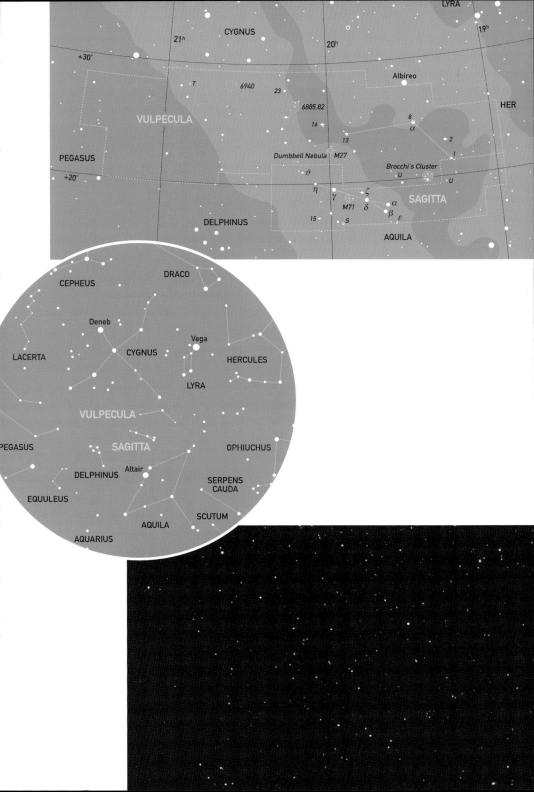

SAGITTARIUS

SAGITTARII • Sgr • THE ARCHER

Although Sagittarius is often linked with the Centaur, Chiron, the latter was a healer and so was unlikely to be armed with a bow and arrows. It probably represents Crotus, the son of Pan, who was reputed to have invented archery.

SOUTH AT 22:00 local time: Jul 30
VISIBLE AT 22:00 local time: Jul–Aug
AREA: 867 sq. deg. (15th)

Sagittarius contains the galactic centre and is such a densely populated region of the Milky Way that there are numerous open and globular clusters, although these tend to be difficult to see against the dense clouds of stars.

β Sgr (19^h23^m, –44°48') appears as a wide double to the naked eye, with stars of mags. 4.0 and 4.3. The southern star ($β^1$ Sgr) is itself a double, but only resolved with a telescope.

M8 (17^h04^m, –24°22'), the Lagoon Nebula, is a gaseous nebula that is sufficiently bright and distinct to be detectable with the naked eye.

M17 (18^h21^m, –16°10'), the Omega or Swan Nebula, is a gaseous nebula, visible in binoculars. A telescope is required to reveal its wealth of detail. (*Continued on p.232.*)

CORONA AUSTRALIS

CORONAE AUSTRALIS • CrA • THE SOUTHERN CROWN

This small constellation, tucked in between Sagittarius and Scorpius, dates back to Greek times, being described by the astronomer Ptolemy in the 2nd century AD.

SOUTH AT 22:00 local time: Aug 05
VISIBLE AT 22:00 local time: Jul–Aug
AREA: 128 sq. deg. (80th)

ε CrA (18^h59^m, –37°06') is an eclipsing binary of the β-Lyrae type, which varies between mags. 4.7 and 5.0, with a period of just over 14 hours.

κ CrA (18^h33^m, –38°43') is a difficult binocular double consisting of white stars of mags. 5.7 and 6.3.

NGC 6541 (18^h08^m, –43°42'), a 7th-mag. globular cluster, appears misshapen in binoculars.

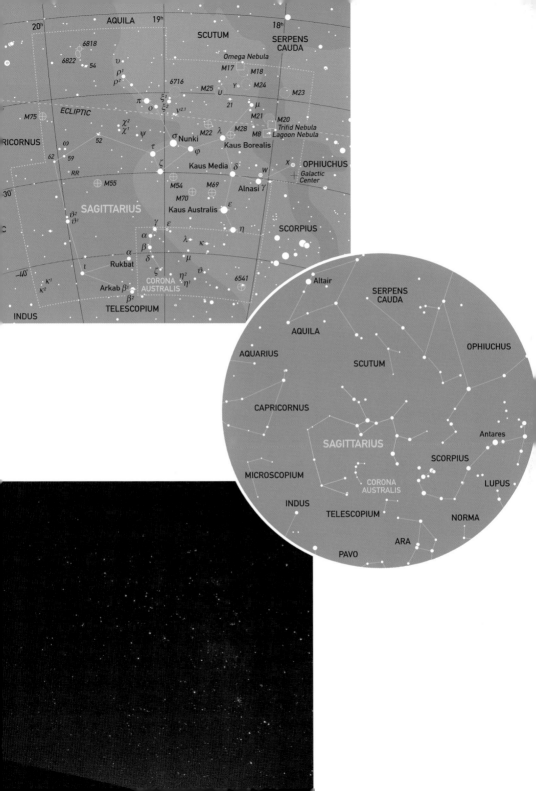

(Continued from p.230.)

M20 (18^h03^m, $-23°03'$), the Trifid Nebula, although detectable with binoculars, like M17, it requires a telescope for the detailed structure to be seen.

M22 (18^h36^m, $-23°54'$) a bright (mag. 5) globular cluster that appears slightly elongated in binoculars.

M23 (17^h57^m, $-19°01'$) is a rich open cluster that is roughly the apparent size of the Moon, and which is resolved in binoculars under good conditions.

M24 (18^h19^m, $-18°23'$) is a patch of the Milky Way that is extremely rich in stars, rather than a true open cluster. There is a small cluster in this area (NGC 6603) but this was not what Messier described.

M25 (18^h32^m, $-19°13'$) is a large open cluster, detectable with the naked eye, that is resolved in binoculars into numerous stars, the brightest of 7th magnitude.

M55 (19^h40^m, $-30°57'$) is a moderatly bright (7th-mag.) globular cluster, visible in binoculars, that lies in a rather sparsely populated area of the constellation and is not particularly easy to find.

M69 (18^h31^m, $-32°20'$) is a moderately faint (8th-mag.) globular cluster, detectable with binoculars.

M70 (18^h43^m, $-32°17'$) is similar to M69, both in magnitude and visibility.

The centre of the Galaxy is hidden behind the star clouds in Sagittarius. Globular clusters (listed on p.137) are concentrated around the galactic centre, but the constellation also contains many open clusters. The latter (listed opposite), predominantly occur along the band of the Milky Way, that is, within the disk of the Galaxy and its spiral arms.

BRIGHT OPEN CLUSTERS

OBJECT	CONST.	RA	DEC.	Mag.	NAME OR NOTES
M 6	Sco	17 40.1	-32 13	5.3	
M 7	Sco	17 53.9	-34 49	4.1	
M 11	Sct	18 51.1	-06 16	6.3	Wild Duck
M 16	Ser	18 18.8	-13 47	6.4	
M 23	Sgr	17 56.8	-19 01	6.9	
M 25	Sgr	18 31.6	-19 15	6.5	
M 34	Per	02 42.0	+42 47	5.5	
M 35	Gem	06 08.9	+24 20	5.3	
M 36	Aur	05 36.1	+34 08	6.3	
M 37	Aur	05 52.4	+32 33	6.2	
M 38	Aur	05 28.4	+35 50	7.4	
M 39	Cyg	21 32.2	+48 26	5.2	
M 41	CMa	06 46.0	-20 44	4.6	
M 44	Cnc	08 40.1	+19 59	3.7	Praesepe
M 45	Tau	03 47.0	+24 07	1.6	Pleiades
M 48	Hya	08 13.8	-05 48	5.5	
M 50	Mon	07 03.2	-08 20	6.3	
M 52	Cas 23	24.2	+61 35	7.3	
M 67	Cnc	08 50.4	+11 49	6.1	
M 103	Cas 01	33.2	+60 42	7.4	
NGC 457	Cas 01	19.1	+58 20	6.4	
NGC 752	And	01 57.8	+37 41	5.7	
NGC 869	Per	02 19.0	+57 09	4	h Per
NGC 884	Per	02 22.4	+57 07	4	χ Per
NGC 1502	Cam	04 07.7	+62 20	5.7	
NGC 1981	Ori	05 35.2	-04 26	4.6	
NGC 2169	Ori	06 08.4	+13 57	5.9	
NGC 2232	Mon	06 26.6	-04 45	3.9	
NGC 2244	Mon	06 32.4	+04 52	4.8	in Rosette Neb.
NGC 2264	Mon	06 41.1	+09 53	3.9	
NGC 6231	Sco	16 54.0	-41 48	2.6	
NGC 6633	Oph	18 27.7	+06 34	4.6	
NGC 6709	Aql	18 51.5	+10 21	6.7	
IC 4665	Oph	17 46.3	+05 43	4.2	
Melotte 111					
Cr 399	Vul	19 25.4	+20 11	3.6	Brocchi's Cl.; Coathanger

SCORPIUS

SCORPII • Sco • THE SCORPION

Mythologically, this constellation represents the scorpion that killed Orion, which is why they are set on opposite sides of the sky. Originally much larger, in Roman times the

'claws' of the scorpion were formed into the separate constellation of Libra.

Scorpius lies in a densely populated region of the Milky Way, and thus contains numerous globular and open clusters, and dense clouds of stars.

α Sco (16^h29^m, $-26°26'$), Antares, whose name means 'rival of Mars', is a bright red supergiant about 600 million kilometres in diameter and some 9,000 times as luminous as the Sun.

ζ Sco (16^h55^m, $-42°22'$) is a wide, naked-eye double. The northern star, $ζ^1$ Sco, is a white supergiant (mag. 4.8) and the brightest member of NGC 6231. The other star, $ζ^2$ Sco, is a red giant of mag. 3.6.

μ Sco (16^h52^m, $-38°03'$) is another wide double easily seen with the naked-eye. The northern star, $μ^1$ Sco, is a β-Lyrae type eclipsing binary, with a range of mag. 3.0–3.3 and a period of about 1 day 10.5 hours. The second star, $μ^2$, slightly farther south, is mag. 3.6.

ω Sco (16^h07^m, $-20°40'$) is yet another naked-eye double, $ω^1$ and $ω^2$, of mags. 4.0 and 4.3, respectively.

M4 (16^h24^m, $-26°31'$) is a fairly loose globular cluster, visible as a fuzzy patch in binoculars at about mag.6.

M6 (17^h40^m, $-32°12'$) is an open cluster (mag. 4.5) that is visible to the naked eye and which is resolved into individual stars in binoculars.

M7 (17^h54^m, $-34°37'$) is a large, bright (mag. 3.5) open cluster, readily visible to the naked eye. It is best seen with low-magnification binoculars.

M80 (16^h17^m, $-22°58'$) is a small, compact globular cluster (about mag. 7.5), readily seen in binoculars.

NGC 6231 (16^h54^m, $-41°47'$) is an extremely bright open cluster, readily seen with the naked eye, with some stars resolved in binoculars.

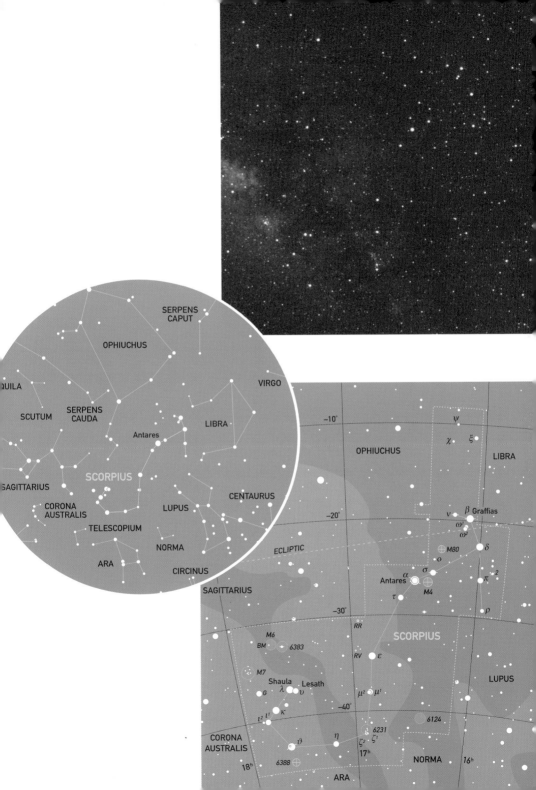

SCUTUM
SCUTI • Sct • THE SHIELD

This small constellation was another that was introduced by Hevelius (p.162), originally under the name of Scutum Sobieski (Sobieski's Shield) in honour of his patron,

SOUTH AT 22:00 local time: **Aug 01**	
VISIBLE AT 22:00 local time: **May–Sep**	
AREA: **109 sq. deg. (84th)**	

the Polish king, John Sobieski III, who is famous for repelling an Turkish invasion of Poland in 1683. It has some of the brightest star clouds of the Milky Way.

δ Sct (18^h42^m, –09°03') is the prototype of an interesting class of pulsating variable stars, but its range is too small (mags. 4.6–4.8) and the changes too rapid (period 4.65 hours) for visual observations to be successful.

R Sct (18^h48^m, –05°42') is an interesting variable of the RV-Tauri type, with a range of 4.3–8.7, and a period of 146.5 days.

M11 (18^h51^m, –06°15'), the Wild Duck Cluster, is a prominent open cluster, readily seen with binoculars, and is a magnificent object with higher magnifications.

SERPENS (CAUDA)
SERPENTIS • Ser • THE SERPENT

As previously noted, Serpens is the only constellation divided into two parts: Serpens Caput (Head of the Serpent) and Serpens Cauda (Tail of the Serpent). Serpens

SOUTH AT 22:00 local time: **Aug 10**	
VISIBLE AT 22:00 local time: **May–Sep**	
AREA (WHOLE CONST.): **637 sq. deg. (23rd)**	

Caput is described with Ophiuchus (the Serpent Bearer).

ν Ser (17^h21^m, –12°51') is a wide double that may be resolved with binoculars. The stars are of mags. 4.3 and 8.1.

M16 (18^h19^m, –13°44') is a combination of an open cluster (NGC 6611), visible in binoculars, and a diffuse nebula, the Eagle Nebula, which adds a background haziness. A large telescope is required to see detail in the gaseous nebulosity.

SEXTANS

SEXTANTIS • Sex • THE SEXTANT

This is another small, faint constellation added by Hevelius (p.208) at the end of the 17th century. Rather than the mariner's sextant with which most people associate the

SOUTH AT 22:00 local time: **Apr 25**

VISIBLE AT 22:00 local time: **Jan–Jun**

AREA: **314 sq. deg. (47th)**

constellation, it actually represents the large, mounted sextant that was commonly used at that period to measure the angles between pairs of stars – an instrument in the use of which Hevelius was particularly proficient.

17 Sex (10^h10^m, $-08°25'$) and **18 Sex** (10^h11^m, $-08°26'$) is a very wide double that should be readily detectable to anyone with average eyesight. The stars are of mag. 5.9 and 5.6, respectively.

NGC 3115 (10^h05^m, $-07°43'$) is the Spindle Galaxy, an elongated elliptical galaxy, seen side on. It is just detectable in binoculars under extremely good conditions.

TAURUS

(Continued from p.240.)

HU Tau (04^h38^m, $+20°41'$) is an interesting Algol-like eclipsing binary, readily followed with binoculars. It has a range of mags. 5.45 to 6.86 and a period of 2.0563 days ($2^d1^h21^m$).

Comparisons for **HU Tau**					
A	5.7	D	6.6	G	7.1
B	6.0	E	6.8	H	7.2
C	6.2	F	6.9	K	7.4

URSA MAJOR

CANCER

LEO

Regulus

VIRGO

SEXTANS

RVUS CRATER

MONOCEROS

HYDRA

PUPPIS

ANTLIA PYXIS

VELA

LEO Regulus ECLIPTIC

+10°

SEXTANS

0°

β α

δ

3115

ε 18·· 17

γ

−10°

11ʰ 10ʰ

CRATER HYDRA

TAURUS

TAURI • Tau • THE BULL

This constellation has been associated with a bull since the time of the first Chaldean and Sumerian astronomers. It is conven- tionally depicted as just the forequarters of

SOUTH AT 22:00 local time: Dec 30

VISIBLE AT 22:00 local time:

AREA: 797 sq. deg. (17th)

a long-horned bull emerging from the sea. As such it depicts the form that, in Greek mythology, Zeus assumed when he carried off Europa to Crete, where one of their sons became the legendary King Minos.

Astronomically, Taurus is best known for orange Aldebaran, and the Hyades and Pleiades clusters.

ϑ **Tau** is a wide double in the Hyades, visible to the naked eye. ϑ^2 **Tau** (04^h29^m, +15°52') is mag. 3.4, and the brightest star in the cluster. ϑ^1 **Tau** (04^h29^m, +15°58') is slightly fainter at mag. 3.8.

λ **Tau** (04^h01^m, +12°30') is a bright eclipsing variable, similar to Algol (β Per). It is easily followed with the naked eye, with a range of 3.23 to 4.10, and a period of 3.952955 days ($3^d22^h52^m$).

COMPARISONS FOR λ TAU			
A = π^3 Ori	3.19	E = ξ Tau	3.74
B = ϵ Tau	3.54	F = ν Tau	3.91
C = o Tau	3.60	G = 5 Tau	4.09
D = γ Tau	3.64	H = μ Tau	4.30

M1 (05^h47^m, +00°06'), the Crab Nebula is just detectable in binoculars under good conditions, despite being rather faint (mag. 9). It is the remnant of a supernova explosion that occurred in 1054 and was observed by Chinese astronomers.

The 'V'-shaped **Hyades** (approx. 04^h27^m, +16°) is one of the closest open clusters (distance 150 light-years) so its stars appear spread over a considerable area of sky. Aldebaran (α Tau) is an orange giant that is not related to the Hyades, and lies at a distance of 60 light-years.

M45 (03^h39^m, +24°07'), the **Pleiades**, is a wonderful open cluster. Most observers find that at least six stars are visible with the naked eye, and many more appear with binoculars. The total number of stars in the cluster is about 500, and the blue-white colour of the brightest stars is an indication that the stars and cluster is extremely young (in astronomical terms) and is about 78 million years old.

(Continued on p.238.)

PERSEUS +30° 3ʰ

AURIGA 5ʰ 4ʰ

6ʰ ψ

β φ

Alnath χ

132 118 η ARIES

1746 BU

M1 τ υ Pleiades

GEMINI ζ ι κ¹ 36

κ²

HU ω +20°

1647 ε ECLIPTIC

119 δ³ Hyades

Aldebaran δ²·¹

σ² α δ²·¹ Taurids

ORION σ¹ ϑ²·¹ γ

ρ π 5

90 λ 30

88 ξ +10°

μ 47 ο

TAURUS **CETUS**

ν

10 0°

ERIDANUS

CAM

Capella AND

Algol

AURIGA PERSEUS

GEMINI TRIANGULUM

TAURUS Pleiades

ARIES

Hyades PISCES

Aldebaran

ORION CETUS

Betelgeuse

ONOCEROS Mira

Rigel ERIDANUS

LEPUS

Pleiades – stars down to mag. 7.5

Asterope

Taygeta

Maia

Celaeno

Atlas Alcyone

BU Electra

η

Pleione

Merope

METEOR SHOWER
Taurids (radiant at 03h44m, +14°) are a consistent meteor shower with only a moderate maximum rate of 10 slow meteors per hour, and some bright members. Active October 20 to November 30, maximum November 3.

URSA MAJOR

URSAE MAJORIS • UMa • THE GREAT BEAR

This constellation and Ursa Minor have been seen as representing bears by many different civilizations and peoples. Our word 'arctic' comes from the Greek arktos, meaning

CIRCUMPOLAR

SOUTH AT 22:00 local time: Apr 15

AREA: 1280 sq. deg. (3rd)

'bear'. Ursa Major is a very large constellation, coming after Hydra and Virgo in extent. Because it lies well away from the Milky Way, numerous galaxies occur in this area, although most are too faint to be readily visible with amateur instruments.

ζ **UMa** (13^h24^m, $+54°55'$), Mizar (mag. 2.3), forms a famous naked-eye double with 80 UMa, Alcor (mag. 4.0). They lie at different distances, however (87 and 81 light-years, respectively), so do not form a binary system. Mizar, is a telescopic binary, and each of those two stars is itself a close binary, so it is a quadruple system. By coincidence, Alcor is also a close binary.

47 UMa (11^h00^m, $+40°25'$), close to the border with Leo Minor, is a 5^{th}-magnitude star, and thus visible to the naked eye. The star is very slightly more massive and brighter than the Sun. It is the location of an extrasolar planetary system, and the first to be discovered that is somewhat similar to our own Solar System. There are at least two planets, one about 2.5 Jupiter masses, orbiting at 2.09 AU from the star, and a second, about 0.75 times the mass of Jupiter, which orbits at 3.73 AU.

Z UMa (11^h57^m, $+57°52'$) is a semiregular variable with a range of 6.20 to 9.2, and intervals with a periodicity of 196 days.

VY UMa (10^h45^m $+67°25'$) is an irregular variable with a range of 5.7 to 7.5. It is an extremely red star – one of the reddest in the sky – and thus difficult to study visually.

M81 (09^h56^m, $+69°03'$) is a spiral galaxy, readily visible in binoculars. **M82** (09^h56^m, $+69°40'$) is an unusual galaxy, not easy to classify. It is detectable in binoculars as a faint elongated object.

M101 (14^h03^m, $+54°20'$), known in North America as the Pinwheel Galaxy, is a spiral galaxy, the central regions of which are detectable in binoculars.

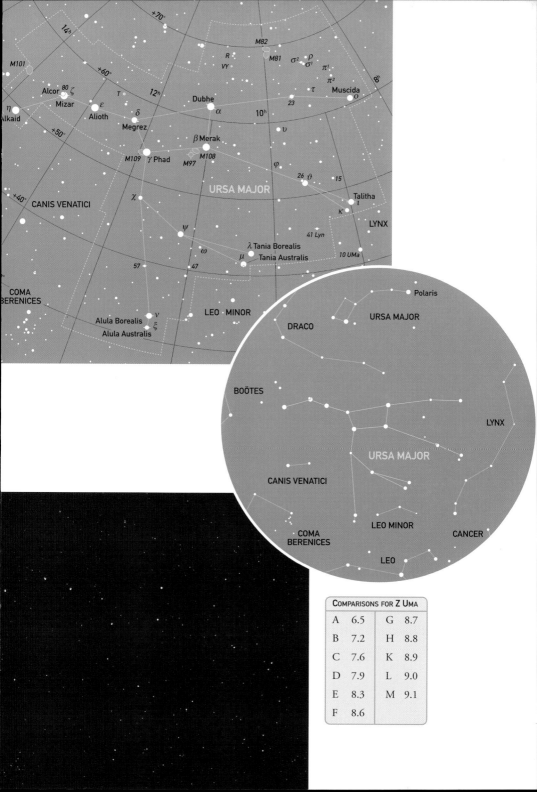

COMPARISONS FOR Z UMA			
A	6.5	G	8.7
B	7.2	H	8.8
C	7.6	K	8.9
D	7.9	L	9.0
E	8.3	M	9.1
F	8.6		

URSA MINOR

URSAE MINORIS • UMi • THE LITTLE BEAR

This constellation dates from the Greek period, and is said to have been introduced by the great astronomer Thales of Miletus in Asia Minor. Even in those days it was

CIRCUMPOLAR AND THUS ALWAYS VISIBLE

SOUTH AT 22:00 local time: May 05

AREA: 256 sq. deg. (56th)

regarded as an essential aid to navigation, because Polaris (α UMi) lies so close to the North Celestial Pole. It was so important to mariners that it was also called Stella Maris: 'Star of the Sea'. In the 16th century, Polaris came to be known as Cynosura (from the Greek words for 'dog with tail', whence the modern-day saying that something is the cynosure of all eyes, because they are all (and always) turned towards it.

α **UMi** (02^h33^m, +89°16') is a yellow supergiant that is slightly variable, and belongs to a sub-class of Cepheid variables. It range has decreased in recent decades (and is not observable visually), and it is suspected that it may be coming to the end of the evolutionary stage at which is displays variability.

γ **UMi** (15^h21^m, +71°49'), Pherkad (a white giant of mag. 3.0), forms a wide double with 11 UMi (an orange giant of mag. 5.0).

η **UMi** (16^h17^m, +75°45') forms part of another very wide double, detectable with the naked eye. η UMi is mag. 5.0, and the companion, **19 UMi,** is of mag. 5.5.

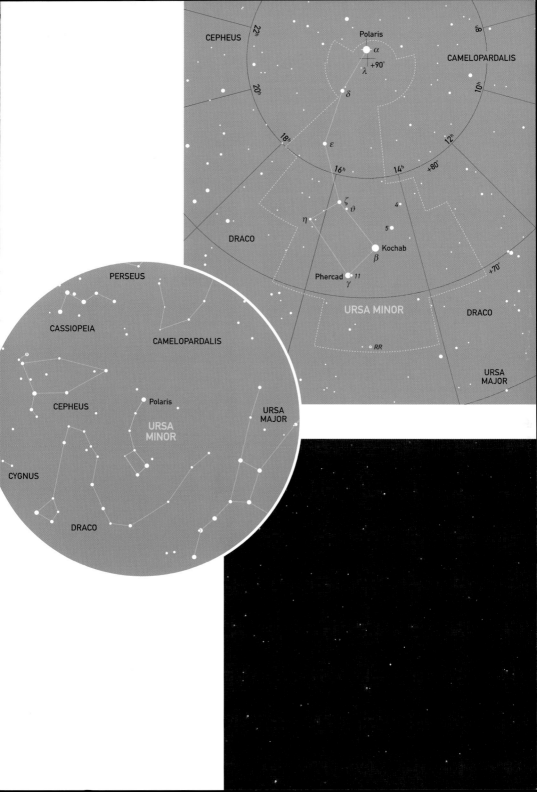

VIRGO

VIRGINIS • Vir • THE VIRGIN

Virgo has been associated with a fertility goddess from the very earliest times, being seen as Ishtar by the Babylonians, Demeter by the Greeks, and Ceres by the Romans,

SOUTH AT 22:00 local time: May 05

VISIBLE AT 22:00 local time: Mar–Jly

AREA: 1294 sq. deg. (2nd)

although the last also saw it as representing Astraea, the goddess of justice, holding the scales (Libra) in her hand. The brightest star, Spica, represents an ear of grain, normally taken to be wheat.

Virgo is the location of the massive Virgo Cluster of galaxies, which lies at the heart of the Local Supercluster, a gigantic system, probably consisting of some 10,000 galaxies. (Our own Local Group lies at its edge.) Unfortunately, most of these galaxies are very faint and difficult to detect, except with the largest amateur telescopes. For such a large constellation – Virgo is second in area, exceeded only by Hydra – it contains few bright stars, and very few objects for observation.

α Vir (13^h25^m, −11°10'), is a blue-white, first-magnitude star (mag. 0.98), which actually consists of a an extremely close binary, where both stars are tidally distorted by their mutual gravitational attraction. This produces a slight variation in brightness as the pair rotates, which is detectable only with sensitive electronic methods.

70 Vir (13^h28^m, +13°46'), lying close to the northern border with Coma Berenices, is an apparently unremarkable, 5th-magnitude star, slightly cooler, but also brighter than the Sun. It was, however, one of the first extrasolar planetary systems to be discovered. The planet is very large, with a mass about 6.8 times that of Jupiter, and has an extremely eccentric orbit, averaging about 0.5 AU from the star, which is slightly cooler and smaller than the Sun. The planet's orbital period is 116.6 days.

M104 (12^h40^m, −11°37'), a spiral galaxy, is also known as the Sombrero Galaxy, because of its appearance in large telescopes, when it exhibits a dense dark lane of dust in its galactic plane. It lies far to the south, on the very border with Corvus, and is probably easiest found from that constellation. It is relatively faint (mag. 8.5), but its elongated shape is just detectable with binoculars.

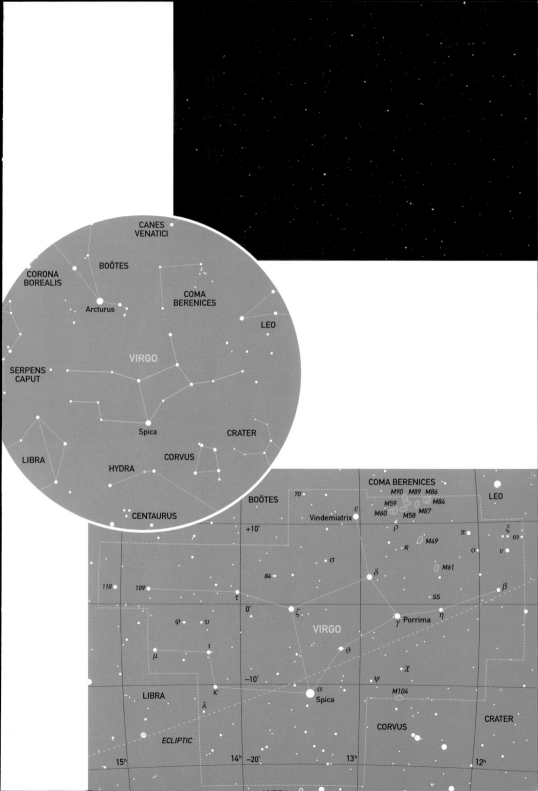

ADDITIONAL TABLES

GALAXIES

OBJECT	CONST.	RA	DEC	M	NAME & NOTES
M31	And	00h43m	+41°16'	3.5	Bright spiral
M32	And	00h47m	+40°52'	8.2	
M33	Tri	01h34m	+30°40'	5.7	
M51	CVn	13h30m	+47°15'	8.4	'Whirlpool'
M64	Com	12h57m	+21°40'	8.5	'Blackeye'
M65	Leo	11h19m	+13°05'	9.3	
M66	Leo	11h20m	+12°59'	9.0	
M74	Psc	01h37m	+15°47'	9.2	
M77	Cet	02h43m	00°00'	8.8	
M81	UMa	09h56m	+69°03'	6.9	
M82	UMa	09h56m	+69°40'	8.4	'Cigar'
M83	Hya	13h37m	−29°52'	7.6	
M101	UMa	14h03m	+54°20'	7.7	'Pinwheel'
M104	Vir	12h40m	−11°37'	8.3	'Sombrero'
M110	And	00h40m	+41°41'	8.0	
NGC 2403	Cam	07h37m	+65°35'	8.4	
NGC 3115	Sex	10h05m	−07°43'	8.3	

BRIGHT GLOBULAR CLUSTERS

OBJECT	CONST.	RA	DEC	M	NAME OR NOTES
M 2	Aqr	21h33.5m	-00 49'	6.5	
M 3	CVn	13h42.2m	+28 23'	6.2	
M 4	Sco	16h23.6m	−26 32'	5.6	
M 5	Ser	15h18.6m	+02 05'	5.6	
M 9	Oph	17h19.2m	−18 31'	7.7	
M 10	Oph	16h57.1m	−04 06'	6.6	
M 12	Oph	16h47.2m	−01 57'	6.7	
M 13	Her	16h41.7m	+36 28'	5.8	
M 14	Oph	17h37.6m	−03 15'	7.6	
M 15	Peg	21h30.0m	+12 10'	6.2	
M 19	Oph	17h02.6m	−26 16'	6.8	
M 22	Sgr	18h36.4m	−23 54'	5.1	3rd brightest
M 53	Com	13h12.9m	+18 10'	7.6	
M 62	Oph	17h01.2m	−30 07'	6.5	
M 71	Sge	19h53.8m	+18 47'	8.2	
M 92	Her	17h17.1m	+43 08'	6.4	

FURTHER INFORMATION

Books

Bone, Neil (1996), *The Aurora*, 2nd edition, Wiley-Praxis, Chichester

Bone, Neil (1993), *Observer's Handbook: Meteors*, George Philip, London and Sky Publ. Corp., Cambridge, Mass.

Burnham, Robert (1978), *Burnham's Celestial Handbook*, 3 vols., Dover Publications, New York

Chartrand, Mark (1999), *Collins Guide to the Night Sky*, HarperCollins, London (1991) and *Field Guide to the Night Sky*, Knopf, New York

Cook, J., ed. (1999), *The Hatfield Photographic Lunar Atlas*, Springer-Verlag, Heidelberg

Dunlop, Storm (1999), *Wild Guide to the Night Sky*, HarperCollins, London

Dunlop, Storm and Tirion, Wil (2000), *Wild Guide Star Finder*, HarperCollins, London

Freedman, Roger A. and Kaufmann, William J. (2001) *Universe*, W.H. Freeman, New York

Harrington, Philip S. (1990), Touring the Universe through Binoculars, Wiley, New York

Hoskin, M., ed. (1997), *Cambridge Illustrated History: Astronomy*, Cambridge University Press

Illingworth, Valerie and Clark, John O.E., ed. (2000), *Collins Dictionary of Astronomy*, 2nd edn, HarperCollins, London and *Facts on File Dictionary of Astronomy*, 4th edn, Facts-on-File, New York

Karkoschka, E. (1999), *The Observer's Sky Atlas*, 2nd edn, Springer-Verlag, New York

Moore, Patrick, (2000), *Exploring the night sky with binoculars,* 4th edn, Cambridge University Press, Cambridge

Phillips' Planisphere, Latitude 51.5°N, Geo. Philip & Son

Ridpath, Ian, ed. (1998), *Norton's Star Atlas*, 19th edn., Longman, London

Ridpath, Ian, ed. (1997), *Oxford Dictionary of Astronomy*, Oxford University Press, Oxford

Ridpath, Ian and Tirion, Wil (2000), *Collins Pocket Guide Stars and Planets*, HarperCollins, London

Rükl, Antonín (1990), *Hamlyn Atlas of the Moon*, Hamlyn, London and Astro Media Inc., Milwaukee

Scagell, Robin (2000), *Philip's Stargazing with a Telescope*, George Philip, London

Tirion, Wil (2001), *Bright Star Atlas*, Willmann Bell Inc., Richmond, Virginia

Tirion, Wil (2001), *Cambridge Star Atlas*, 3rd edn, Cambridge University Press, Cambridge

Tirion, Wil and Sinnott, Roger (1998), *Sky Atlas 2000.0*, 2nd edn, Cambridge University Press and Sky Publ. Corp., Cambridge, Mass.

Handbooks

British Astronomical Association, *Handbook* (published yearly)

Royal Astronomical Society of Canada, *Observer's Handbook* (published yearly)

Journals

Astronomy, Astro Media Corp., 21027 Crossroads Circle, P.O. Box 1612, Waukesha, WI 53187-1612 USA. WWW: http://www.astronomy.com

Astronomy Now, Pole Star Publications, PO Box 175, Tonbridge, Kent TN10 4QX UK. WWW: http://www.astronomynow.com

Sky & Telescope, Sky Publishing Corp., Cambridge, MA 02138-1200, USA. WWW: http://www.skyandtelescope.com/

Societies

American Association of Variable Star Observers, 25 Birch Street, Cambridge, Mass. 02138-1205, USA. WWW: http://www.aavso.org/
A society primarily concerned with the observation of variable stars, with an international membership and vast database of past observations.

Astronomical League, Executive Secretary: 11305 King Street, Overland Park, KS 66210-3421. WWW: http://www.astroleague.org/
An umbrella organization to which many local astronomical societies in the USA belong, and which is able to provide contact information.

British Astronomical Association, Burlington House, Piccadilly, London W1J 0DU WWW: http://www.ast.cam.ac.uk/~baa/
The principal British organisation for amateur astronomers (with some professional members), particularly for those interested in carrying out observational programmes. Its membership is, however, worldwide. It publishes fully refereed, scientific papers and other material in its well-regarded *Journal*.

Federation of Astronomical Societies, Secretary: Ken Sheldon, Whitehaven, Maytree Road, Lower Moor, Pershore, Worcs. WR10 2NY.
WWW: http://www.ukindex.co.uk/ukastro/fasmain.html
An organization that is able to provide contact information for local astronomical societies in the United Kingdom.

Royal Astronomical Society, Burlington House, Piccadilly, London W1J 0BQ. WWW: http://www.ras.org.uk/
The premier astronomical society, with membership primarily drawn from professionals and experienced amateurs. It has an exceptional library and is a designated centre for the retention of certain classes of astronomical data. Its publications are the standard medium for dissemination of astronomical research.

Royal Astronomical Society of Canada, 136 Dupont Street, Toronto, Ontario M5R 1V2 Canada. WWW: http://www.rasc.ca
The principal Canadian society, including both amateur and professional astronomers. It has various regional centres, and its *Journal* contains amateur and professional contributions.

Society for Popular Astronomy, 36 Fairway, Keyworth, Nottingham NG12 5DU. WWW: http://www.popastro.com/home.htm
A society for astronomical beginners of all ages, which concentrates on increasing members understanding and enjoyment, but which does have some observational programmes. Its journal is entitled *Popular Astronomy*.

Software

Dark Skies (Twilight and lunar phase freeware program) by Todd Daniels.
WWW: http://www.acretiondisk.org
Planet's Visibility, (Planetary and eclipse freeware): Alcyone Software, Germany.
WWW: http://www.alcyone.de
Redshift 4, Focus Multimedia Ltd, Rugeley, Staffs., UK.
WWW: http://www.maris.com
Starry Night & *Starry Night Pro*, Sienna Software Inc., Toronto, Canada.
WWW: http://www.starrynight.com

Internet sources

There a numerous sites with information about all aspects of astronomy, and all of those give above have numerous links. Although many amateur sites are excellent, treat any statements and data with caution. The additional sites listed below offer accurate information. Please note that the URLs may change. If so, use a good search engine, such as Google, to locate the information source.

Information

Auroral information: Michigan Tech: http://www.geo.mtu.edu/weather/aurora/
Comets: JPL Comet Home Page: http://encke.jpl.nasa.gov/
Comets and Meteor Showers: Gary Kronk's Home Page:
 http://comets.amsmeteors.org/
Deep sky objects: Saguaro Astronomy Club Database:
 http://www.virtualcolony.com/sac/
Eclipses: Fred Espenak's Eclipse Page:
 http://planets.gsfc.nasa.gov/eclipse/eclipse.html
Moon (inc. Atlas): Inconstant Moon: http://www.inconstantmoon.com/
Planets: Goddard Spaceflight Center: http://planets.gsfc.nasa.gov
Satellites (inc. Space Station): Heavens Above: http://www.heavens-above.com/
 Visual Satellite Observer's: http://www.satellite.eu.org/satintro.html
Star Chart National Geographic Chart:
 http://www.nationalgeographic.com/features/97/stars/chart/index.html
What's Visible: Skyhound: http://www.skyhound.com/sh/skyhound.html
 Skyview Cafe: http://www.skyviewcafe.com
 Stargazer: http://www.outerbody.com/stargazer/
 (choose 'New View', click and drag to change)

Institutes and Organisations

European Space Agency: http://www.esa.int/
International Dark Sky Association: http://www.darksky.org/
Jet Propulsion Laboratory: http://www.jpl.nasa.gov/
Lunar and Planetary Laboratory: http://cass.jsc.nasa.gov/lpi.html
National Aeronautics and Space Administration: http://www.hq.nasa.gov/
Solar Institute: http://umbra.gsfc.nasa.gov/
Space Telescope Science Institute: http://www.stsci.edu/public.html

GLOSSARY

amplitude In astronomy, the range of magnitudes (maximum to minimum) reached by a variable star or other object that fluctuates in brightness. (This differs from the usual definition in physics, where the term is used for half the total variation.)

appulse The apparent close approach of two celestial objects, such as two planets, a planet and a star, etc., but where the closer does not obscure the more distant in an **occultation**.

astronomical unit (**AU**) The mean distance of the Earth from the Sun, 149,597,870 km, used as a convenient unit for describing distances within the Solar System.

averted vision The technique of detecting faint objects by deliberately looking slightly to one side of them (not directly), so that the light falls on a more sensitive area of the retina.

cusp The pointed 'horn' of a crescent (as seen on the Moon or a planet) where the **terminator** meets the **limb**.

dark adaption The increased sensitivity of the eye to faint light arising from the gradual increase of a pigment in the retina. The eye must be in the dark for 20–30 minutes (or even more) for the effect to develop fully.

absolute magnitude The brightness a star would have if it were at a specific distance (10 **parsecs** or 32.616 **light-years**). Absolute magnitude is thus a measure of a star's true luminosity, i.e., of the amount of energy it is emitting.

apparent magnitude The brightness of stars, planets, or other objects as they appear in the sky and which does not take into account an object's distance.

celestial equator The great circle on the celestial sphere that is in the same plane as the Earth's equator.

celestial longitude The position of a Solar-System object, as measured along the **ecliptic**, starting from the **vernal equinox**.

celestial poles The two points around which the **celestial sphere** appears to rotate, and which are aligned with the Earth's rotation axis.

conjunction The point at which two Solar-System objects have the same celestial longitude. A planet is at superior conjunction when it is on the far side of the Sun from the Earth, but the inner planets (Mercury and Venus) are at inferior conjunction when between the Earth and the Sun.

culmination The point at which a celestial body crosses the observer's meridian. Circumpolar objects have upper and lower culmination, when above and below the pole, respectively. For non-circumpolar objects, they reach their highest altitudes above the horizon when they cross (**transit**) the meridian.

declination The angular distance (measured in degrees) of an object above (+) or below (–) the **celestial equator**. The North and South Celestial Poles are at Declinations +90° and –90°, respectively.

ecliptic The Sun's apparent path across the sky. It actually represents the plane of the Earth's orbit around the Sun.

ephemeris (pl. ephemerides) A table of prediction positions for a Solar-System object such as a planet, minor planet, or comet.

epoch A specific instant in time for which charts are drawn or calculations made. Current charts are drawn for epoch 2000.0, the start of the year 2000.

equinox The two points in time during the year when night and day are both 12 hours in length. Also: the points on the sky at which the **ecliptic** intersects the celestial equator. The **vernal equinox** is of particular importance in astronomy.

exit pupil The normally circular area at the eyepiece of an optical instrument, through which passes all the light that leaves the instrument. Its diameter is related to the size of the objective and the overall magnification of the system.

gibbous The stage in the sequence of phases at which the illumination of a body lies between half and full. In the case of the Moon, the term is applied to phases between First Quarter and Full, and between Full and Last Quarter.

hour angle The angle, measured westwards along the **celestial equator**, between the **meridian** and the **hour circle** passing through the celestial object. Hour angle increases with the passage of time.

hour circle The great circle passing through the **celestial poles** and the celestial object in question, crossing the **celestial equator** at the object's **right ascension**.

Kelvin A unit of heat (K), equivalent to one degree Celsius. The zero point of the Kelvin temperature scale is absolute zero, at which all molecular motion ceases (–273.16°C). The temperature of the surface of the Sun is approximately 6000 K.

libration The apparent 'rocking' of the Moon, as seen from Earth, enabling us to see more than 50 per cent of its surface. It arises primarily from changes in the Moon's velocity in its elliptical orbit, from the fact that the Moon's orbit is inclined to that of the ecliptic, and also from parallax effects caused by viewing the Moon in slightly different directions, depending on the observer's position of Earth.

light-year The distance travelled by light in one year, at a velocity of 299,792.458 km/s.

limb The apparent edge of the Sun, Moon or other celestial body.

luminosity A measure of the amount of energy emitted by a star. For radiation emitted at visual wavelengths it is given by the star's **absolute magnitude**.

magnitude The brightness of a star, planet, or other celestial body. It is a logarithmic scale, where larger numbers indicate fainter brightness. A difference of 5 in magnitude indicates a difference of 100 in actual brightness, thus a first-magnitude star is 100 times as bright as one of sixth magnitude. (See also **absolute magnitude**, **apparent magnitude**.)

magnitude, eclipse The percentage of the Moon that enters the dark umbral cone cast by the Earth. If the percentage is greater than 100, this is an indication of the amount of time that the Moon's disk is completely immersed in the shadow.

meridian The great circle on the celestial sphere that passes through an observer's north and south points, as well as their **zenith** and **nadir**.

nadir The point on the celestial sphere directly below an observer's feet, opposite the **zenith**.

occultation The disappearance of one celestial body behind another, such as when stars are hidden behind the Moon. Occultations of stars by minor planets can provide precise information about the shape and size of these tiny bodies.

opposition The point at which a superior planet appears opposite the Sun in the sky, crossing the meridian at midnight. This is generally the most favourable period for observation.

parallax The apparent shift in an object's position relative to more distant objects when the observing viewpoint is altered. In astronomy, it applies in particular to nearby Solar-System objects such as the Moon and the Sun, and also to the stars, where it is the basis of distance measurement.

parsec A unit of distance frequently used by professional astronomers. It is the distance (3.2616 **light-years**) at which the radius of the Earth's orbit subtends an angle of one second of arc. Expressed differently, it is the distance at which a star, observed from two diametrically opposite points of the Earth's orbit (i.e., at an interval of six months), exhibits a shift, relative to more distant background stars, of two seconds of arc.

perihelion The closest point to the Sun on the orbit of any Solar-system body, such as a planet, minor planet, or comet.

phase The portion of the visible disk of a celestial body that is illuminated by the Sun. Only the Moon and Venus show a complete sequence of phases in small instruments (the disk of Mercury being generally too small for the phase to be detected). For the outer planets, the phase effect, although present, is generally very small. In the case of Mars, it may cause the planet to appear slightly **gibbous**.

retrograde Motion (or rotation) in the opposite direction to that generally found in the Solar System. All the planets revolve around the Sun in the same direction, appearing from Earth to move from west to east. All, however, exhibit periods when their apparent motion reverses. Similarly, most of the planets rotate in the same direction (anticlockwise looking down on the North Pole), but Venus, Uranus and Pluto have retrograde rotation.

right ascension One of the two main celestial co-ordinates used to specify positions on the sky (the other being **declination**). Measured in hours, minutes and seconds of time, eastwards along the **celestial equator**, starting at the **vernal equinox**.

terminator The line separating the illuminated and non-illuminated portions of a celestial body, where the source of light (normally the Sun) is either rising or setting.

transit The passage of a celestial body in front of another, particularly of Mercury and Venus across the Sun's disk as seen from Earth. Also: the act of crossing the meridian.

vernal equinox The spring equinox, when the Sun, moving along the **ecliptic**, crosses the **celestial equator** from south to north. The origin (zero point) for the celestial co-ordinates of **Right Ascension** and **celestial longitude**. Also known as the First Point of Aries.

zenith The point on the celestial sphere directly above an observer's head.

INDEX